COLLABORATION AND RESISTANCE

IMAGES OF LIFE IN VICHY FRANCE

1940–1944

Texts by Denis Peschanski, Yves Durand, Dominique Veillon, Pascal Ory, Jean-Pierre Azéma, Robert Frank, Jacqueline Eichart, Denis Maréchal

Translated from the French by Lory Frankel

HARRY N. ABRAMS, INC., PUBLISHERS

Conception and realization: La Documentation Photographique/La Documentation Française
Coordination: D. Bataille, C.-M. Buttin, M. Frank, B. Gorce
Layout: R. Bonjour, F. Gélibert, M. Harlouchet

Project Manager, English-language edition: Ellen Nidy
Editor, English-language edition: Lory Frankel
Design Coordinator, English-language edition: Dirk Luykx

Library of Congress Cataloging-in-Publication Data
Images de la France de Vichy. English
Collaboration and resistance : images of life in Vichy France, 1940–44/ texts by Denis
Peschanski ... [et al.] ; translated from the French by Lory Frankel.
 p. cm.
ISBN 0–8109–4123–6
1. France—History—German occupation, 1940–45—Pictorial works. 2. France—Politics and
government—1940–45—Sources. 3. Pétain, Philippe, 1856–1951—Political and social views.
4. World War, 1939–1945—France—Collaborationists. 5. World War, 1939–1945—Underground
movements—France. I. Peschanski, Denis.

DC397 .I46 2000
940.54'8644—dc21 99–534637

Printed and bound in France

Harry N. Abrams, Inc.
100 Fifth Avenue
New York, N.Y. 10011
www.abramsbooks.com

Contents

Introduction

The fact that Documentation Française—the direct descendant of the information bureau of the Free French movement—which is manifestly concerned with contemporary affairs, has produced *Collaboration and Resistance: Images of Life in Vichy France, 1940–1944* presents a double paradox. Its undertaking calls for an explanation.

In publishing this work, Documentation Française is opening to public view a portion of its original legacy, which has been in its keeping since 1945: the photographs that went through the Information Commissariat of Vichy between 1939 and 1944. Another portion of its legacy, images of London and Algiers, scenes of fighting France—another subject altogether—are almost entirely missing from this volume.

The remaining portion is clear. It not only traces a new illustrated history of the Vichy government's four years—with images supporting the historical discussion—but also, even more important, demonstrates how the photographs that emerged from news agencies, under the control of the Vichy authorities, formulated the official ideology, highlighted signs of unity, and conveyed the daily life of the French people.

The power of the image, its role as an ideological weapon, is striking. Lyrical images and photographs of solidarity or national unanimity all had as their goal to make a show of the values of an idealized France under Marshal Pétain: work, family, fatherland, and also folklore, ruralism, religion. In effect, they established the Vichy government's legitimacy.

At the beginning of the occupation, the authorities faced little competition, but beginning in the winter of 1942–43, they had to contend with defiant messages disseminated by the Resistance. The underground of France rarely exposed itself to the photographic lens. In order to protect itself against accusations of terrorism and to promote its values, it instead used leaflets, graffiti, and posters, and it listened to the BBC.[1] Some of the underground newspapers sometimes published photographs, however.

Through the agency of about four hundred photographs and archival documents organized into ten chapters, this book analyzes the oratory of the various actors within the borders of France. Each chapter is briefly introduced by a historian familiar with the period. He or she invites the reader to discover, behind the image, the passwords of propaganda and their impact in the real country.

The photographs themselves are accompanied by short texts that place them in their context. In cases where the original caption or inscription, found on the back of the photograph, carried a particularly strong political message, it was retained.[2] It was actually in the close relationship, skillfully calculated, between the image and text that the ideological message attained its true dimension. Leafing through these pages and looking at the photographs, most of them pretty, one senses, beyond the simple representation of a more or less arranged reality, a resolve to speak to the heart, the reason, or the imagination of the French people.

In order to evoke what the authorized images left out through censorship—prisons, camps, tortures, massacres—other public sources were drawn on. However, these documents appear only in counterpoint to the photographs stamped with the seal of the censor's office of the French state.

Documentation Française

1. In 1976 Documentation Française published a work in five volumes entitled *Ici Londres: Les voix de la liberté*, under the direction of J.-L. Crémieux-Brilhac.
2. These texts are placed on a gray background in the commentaries.

A Leader, a Myth

Narbonne, 13 June 1942: "He wades into the middle of the crowd and I finally have a revelation of what these tours of the marshal are like: the shrieks of love from a crowd swooning with adoration and wonder, these faces drenched in tears of happiness, the emotions of the crowd like a gusty wind on a field of wheat; they bow down at his feet a bit more." As André Lavagne, then chief of Marshal Philippe Pétain's civilian staff, demonstrated in his *Journal inédit*, the cult of the leader, maintained by the widespread dispersion of his image, plays a central role in the ideological formation of a new regime. Needing to achieve cohesion of the national and social fabric, the regime aimed to fuel a mass cult of the marshal.

The image of the leader also had to be multiple. Simultaneously guide and miracle worker, the marshal was king. When he offered himself as a sacrificial victim after the traumatic defeat of spring 1940, he was Christ; in defeated France, he remained the military leader crowned by the victory of Verdun; the firm defender of a system of values that allowed the only route to France's rebirth if followed strictly, he was also the father or grandfather of all and everyone.

The cult adhered to an authoritarian political project: a veritable constitutional revolution dismantled the essential structures of the republic. Pétain, self-proclaimed head of the French state, gathered to himself constituant, executive, and legislative powers as well as an element of judicial power. He designated his successor. Civil servants had to swear an oath of personal loyalty to him.

The head of state was not, nevertheless, all-powerful; although he and his followers attempted to impose a unity centered on his singularity, the diverse components of the regime required that Vichy be conceived of in the plural. The followers of Charles Maurras, who advocated the supremacy of the state, the primacy of French interests in international relations, and a return to reactionary forms of French "greatness," were much in evidence in the early years. There were the former liberals, such as Henri Moysset, or collaborators such as Paul Marion or Jacques Benoist-Méchin; many of them took part in the

reflections on the economy of the state ("the spirit of the 1930s"). There were numerous currents and the most varied itineraries. The chronology adds to the confusion. At least four periods can be distinguished. From January 1940 to February 1941 is the golden age of the National Revolution. The year that François Darlan was head of government, second to Pétain, marked a thrust by the collaborationists and the arrival behind the scenes of the technocrats. With the return of Pierre Laval to the government in April 1942, the National Revolution was marginalized while repression came to the fore, and outside the country, the head of government tried to play a game of poker with Hitler, not realizing he did not hold the cards he needed. In the first half of 1944, the regime grew even harsher. Marshal Pétain's collisions with Laval and Darlan were basically rooted in rivalry for control of negotiations with the occupying forces. Furthermore, from 1940 to 1944, the regime was ruled by its circumstances and the international situation was unstable. A great many reasons explain why it remained far from a project of political practice.

The choice of collaboration was sealed by the armistice and confirmed at Montoire in October 1940. To begin with, Pétain believed in a German victory, in a *pax germanica,* and, therefore, in a German Europe. He thought that his choice would alleviate the hardships of occupation, would position France favorably in the new disposition of nations, and would set in motion, without external restraints, his great project of the National Revolution. Some of his entourage, such as André Lavagne, urged him to consider carefully the weight of the United States. Darlan and Laval, each in his own manner, decisively struck out on the road to collaboration. What hope remained for Vichy in November 1942, when the "free" zone was occupied, the fleet scuttled, and the empire, in essence, lost? The convictions of some and the questions of others, before as after November 1942, came up against an irreducible obstacle: Hitler wanted little from Vichy. All he looked for was a caretaker government that would keep watch over the country—much more effectively than he could have done with an occupying army.

Denis Peschanski

Marshal Pétain Welcomed by the People of France, *a painting by Charles Blanc, was exhibited at the Vichy museum on 1 May 1942.*

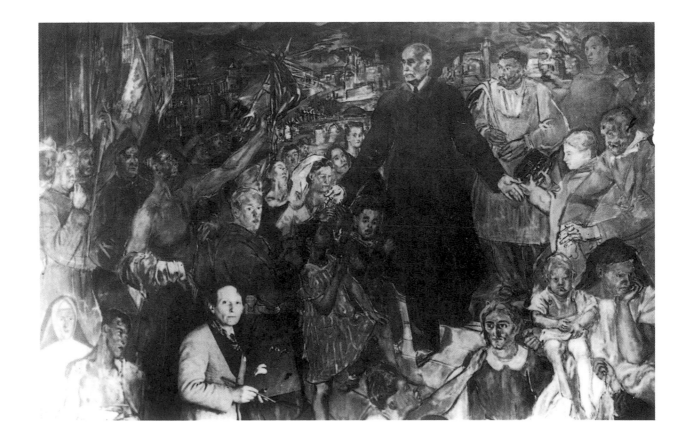

YEUX

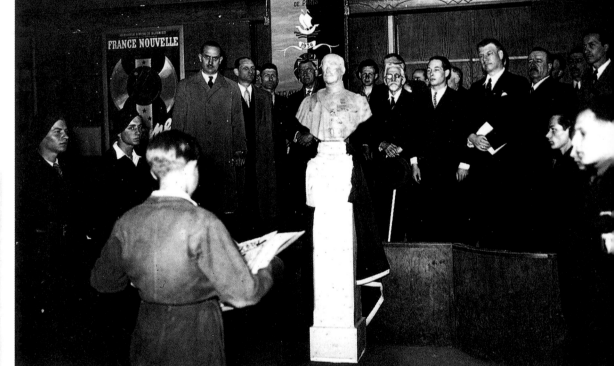

AMOUR

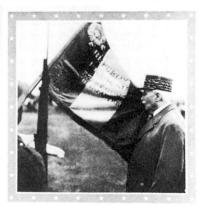

12

The ubiquitous marshal.

Who is looking at whom? A personality cult of Marshal Pétain developed, and his image appeared everywhere. In March 1941, it was announced that his bust, executed by François Cogné, would replace that of the Republic in all public institutions. That month, a native of Bordeaux noted in his diary, "Questioned the postman on the subject of the distribution of the Marshal's portrait. The most popular are no. 2 (left profile, bareheaded) and no. 5 (right profile, head covered). A great deal of activity; many people are purchasing the five portraits for 25 francs" (cited by H. Amouroux). In fifteen days, nearly 1.4 million portraits had been sold in the southern zone. Pétain's entourage proved very energetic at distributing the leader's image: the documentation office published almanacs, calendars, and alphabet books in which each letter was purported to illustrate an episode in his life or one of his innumerable qualities. The "Arts Division of the Marshal" promoted its creation.

"'A portrait? Will it look like me?'

"'I will do my best,' stammered the artist.

"'Because most of the time,' the Marshal said thoughtfully, 'portraits more closely resemble those who make them than those of whom they are made.'

"'I will get out of the way completely!' cried the artist."

opposite center: Delivery of a bust of Marshal Pétain to a training school for electricians, Paris, April 1942. Georges Lamirand, at left, was secretary-general of youth.

opposite above and below and above: An alphabet book published by the head of state's documentation office, Draeger, 1943.

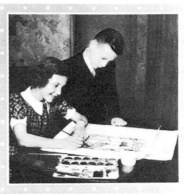

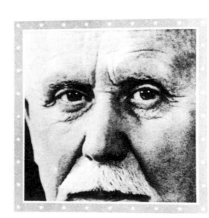

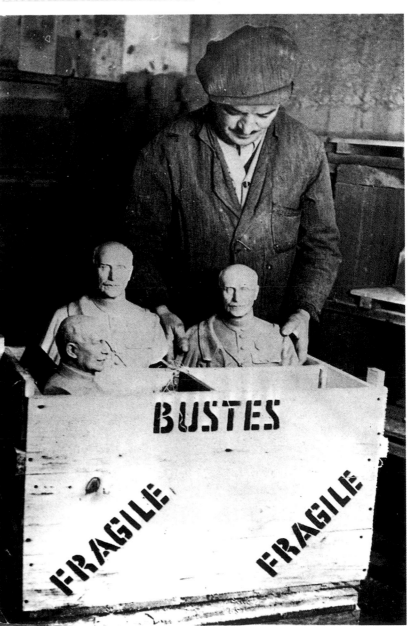

right: Busts of Pétain are placed in boxes, November 1941.

13

"JE ME DIRIGE TOUT SEUL"

Enfant d'un humble village de l'Artois, PHILIPPE PÉTAIN, en 1870 avait atteint l'âge de 13 ans. Bien avant que la France fût endeuillée, dès ses premières années, il avait vibré aux exploits des grands Capitaines, qu'il brûlait d'imiter. Ses camarades prenaient pour chef cet enfant intrépide aux cheveux d'or. Il les guidait dans leurs jeux. Il les commandait. Aussi en abordant la vie pouvait-il dire, comme il le fit au Supérieur des Dominicains d'Arcueil, qui l'accueillait dans son école où il voulait préparer Saint-Cyr : "JE ME DIRIGE TOUT SEUL".

IMAGERIE DU MARÉCHAL - Imprimé à LIMOGES 1941

"LES MIEUX FRITES, MON GÉNÉRAL!"

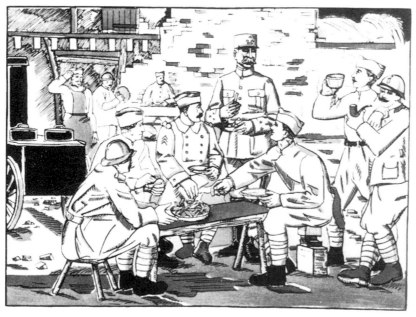

L'ARC DE TRIOM

L'ESPAGNE RETROUVE LA FRANCE

Cependant, le Monde ne recouvrait pas la Paix. Plus qu'une autre nation, l'Espagne fut déchirée. À peine eût-elle reconquis son noble et fier visage, que la France, longtemps défigurée, s'empressa de se faire reconnaître à elle, sous ses traits les plus purs. Le MARÉCHAL était le seul qui fût digne de l'immortel génie d'une Nation que des idéologies étrangères avaient fait méconnaître. Lorsqu'il présenta ses lettres de créance au Général FRANCO, son frère d'armes au RIF, les nuages se dissipèrent. De nouveau il n'y eut plus de Pyrénées.

IMAGERIE DU MARÉCHAL - Imprimé à LIMOGES 1941

A life, an example.

From the leader he was, even before joining the military, to the new Christ who, in June 1940, offered himself to a grateful country, a magnified version of Marshal Pétain had to enter every cottage. Gladly resuming a tradition, an artistic department placed under control of the head of state—the Imagerie du Maréchal, or image making of the marshal—recruited artists and artisans who created pamphlets of popular images. The first was devoted to Pétain's life, recounted in twelve plates, one in a coloring book version that gave children the opportunity to display their artistic talent.

The Life of the Marshal, a Small Coloring Book for the Children of France, Limoges: Imagerie du Maréchal, 1941. *"Even alone, I lead" (opposite above) extols the leadership qualities of the thirteen-year-old Pétain; "The best French fries, General!" (opposite far left) and "The Arc de Triomphe" (opposite left) distill his heroic service in World War I; "Spain Returns to France" (above) retails his performance as ambassador to Spain (where he greets Franco as his "brother in arms" in 1939; and, finally, "The Gift to the Country, June 1940" (below).*

LE DON A LA PATRIE JUIN 1940

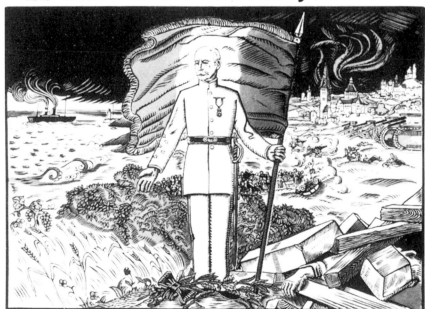

Depuis la Victoire, L'ESPRIT DE JOUISSANCE L'A EMPORTÉ SUR L'ESPRIT DE SACRIFICE. On a revendiqué plus qu'on n'a servi. On a voulu épargner l'effort, on rencontre aujourd'hui le malheur - JE FAIS A LA FRANCE LE DON DE MA PERSONNE, pour atténuer son malheur - Je ne serais pas digne de rester à votre tête, si j'avais accepté de répandre le sang français pour prolonger le rêve de quelques Français mal instruits des conditions de la lutte. Je n'ai voulu placer hors du SOL DE FRANCE ni ma personne, ni mon espoir. (Paroles du Maréchal - 1940).

IMAGERIE DU MARÉCHAL - Imprimé à LIMOGES 1941

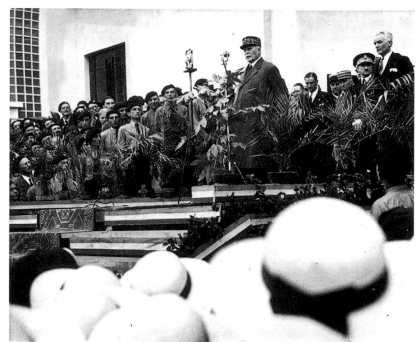

above: Pétain speaks at Châteauroux (Indre), May 1942.

below: Pétain visits the Croix-Rousse neighborhood in Lyons, November 1940.

opposite above left:
"This candid snapshot was immensely moving: a sister at the Hôpital de la Grange Blanche in Lyons noticed the head of state and she clasped her hands, as if witnessing a supernatural manifestation."
June 1944.

opposite above right: On the place des Terreaux in Lyons, the crowd listens to Marshal Pétain, addressing them from the balcony of city hall, June 1944.

opposite below left: At the Hôpital Desgenettes in Lyons, November 1940.

opposite below right: Pétain converses with a peasant in Lalizolle (Allier), September 1940.

16

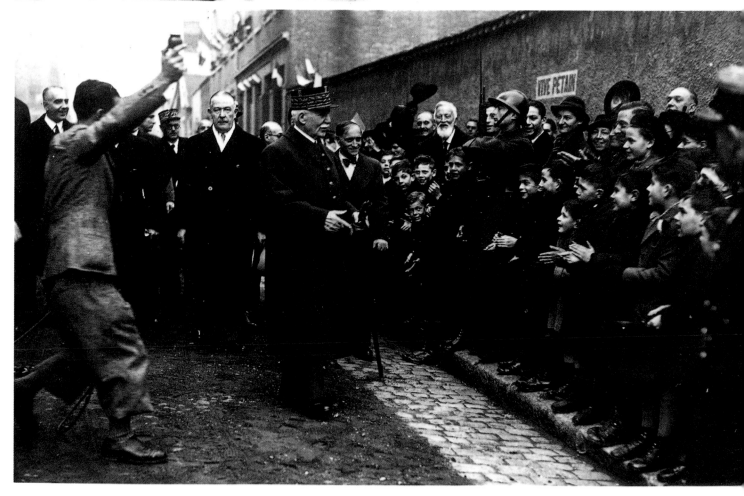

The marshal's tours.

On his travels, the man took on a human face. The visit to Lalizolle, near Vichy, as the school year began had been conceived by Marcel Peyrouton, minister of the interior, as a trial run. For four years, the marshal continued to follow this kind of practice, which he mastered perfectly. Whether the miracle-performing king or the cajoling grandfather, always facing a group of veterans in the front row, who confirmed his national and historical legitimacy, Pétain followed the prescribed script: saluting the flag, leading the oath for the members of the Légion Française des Combattants, a group of veterans created by Vichy, visiting the wounded, and basking in the warmth of the crowd. The journalist Maurice Martin du Gard, cousin of the novelist Roger, wrote in his *Chronique de Vichy* on the occasion of the Lyons visit in November 1940, "In Lyons, mystic city, the journey of the Marshal, as at Toulouse, was a triumph. Canonization: Saint Pétain. But no, rather: the entry into Jerusalem. . . . Everyone wanted to touch his coat in the crowd, which he joined easily, scattering the mounted police. One day, he will walk on the Allier [River], if this continues."

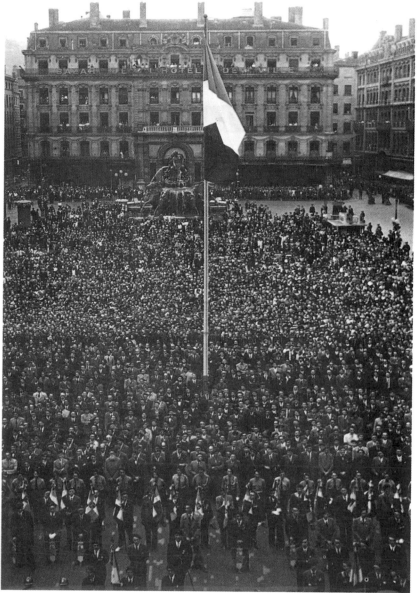

The marshal and children.

The photographs of Vichy abound with meetings between the children and the father-grandfather of the nation, in which all the actors, from the youngest to the oldest, are basically infantilized. "France, listen to this old man above you, who leans over and talks to you like a father," wrote Paul Claudel in 1940. The marshal's birthday, 24 April, occurred during the Easter celebrations, and it was followed by the feast of Saint Philip, the day set by the Vichy regime to celebrate work, and the celebration of Joan of Arc. This created a fortnight dedicated to the cult of the marshal every year, especially the Sunday when the head of state attended the traditional flag-raising ceremony.

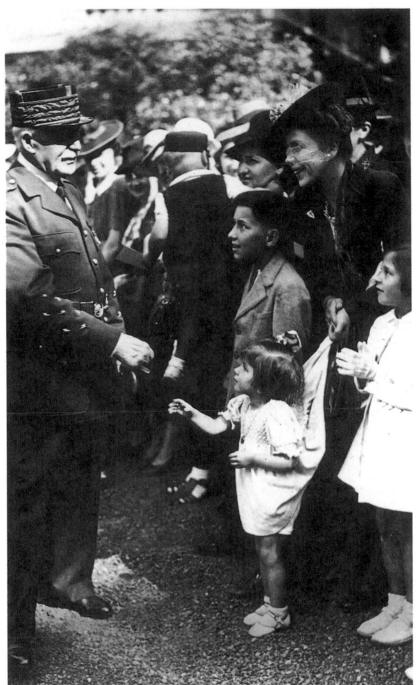

At Tulle, July 1942.

opposite: On Easter Sunday, Pétain greets children in front of the Hôtel du Parc, the head of state's residence in Vichy, 25 April 1943.
"On the day after the birthday of the Marshal of France . . . hundreds of children who could not be restrained by the police surged toward the head of state, moved by this spontaneous manifestation of affection."

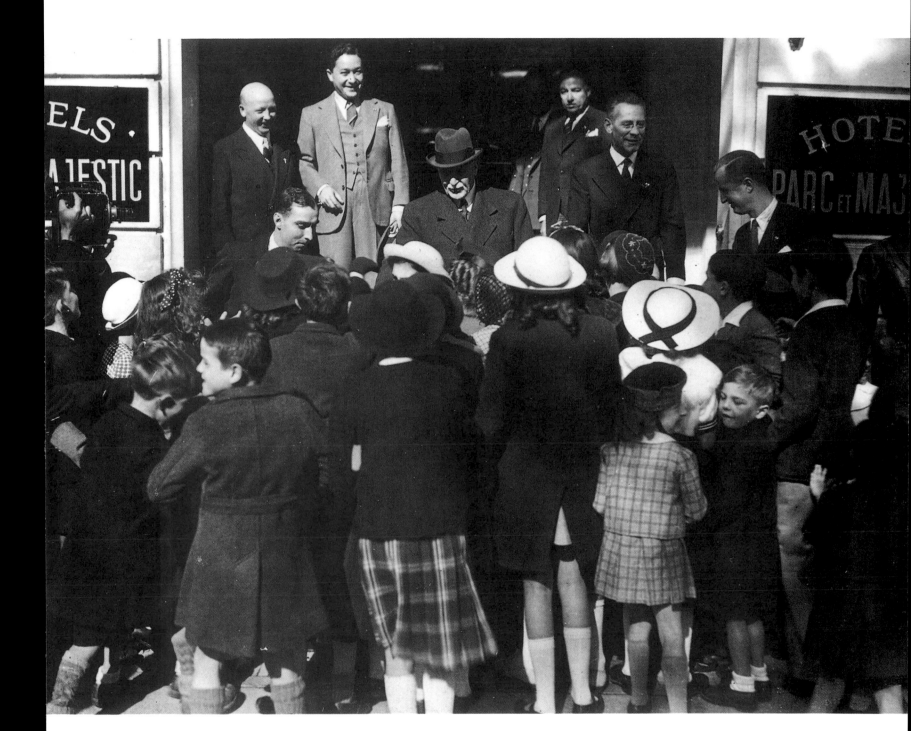

The cult of the insignia.

Just about everyone had to offer a gift to the savior, whose image had been engraved in metal by an anonymous artisan described as a "famous engraver" in a circular of the Ministry of Education. From bottles of wine to statuettes, from canes to cookie tins, the inventory of gifts found in the Hôtel du Parc calls to mind the poetry of Jacques Prévert. The marshal had even received 171 boxes of candy. While the inspiration was often the same, the results could be wildly imaginative, as demonstrated by the many variations on the *francisque,* the Frankish battle-ax chosen as the new regime's insignia, here transformed into a radio, there into an emblem of the fruits of the earth.

opposite above: A twenty-two-year-old Parisian artisan fabricated a radio in the form of a Frankish battle-ax. The dial is to the right of the handle, the loudspeaker to the left; July 1944.

opposite below: This silverware, made in 1943, is decorated with the seven stars of the marshal and the Frankish battle-ax.

above: The medal of labor was created by M. Bazor, Paris, December 1943.

below: At the Exposition of the Rural Restoration, Vichy, February 1943.

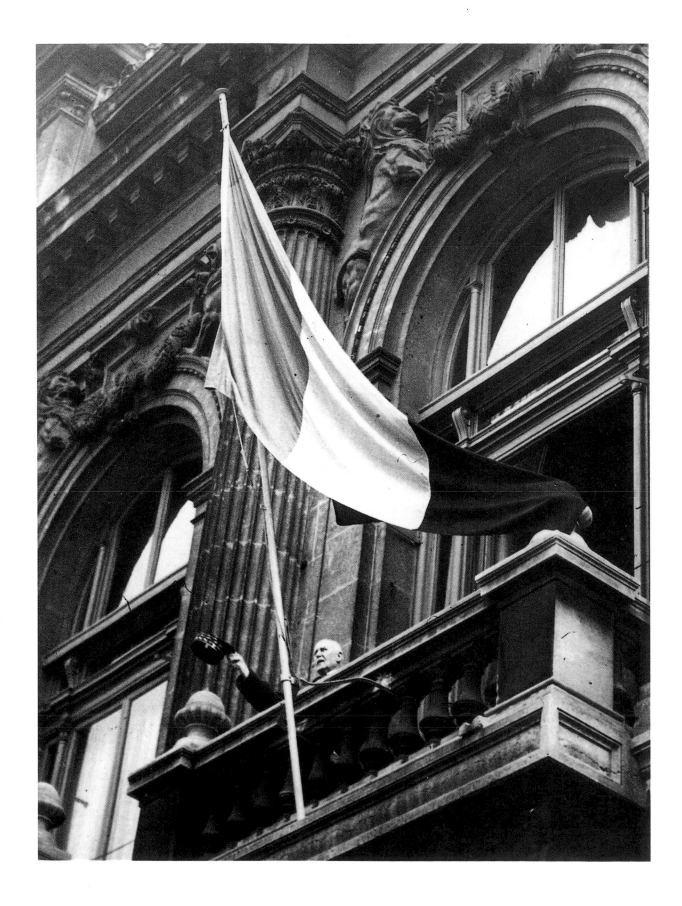

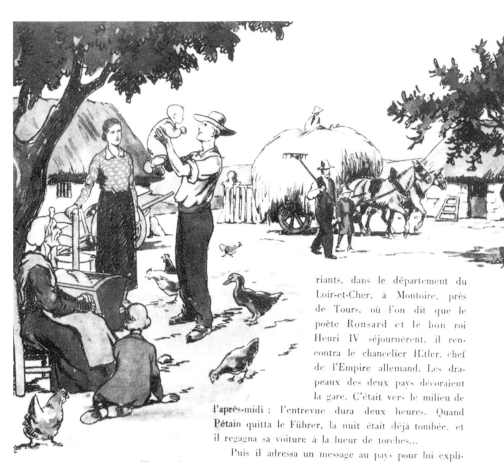

riants, dans le département du Loir-et-Cher, à Montoire, près de Tours, où l'on dit que le poète Ronsard et le bon roi Henri IV séjournèrent, il rencontra le chancelier Hitler, chef de l'Empire allemand. Les drapeaux des deux pays décoraient la gare. C'était vers le milieu de l'après-midi : l'entrevue dura deux heures. Quand **Pétain** quitta le Führer, la nuit était déjà tombée, et il regagna sa voiture à la lueur de torches...

Puis il adressa un message au pays pour lui expliquer que cette libre et loyale rencontre entre le vainqueur et le vaincu marquait le premier redressement de la France, qu'une collaboration entre les deux pays avait été envisagée, qu'il s'y était décidé dans l'honneur et afin que notre pays conservât son unité, une unité de dix siècles, dans la grande Europe nouvelle en train de s'édifier : « *Suivez-moi,* dit-il en terminant. *Gardez votre confiance en la France éternelle !* »

C'est parce qu'il ne cessa jamais, en effet, de croire et d'avoir confiance en Elle que les Français ne cessèrent jamais non plus de croire et d'avoir confiance en lui.

Chevalier sans peur et sans reproche comme le fut Bayard, sauveur de la France comme le fut Jeanne d'Arc, il reste l'une des plus belles, des plus pures figures de notre grande Histoire.

Sa vie est aussi claire et lumineuse qu'une légende.

Et c'est pourquoi, lorsqu'on veut la conter, on commence ainsi que nous avons commencé ce livre : « Il était une fois un Maréchal de France... »

Patriotism and collaboration.

Few other French governments have as heavily invoked the symbolism of the flag and the word *patriotism* in official speech. The choice of collaboration with the occupying power, formally recorded in the armistice, was strongly confirmed on 24 October 1940 during the meeting between Adolf Hitler and Pétain at Montoire. "It is said that the poet Ronsard and good King Henri IV lived at Montoire," explains a pamphlet (above) entitled *Once upon a Time There Was a Marshal of France.* The pamphlet describes the meeting between Hitler and Pétain and the latter's speech to the country afterward, which he ends by exclaiming, "Follow me! Retain your faith in eternal France!"

opposite: On the balcony of Lyons's city hall, November 1940.

above: Pamphlet published in 1941 by Editions et Publications Françaises.

below: The meeting at Montoire, 24 October 1940.

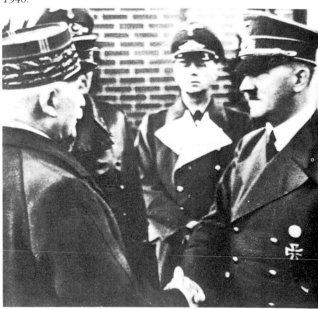

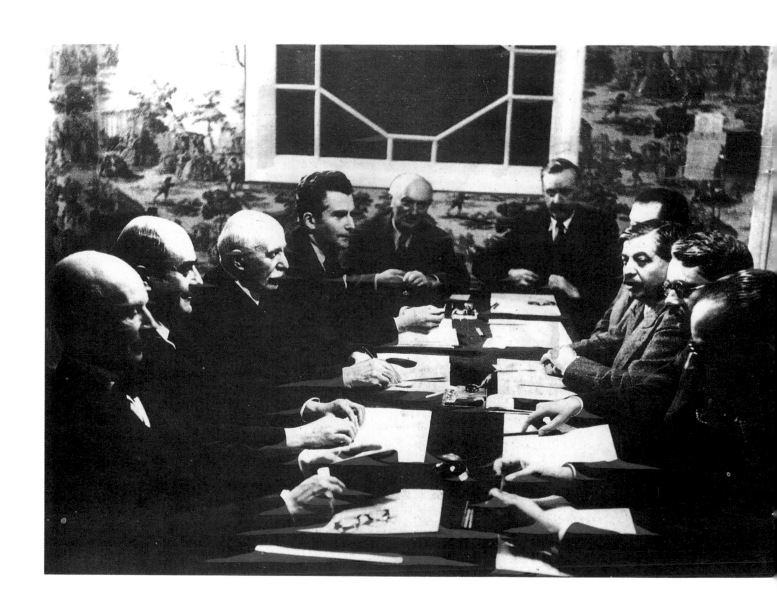

The political cast.

Rendered ethereal in ideological evocations, the image of the government becomes concrete in these three moments of political activity.

A meeting of the cabinet held shortly after it was reshuffled on 6 September 1940 (opposite) offers one of the rare images of the government during the war. Pétain was then head of state and head of government, while Laval served as deputy prime minister. Pétain had initiated the system of two councils, with, on the one hand, the full cabinet council, which brought together all the members of the government, and, on the other, the "small council" (as General Maxime Weygand, minister of national defense, called it) and the "council of ministers" (as Yves Bouthillier, finance minister, called it), the political and legislative council at which, each morning, only the ministers gathered. Here were assembled the ministers of war, of justice, and, to the left of the head of state, of foreign affairs, of the navy, of agriculture, of the interior, of finances, and of industrial production and labor.

The visit on 1 March 1941 to Saint-Etienne marked the public installation of Darlan, who had become deputy prime minister three weeks earlier—two months after Laval's dismissal from the government.

On 19 April 1942, in Vichy, Pétain shook hands with Pierre Laval, brought back into the government the day before, this time with privileges and the title of head of government. The press, summoned for the event, must have widely distributed this photograph, which was quickly withdrawn from circulation, as it provoked an unforeseen comment: "They shake hands, but a world separates them." Nevertheless, and despite a few skirmishes, the pair remained united until France's liberation.

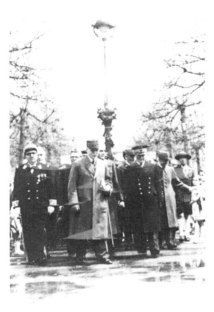

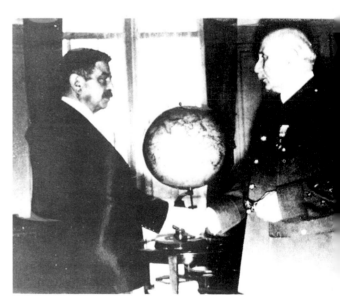

opposite: The council of ministers at Vichy, September 1940. From left to right: General Charles Huntziger, Raphaël Alibert, Pétain, Paul Baudouin, Darlan, Pierre Caziot, Marcel Peyrouton, Laval, Bouthillier, and René Belin.

above: Pétain and Darlan in Saint-Etienne, 1 March 1941.

below: Pétain and Laval in Vichy, 18 April 1942.

Pierre Laval.

His relations with Marshal Pétain were strained. The meeting between Hitler and Laval on 29 April 1943 took place with undercurrents of conspiracy—conspiracy on the part of Pétain, who sought a way to get rid of Laval; on the part of Laval, who, sensing his danger, maneuvered to incite the Germans to make a clean sweep. The major source of contention was control over negotiations with the Germans, which Pétain wanted to take from his deputy prime minister. Laval could find interest only in a momentous game of poker, which he thought he could play with the vanquisher.

The release of neither thirty photographs intended to show "a day with President Laval" nor 1.6 million copies of the propaganda book *Who Is Pierre Laval?* succeeded in improving his image with the public, which continued to view him as untrustworthy.

above and opposite above: A day with President Laval, 20 October 1942.

below: Laval gives a speech at the Compiègne train station on 11 August 1942, the first act of the Relève, or relief shift, in which prisoners of war were returned in exchange for workers who volunteered to go to Germany. Behind him is Ambassador Karl Ritter, representing Area Commander Fritz Sauckel, the German in charge of harnessing foreign labor.

opposite below: In Germany, 29 April 1943, Laval departs for his meeting with Hitler.

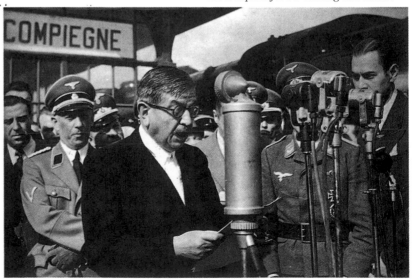

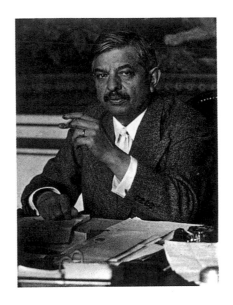

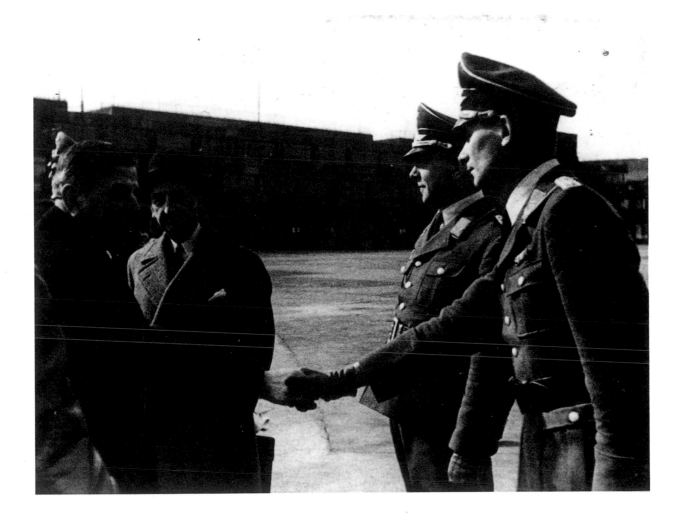

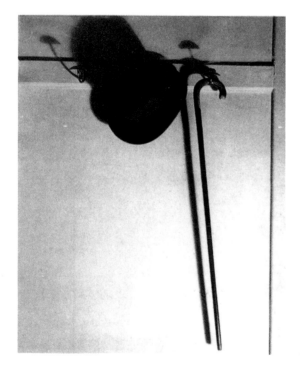

Pierre Laval's hat and cane.

Values

Vichy conveys, to begin with, a special idea of defeat. The ideologues of the new regime found their way again by seeking through defeat the possibility of completely remaking French society: utopia from a clean slate. Thus, defeat was interpreted as the sanction of the regime, an unexpected opportunity, within the limitations of circumstance, to reendow France with the values of character that gave it its glory and would allow it to rise again. Within the first few months, Pétain and his entourage set out the doctrinal issues, generally similar to those of the ultranationalist right-wing group Action Française. Laval, for his part, had no interest in Pétain's National Revolution, and other components would add their own references, whether inspired by social Catholicism, the socialism of Pierre-Joseph Proudhon, or the groups rethinking the state and the economy that proliferated before World War II. Nevertheless, the dominant note remained strongly similar to the ideas propounded by Charles Maurras, the leader of Action Française.

Official doctrine proved, above all, anti-individualist: "Nature did not create society from individuals, it created individuals from society," wrote Pétain in January 1941. The individual was forced to retire behind the intermediary bodies—family, occupation, province, country—that constituted the sole form of existence in the social ensemble. Mother or veteran, peasant or artisan: propaganda offered the country a series of obligatory references.

The fertile mother became one of the major figures of the National Revolution. Government policies and speech, moralistic or repressive, make constant references to the birthrate, a preoccupation that reaches far back in time. Pétain stated already by 15 September 1940, "The family is the essential unit, it is the foundation of the social structure. It is on it that we must build."

Against the factory and the city, where the traditional bonds of sociability and social harmony dissipate, was set the rural family, agricultural or artisanal. Of course, this choice stemmed in part from the location of the regime in predominantly rural southern France.

Regardless, the peasant and, to a lesser extent, the artisan symbolized tradition, untroubled submission to nature, and discipline. The return to the earth by prodigal sons of a dishonored France was a form of working off collective guilt.

Folklorism and regionalism are also associated with the exaltation of the province and the region, other natural communities in which the individual becomes dissolved in space and time. However, the encouragement of folkloric themes and the organizations that support them was accompanied by a strongly centralized government.

The contradictions become even more striking when the fatherland was exalted. The veteran was continually offered as a role model, the personification of discipline, of past suffering, of a victory—that of 1918, owed entirely to the military forces—and of a defeat—of 1940, owed entirely to the parliamentary republic. The constant references to the fatherland only marginally concerned the occupying forces; the nationalism of Vichy remained resolutely internal. The restoration of France would occur through an interior regeneration.

Whether the mother, the peasant, or the veteran, the images and references of official propaganda all pointed to the condemnation of the regime Vichy replaced. The symbol of the trilogy of the French state—Travail, Famille, Patrie (Work, Family, Fatherland)—supplanted that of the republic—Liberté, Egalité, Fraternité (Liberty, Equality, Fraternity). Vichy thus represents a reactionary movement that, for many of its leaders, strove to erase what they saw as France's major historical lapse, the French Revolution, a lapse reiterated at the beginning of the century by the Dreyfus affair and the separation of Church and State, then in 1936 by the government of the Popular Front.

Denis Peschanski

Motherhood.

Pétain's ideal of the woman was, above all, a mother. In creating a ministerial position for the family and health and a commissioner for the family and instituting a holiday to celebrate mothers, Vichy hardly broke with the Third Republic, which had been aware of France's declining birthrate. Nonetheless, the new regime marked the definitive passage from a concern limited to the birthrate to an outlook centered on the family proper. And the mother served as one of the National Revolution's primary ideological symbols.

Mother's Day at a nursery in Bourg-en-Bresse, May 1941.

opposite: A poster advertising Mother's Day by Phili, 1943.

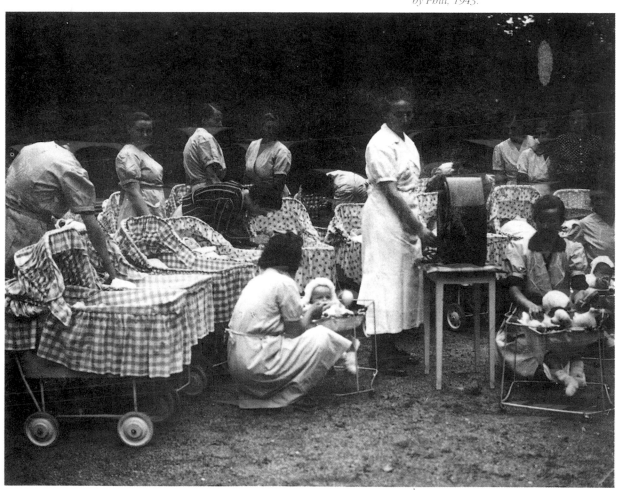

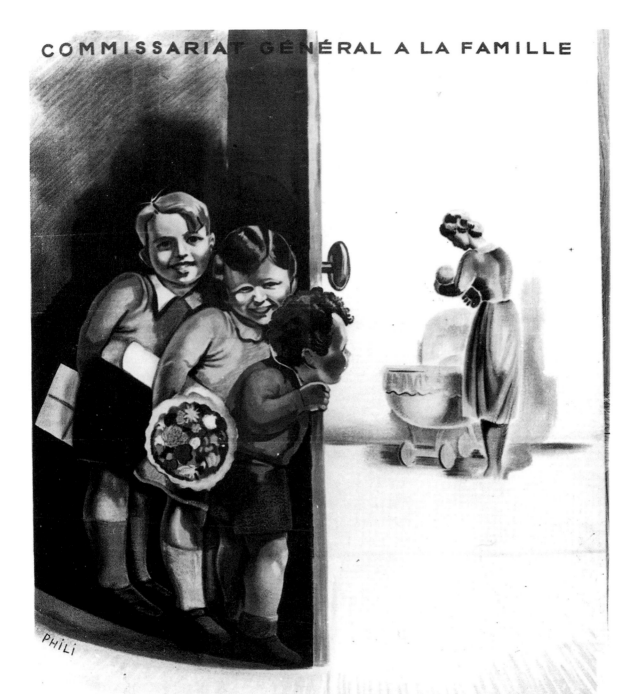

COMMISSARIAT GÉNÉRAL A LA FAMILLE

JOURNÉE DES MÈRES

DIMANCHE 30 MAI 1943

PHILI

EDITÉ PAR L'OFFICE DE PROPAGANDE GÉNÉRALE, 37, RUE DE LILLE · PARIS (3-1943)

The large family.

Vichy ideology equated the prolific mother and the large family with a stable regime. On 15 September 1940, Marshal Pétain wrote in the *Revue des Deux Mondes,* "The rights of families precede and override those of the State and also of individuals. The family is the essential unit, it is the foundation of the social structure. It is on it that we must build." The fathers of large families, like the veterans and the peasants, had their rights protected in numerous organizations, up to the budgetary commission (which replaced the finance commission of Parliament). If the "glorious family" were of peasant stock to boot, then France was saved. The Sully prize was created to aid the "poor peasant families that have the merit of raising several children"; ninety families with nine children or more received awards of 20,000 francs.

above: In a suburb of Lyons, May or June 1941.
"M. Caziot, minister of agriculture, is introduced to the head of a splendid family of twelve children."

below: Veauce (Allier), December 1943.
"The M. household has the good fortune to have twelve children, all in excellent health. This glorious French family will soon become the object of a Cognacq award of 20,000 francs, which will be welcome help in feeding all those small mouths."

opposite: A family awarded the Sully prize, February 1942.

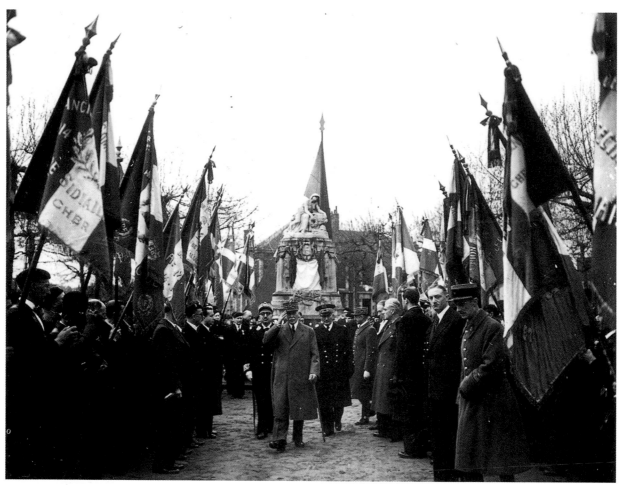

The veteran.

Falling in with the victor of Verdun, the leader close to his troops, France reasserted such fundamental values as discipline, self-sacrifice, and devotion, the lot of the ex-serviceman.

During the period between the wars, the veterans of World War I formed an influential lobby based on their organizations that was strongly antiparliamentarian. Making these men and victims of the French military campaign heroes and heralds of the new regime, led by a military officer, meant affirming those values. It also asserted that the army did not bear responsibility for the defeat of 1940.

opposite above: Pétain salutes the flag at Montluçon, May 1941.

opposite below left: The marshal clasps the hand of a wounded veteran at Clermont-Ferrand.

opposite below right: The marshal greets a priest with an amputated leg at Annecy, September 1941.

Beneath the Frankish battle-ax, Clermont-Ferrand, October 1943.

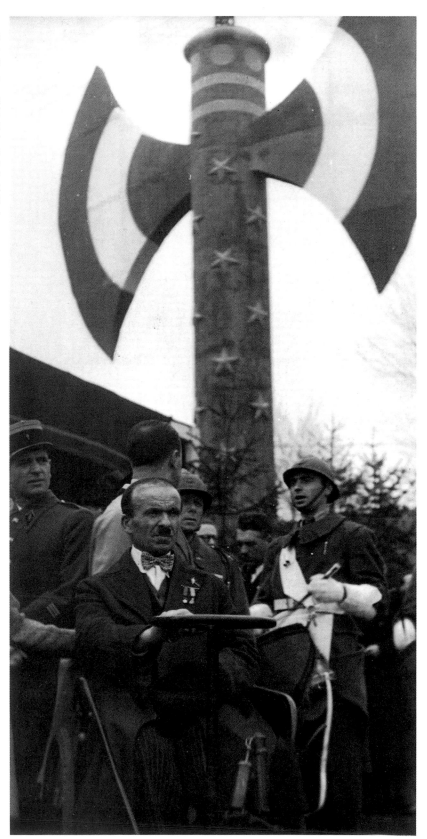

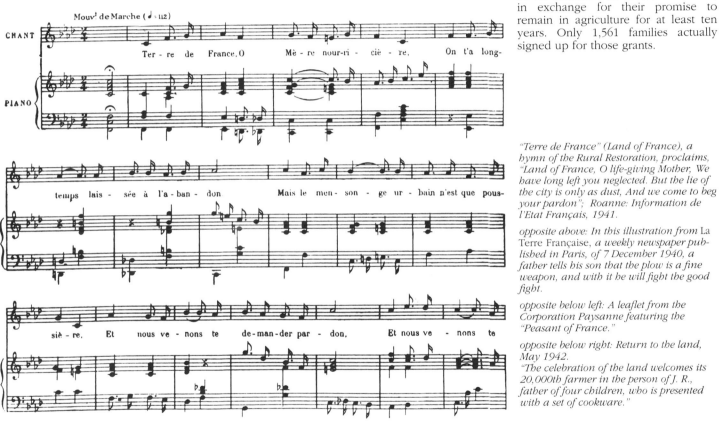

TERRE DE FRANCE

HYMNE DES JEUNES

Paroles de
GEORGES KLETCH

Musique de
GEORGES KLETCH et **LOUIS PRÉCHAC**

« La Terre ne ment pas. Elle demeure votre recours. Elle est la Patrie elle-même. Un champ qui tombe en friche, c'est une portion de France qui meurt. Une jachère de nouveau emblavée, c'est une portion de France qui renaît. »

PH. PÉTAIN.

Mouv¹ de Marche (♩ = 112)

CHANT

PIANO

Ter-re de France, O Mè-re nour-ri-ciè-re, On t'a long-temps lais-sée à l'a-ban-don. Mais le men-son-ge ur-bain n'est que pous-siè-re. Et nous ve-nons te de-man-der par-don, Et nous ve-nons te

"Terre de France" (Land of France), a hymn of the Rural Restoration, proclaims, "Land of France, O life-giving Mother, We have long left you neglected. But the lie of the city is only as dust, And we come to beg your pardon"; Roanne: Information de l'Etat Français, 1941.

opposite above: In this illustration from La Terre Française, *a weekly newspaper published in Paris, of 7 December 1940, a father tells his son that the plow is a fine weapon, and with it he will fight the good fight.*

opposite below left: A leaflet from the Corporation Paysanne featuring the "Peasant of France."

opposite below right: Return to the land, May 1942. "The celebration of the land welcomes its 20,000th farmer in the person of J. R., father of four children, who is presented with a set of cookware."

2ᵉ COUPLET.

Terre de France, ô fidèle maîtresse,
Nous te ferons plus belle chaque jour.
Tu connaîtras notre rude caresse
Et tes sillons, le fruit de notre amour. (Bis)

3ᵉ COUPLET.

Terre de France, orgueil de notre race,
Tu ne mourras jamais, nous le jurons !
De nos efforts nos fils suivront la trace
Et chanteront, plus gais que des clairons. (Bis)

REFRAIN.

Vive le Pays de France
Et les Paysans !
Le Printemps, notre espérance,
Revient tous les ans.
Tra-la-la-la-la-la !

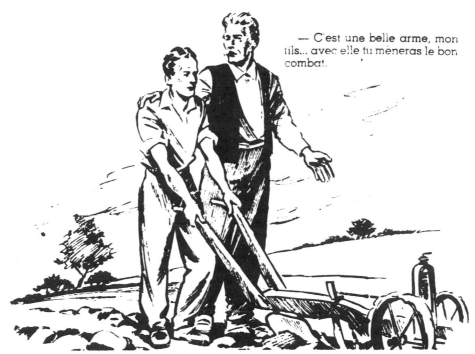

— C'est une belle arme, mon fils... avec elle tu meneras le bon combat.

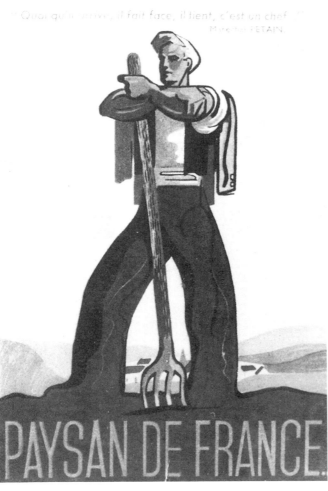

PAYSAN DE FRANCE.

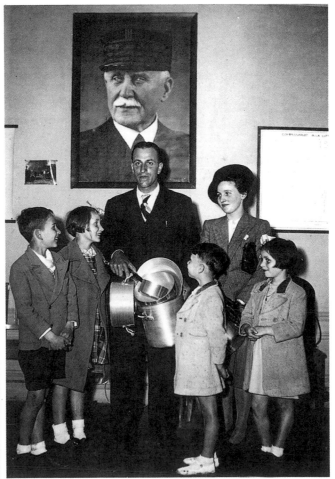

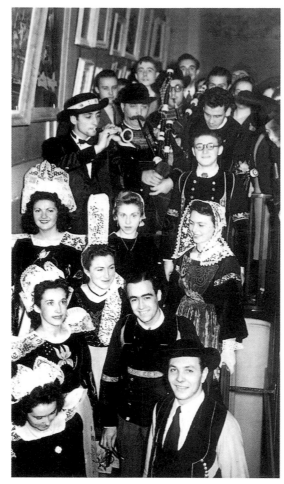

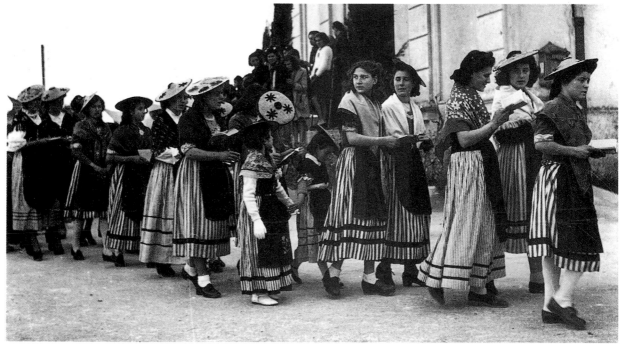

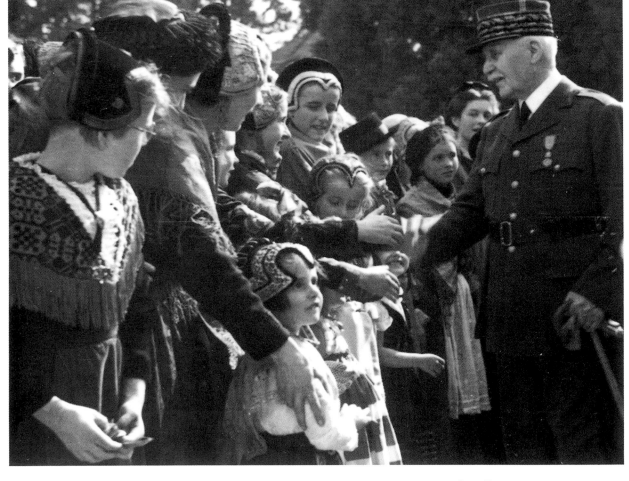

Nos provinces

*Bretagne pieuse et nostalgique,
terre des hommes aux yeux clairs
et à l'âme indomptable.*

BRETAGNE

Regionalism.
Folklore and regionalism touched on
the most traditionalist underpinnings
of the regime, directly inspired by the
theories of Charles Maurras. The indi-
vidual yields to such natural communi-
ties as the province, which forms the
basic social structure. The new France
was to arise from provincial France.

*opposite above left: An exhibition of the art
of Bretagne in Paris, November 1942.*

*opposite above right: An exhibition of the
Rural Restoration, Vichy, February 1942.*

*opposite below: Peasant festival in Nice,
1944.*

above: Annecy, September 1941.

*below: An illustration for "Our Provinces:
Bretagne" in* La Terre Française, *23 August
1941.*

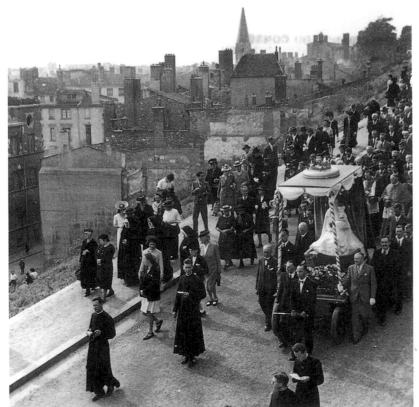

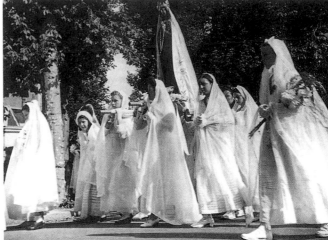

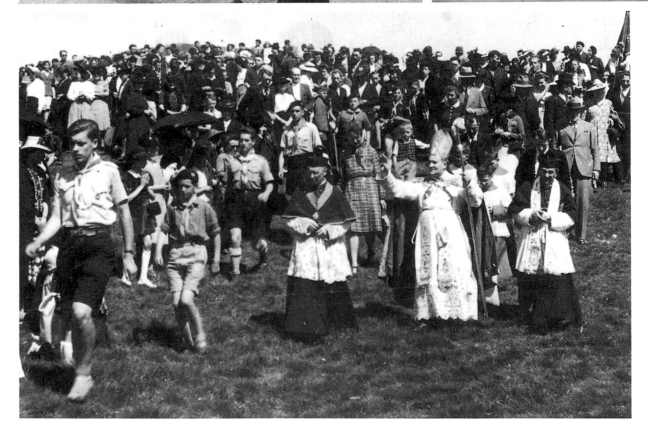

Pour que l'Enfant Jésus protège le Maréchal.

Les enfants du Couvent de l'Assomption de Cannes
Lui ont offert tout au long de l'Avent

Messes 559

Communions 373

½ heures de Travail assidu 1674

Actes d'Obéissance 2217

Religion.

In the Catholic Church, the state recognized an essential element of the new regime, as the upholder and guardian of universal values. Religious schools were largely underwritten; memos from the minister of the interior in 1941 stated that from that point on it was permissible to place a crucifix in schools and town halls, regardless of any decision taken by the municipal council.

The procession of Notre-Dame de Boulogne in Lyons, that of Vichy in 1943, and the one of 15 August 1944 in Vichy in which a papal nuncio took part, the renaissance of Puy-en-Velay as a religious center—all illustrate the new impetus of the Marian cult, between the "Ardent Voice" of 1938 and the "Great Return" of 1948, the Marian decade.

Monsignor Piguet, the bishop of Clermont, was an ardent supporter of Pétain's program. For the first anniversary of the Légion Française des Combattants in August 1941, for example, he ordered that all the churches in the diocese ring their bells to demonstrate the link between Catholics and the marshal. Although he remained a staunch supporter of Pétain, on 28 May 1944 Monsignor Piguet was arrested by the Germans, who suspected him of having assisted a fugitive priest.

opposite above left: The procession of Notre-Dame de Boulogne between Fourvières and the primatial church of Saint-Jean, Lyons, September 1943.

opposite above right: The black Virgin is carried by the children of Mary in Vichy, 15 August 1944.

opposite below: Monsignor Piguet, the bishop of Clermont, blesses pilgrims on the mountain of Vassivières, July 1943.

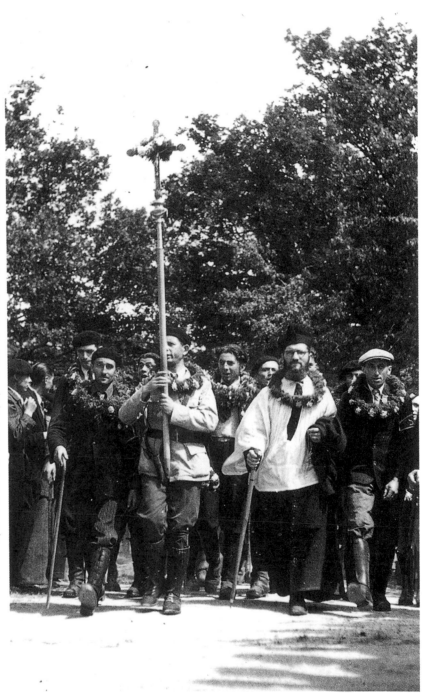

43

The transmission of values.

It was not enough to give as examples the few emblematic figures of the new regime or to confirm its Christian roots. The transmission of those values to youth would prepare the regeneration of France. Therefore, young people read, looked at, and listened to the marshal.

At the beginning of the school year in 1941, Pétain addressed France's students in these terms: "Since you would like to be with me, it is not enough that you tell me, you must make it clear to everyone. . . . I have need of brave girls and boys to take up the struggle against two of their main adversaries: forgetfulness of good resolutions and disloyalty in class. . . . I tell you what I told my soldiers in the other war: be brave, do not surrender."

Pétain had always been interested in educational issues; in 1934, he wanted to be minister of public instruction, but Prime Minister Gaston Doumergue made him minister of war instead. Convinced of the primacy of the military model, he had little confidence in the teaching profession, but the school had to be an effective link that extended each family unit; the father of the family had to set an example and transmit his knowledge.

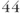

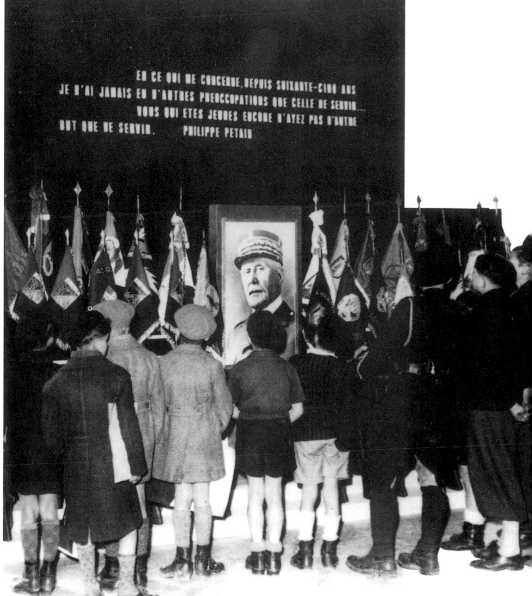

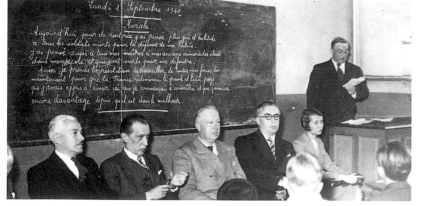

above: Exhibition of the New Army (the army of the armistice), Vichy, April 1942.

below: On the first day of classes in an elementary school in Clermont-Ferrand, the principal reads and comments on a text by Marshal Pétain, as (from left to right) the rector, the prefect of Puy-de-Dôme, the inspector of the academy, and the elementary school inspector listen, September 1940.

opposite: An elementary school teacher and his students set up a radio in order to listen to the marshal's speeches given especially for schoolchildren, October 1941.

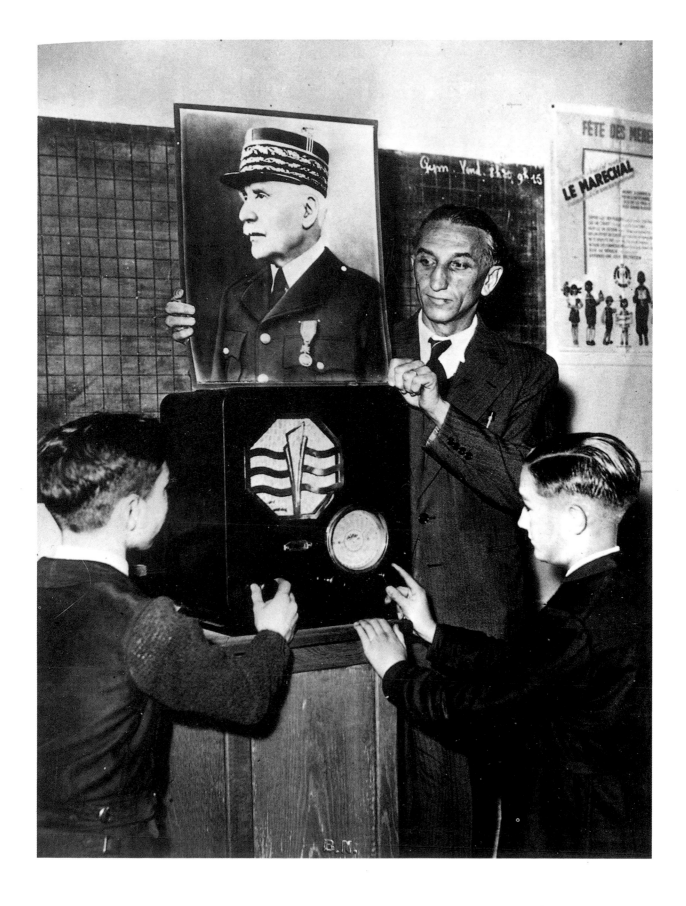

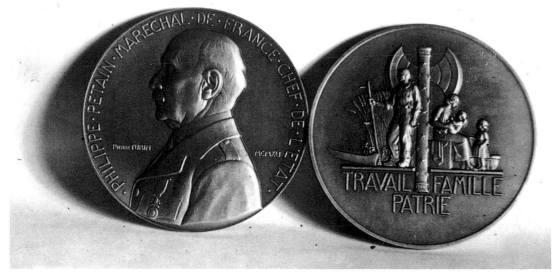

A Farmer's Medallion, 1942.

Molding a New Society

The power of the state was used to draw the contours of the new society that it desired to call into being. This reconstitution of the national fabric, this redefinition of the group, worked by excluding what it considered the outlander, the foreign "Other," and by mobilizing the energies it labeled healthy.

Exclusion was consubstantial with the Vichy regime. It provided a simple explanation: the defeat was the result of the former regime's defects, which resided in a multiheaded conspiracy, bringing together Jew, Freemason, Communist, and foreigner. Since then, any attempt at national renovation had to exclude this phantasm of the Other. The banning of "secret societies," the administrative internment of foreign Jews and Communists, the laws regulating Jews—these major legislative coercive measures were taken in the regime's first few months and needed no pressure from the occupier. Starting in the summer of 1942, anti-Semitic policy found its way into a different kind of project: the Nazi policy of extermination, the "final solution," which led to the deportation of 75,000 French Jews and the death of more than 95 percent of these. The "final solution" did not enter into the logic of Vichy policy, yet it would not have been able to take such a heavy toll had France not served as intermediary; these two statements are essential to understand the logic that ruled French policy.

In order to mobilize the souls and bodies it wanted to save, it had to serve as an intermediary. The two pillars of the regime, that is, the army and the Catholic hierarchy, were traditionalist. There had never been more soldiers in the corridors of power than following the disaster of 1940. The "great silent" army seized the opportunity to avenge the indignities it felt it had suffered in the Dreyfus affair some forty years earlier. The Catholic hierarchy intended to make up for the separation of Church and State. Furthermore, the public ideology of the rulers and the practical measures they took in support of the family and confessional instruction could not help but please a Catholic hierarchy, which responded with increased signs of allegiance and played a major role in the new institutions. It is important to balance

this attitude, however, against the fierce opposition of Catholic groups to the issue of a single youth organization and the public and spectacular protest of several bishops against the anti-Semitic roundups of the summer of 1942. Taking the Catholic Church in its totality calls for further balancing.

The same traditionalist ethic animated the Légion Française des Combattants, a unique organization of ex-servicemen created at the end of August 1940. General Emil Laure, secretary-general of Pétain's cabinet, outlined its role in 1941: "The Légion, you see, is a great assemblage of Frenchmen who know only one order: Duty. . . . It is you who must change the spirit of the masses, give them the idea of duty, of sacrifice." Yet in bringing the Légion into existence, Pétain closed the door on the idea of a single party, a traditional authoritarian method of consolidating power. This attitude illustrates the conflicts that appeared beginning in the summer of 1940, a season of all manner of utopias, and could only make them worse.

At its roots, the Vichy regime truly harbored a desire to fashion a new society, through the exclusion of some and the containment of others, but the results do not match the intentions. If repression could only increase in response to the radicalization of the regime and the demands of the Germans, at first it indicated the failure of the policy of containment. Hostile from the beginning to collaboration on the whole, French public opinion always retained its trust in Pétain while, from 1941, mistrusting the principles of the National Revolution. It largely shared the regime's anti-Semitism, but the initial anti-Jewish laws, if not greeted with indifference, had largely slaked this sentiment. The shock evoked by the roundups of the summer of 1942 had the effect of isolating the leaders, always more closely associated with the occupying power to begin with. These variables and constants caused a fluctuation of public opinion. Yet, very quickly, the failure of Vichy's policy of containment was sealed.

In this poster, published by the propaganda center of the National Revolution of Avignon, a France built on radicalism, "democracies, i.e., Communism," capitalism, parliament, and egoism founders, while a France supported by the pillars of school, artisans, peasantry, and the Légion, resting on the foundation of discipline, order, savings, and courage, remains stable.

Denis Peschanski

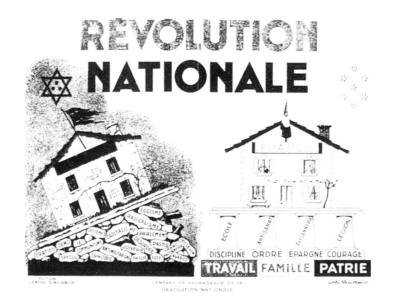

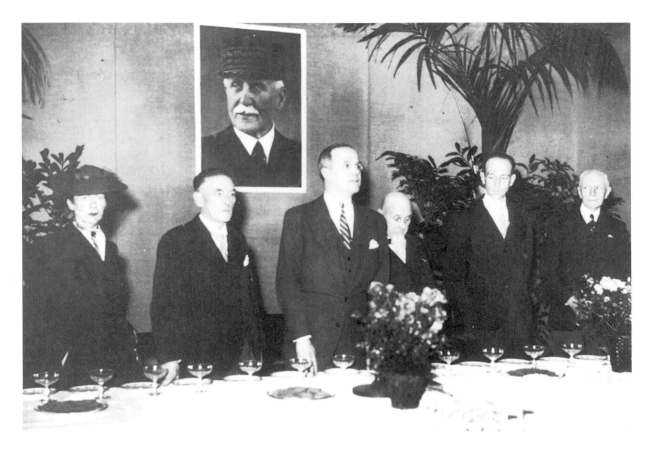

Jews were excluded from the new society.

On 3 October 1940, the government promulgated a "statute" that banned Jews from any public role as well as from many of the liberal professions. The regime needed no pressure from the Germans to be persuaded of the logic of exclusion. The second statute, published on 2 June 1941, proved even more stringent, while on the same day a law proclaimed that all Jews had to be registered. Two months earlier, the office of commissioner-general for Jewish affairs had been created and placed in the hands of Xavier Vallat, who was succeeded on 6 May 1942 by Louis Darquier de Pellepoix. Under his leadership, the policy of the office became more extreme; he founded, for example, a series of anti-Semitic institutes, including the Institute of Anthropology-Sociology, presided over by Claude Vacher de Lapouge and with Dr. René Martial as one of its major promoters.

The inauguration of the Institute of Anthropology-Sociology in Paris, December 1942, was attended by Louis Darquier de Pellepoix (center), flanked by René Martial on his left and Claude Vacher de Lapouge on his right.

opposite: A poster informs the Jews of Marseilles that a new law requires them to register with the police at city hall.

50

ÉTAT FRANÇAIS

VILLE DE MARSEILLE

ARRÊTÉ

relatif au

RECENSEMENT DES JUIFS

NOUS, Préfet des Bouches-du-Rhône, Administrateur Extraordinaire de la Ville de Marseille, Officier de la Légion d'Honneur ;

VU la loi du 5 Avril 1884 ;

VU le décret du 20 Mars 1939, pris en exécution du décret-loi du 12 Novembre 1938 ;

VU la loi du 29 Juillet 1940 ;

VU la loi du 2 Juin 1941 ;

VU la loi du 13 Juillet 1941 ;

VU l'article 471, paragraphe 15 du Code Pénal.

ARRÊTONS :

ARTICLE PREMIER. — Toute personne juive au regard de la loi du 2 Juin 1941 portant statut des juifs doit en faire la déclaration, sur un imprimé spécial, en l'Hôtel de Ville, service de la Police Administrative, avant le 31 Juillet 1941, délai de rigueur.

ART. 2. — La déclaration ne sera réputée accomplie que lorsque l'imprimé réglementaire aura été dûment rempli par les intéressés, et déposé, ou adressé par la poste en recommandé, à l'Hôtel de Ville. Toute déclaration effectuée avant la publication du présent arrêté ou non souscrite au moyen de l'imprimé réglementaire est nulle et de nul effet.

ART. 3. — M. le Commissaire Central de Police, M. le Commandant de Gendarmerie. M. le Directeur de la Police Administrative sont chargés, chacun en ce qui le concerne, de veiller à l'exécution du présent arrêté.

Fait à Marseille, le 22 Juillet 1941.

P. le Préfet des Bouches-du-Rhône,
Administrateur Extraordinaire de la Ville de Marseille,
Le Secrétaire Général de la Préfecture délégué :

PIERRE BARRAUD.

Imp. Municipale

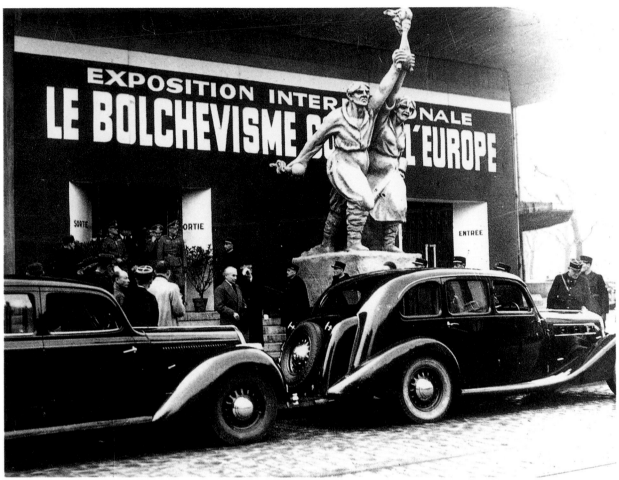

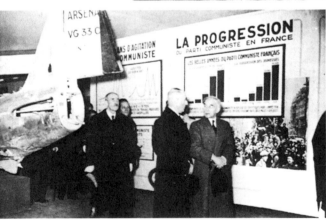

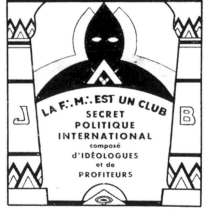

POURQUOI
a-t-on condamné la
FRANC-MAÇONNERIE?

PARCE QUE:

LA F∴M∴ EST UN CLUB
SECRET
POLITIQUE
INTERNATIONAL
composé
d'IDÉOLOGUES
et de
PROFITEURS

Pour nous en convaincre, il n'est que de lire les déclarations
des maçons eux-mêmes, dans leurs assemblées annuelles
qui s'appelaient des CONVENTS.

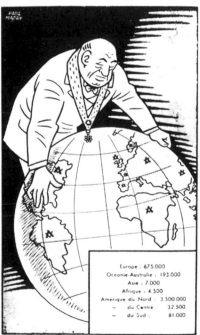

Europe : 675.000
Océanie-Australie : 193.000
Asie : 7.000
Afrique : 4.500
Amérique du Nord : 3.500.000
— du Centre : 32.500
— du Sud : 81.000

Excluded from the new society: Freemasons and Communists.

Excluded: Jews. Excluded: foreigners, Freemasons, and Communists. Regeneration would be achieved through exclusion. The main measures were taken beginning in the summer of 1940, such as the decree ordering the dissolution of secret societies (13 August). The conspiracy of the Freemason—an obsessional theme—was perceived as a rejection of the nation. In the margin of the caricature opposite (below center) is written, "When the interests of Freemasonry and French interests are opposed, Freemasons give precedence to their association over the French interests."

The Vichy brand of anti-Communism formed another variant of the conspiracy phantasm. The idea of a large exhibition, *Bolshevism against Europe*, arose in Parisian milieus partial to the rightist party of Jacques Doriot, a one-time Communist who had become a rabid anti-Communist, and the Comité Antibolchevique, but it gained the support of Paul Marion, the minister of information. The exhibition opened its doors on 1 March 1942 in Paris. A year later, it went to Lyons, inaugurated by Abel Bonnard, minister of education, and Paul Creyssel, then secretary-general of propaganda.

opposite, above and below left: Abel Bonnard exiting and going through the exhibition Bolshevism against Europe, *Lyons, March 1943.*

opposite, below center and right: Pages from an anti-Freemasonry pamphlet published by the Department of Propaganda and Information, Vichy, 1941.

A man, following the directions on a sign at the exit to the anti-Freemasonry exhibition held in Paris, October 1940, pays homage to the French flag.

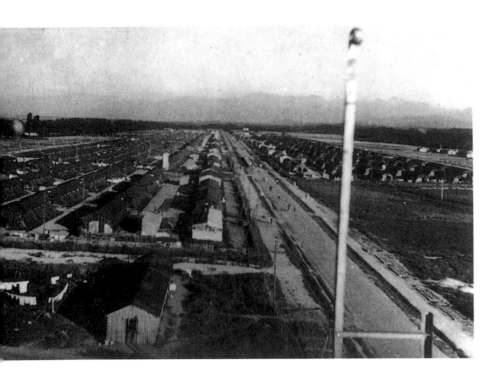

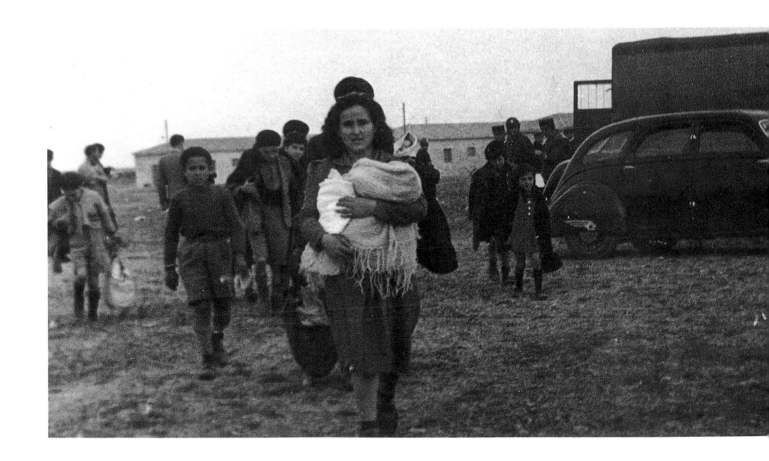

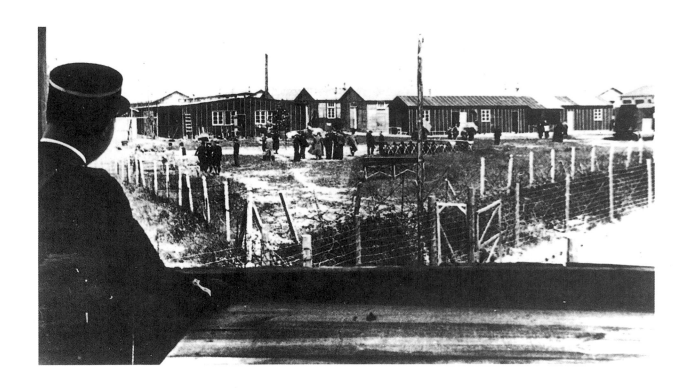

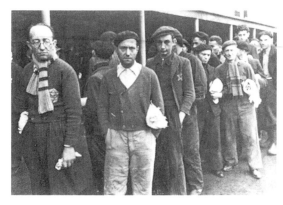

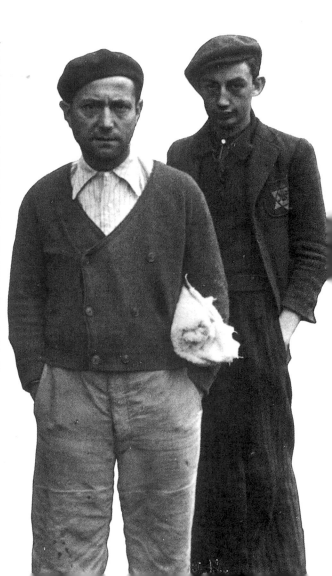

The internees.

France: land of asylum or land of camps? At the end of the 1930s, camps had been built to shelter Spanish Republicans and the defeated fighters of the international brigades. Then they were targeted as internment camps for Germans and Austrians, who in September 1939 were considered enemies, although most of them had fled from the Nazis. After France's defeat, administrative internment became an essential element of the repressive legislation. It signaled a major change in policy, as exclusion was one of the bases of the new regime. The reports left by charitable organizations reveal the appalling food and hygiene in these camps. In 1942 a new use developed for the camps, all of which, with the exception of one in Compiègne, fell under French jurisdiction. Whether in the "free," or southern, zone or in occupied territory, they became antechambers of death, the first stage of the "final solution." On 27 March 1942, the first train of death left Compiègne for Auschwitz.

opposite above: The camp in Gurs, in the Pyrenees.

opposite below: The camp in Rivesaltes (Pyrénées-Orientales), 1941.

above: The camp in Pithiviers, Loiret.

center: The camp in Drancy, near Paris, 1942.

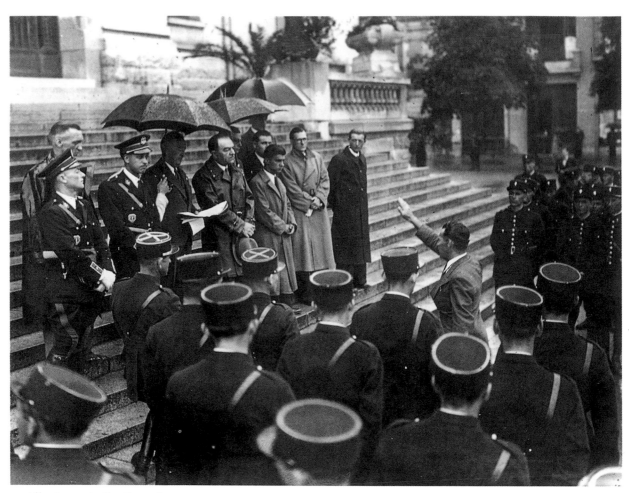

Allegiance to the French state.

The personal allegiance of every citizen to the head of state was considered a condition of social cohesion. Its manifestations were more or less popular, more or less official in nature. At Saint-Etienne in March 1941, in an obligatory ceremony for most of the marshal's visits, members of the Légion Française des Combattants swear an oath. By the constitutional acts numbers 8 and 9 of 14 August 1941, no one was allowed to serve in the army or perform the duties of a magistrate "if he does not take the oath of loyalty to the head of state." The constitutional act number 10 of 4 October 1941 extended the requirement to all the government's civil servants.

In Vichy, the police of Bourbonnais (above, in August 1942) and the Council of State (right, in January 1942) swear the oath of loyalty.

opposite: Members of the Légion Française des Combattants swear an oath in Saint-Etienne near the war memorial on the place Fourneyron, 1 March 1941.

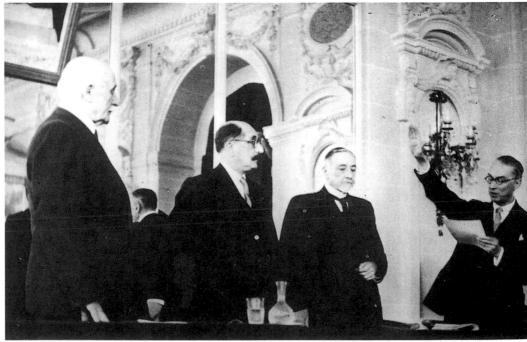

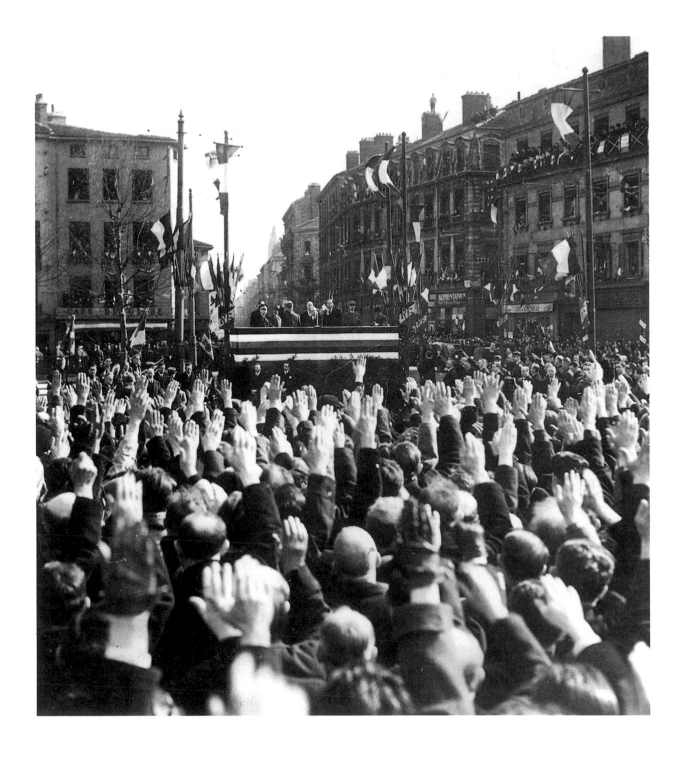

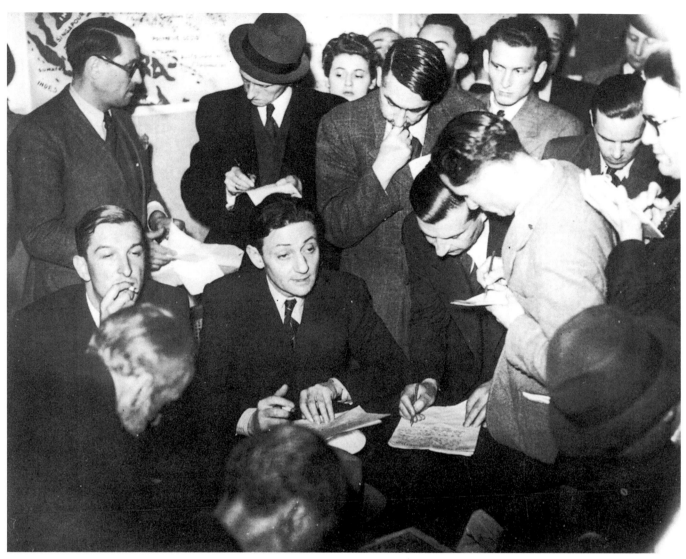

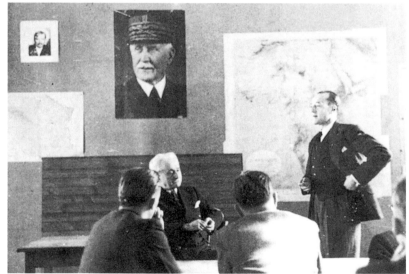

Information and propaganda.

In February 1941, Paul Marion took charge of the information services in the cabinet organized by François Darlan. Although still only adjunct secretary-general, he actually enjoyed extensive powers. He attempted to consolidate a policy of total containment that would rest on a network of propaganda deputies trained in the Ecole Nationale des Cadres Civiques (National School for Civic Officials) established in Mayet-de-Montagne (near Vichy) starting in the fall of 1941. By the time Paul Creyssel was photographed at Mayet in October 1942, Marion had already lost most of his prerogatives. It was Creyssel who directed the propaganda services, and he would soon be named secretary-general of propaganda under the direct sponsorship of Laval. The nomination of Philippe Henriot in January 1944 as minister of information and propaganda corresponded to a new harshness of the regime, with the entry of Parisian collaborationists in the government.

opposite above: Paul Marion tells the press the makeup of the new government, Vichy, April 1942.

opposite below left: Francis Bout de l'An visits the Ecole Nationale des Cadres Civiques in April 1944.

opposite below right: Paul Creyssel during a conference at Mayet-de-Montagne, October 1942.

above: Sketch for the cover (by H. Baille) of a collection of small posters published by the technical propaganda services of the minister of information.

below: Philippe Henriot (with his head turned), minister of information and propaganda, presides over a banquet of regional deputies for the Ministry of Information, Vichy, April 1944.

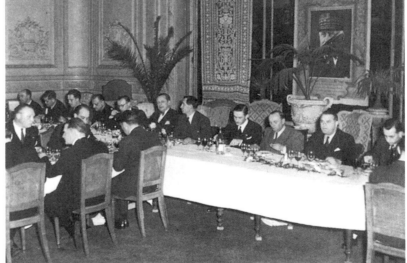

59

The Légion.

An ersatz single party, the Légion Française des Combattants was created by Pétain on 29 August 1940. Each year, its members mounted an elaborate set of ceremonies. For its first anniversary, the "flame of the union" crossed the entire southern zone between 28 and 31 August 1941. For its second anniversary, it met at the ancient Gallic site of Gergovie; the periodical *La Légion* (15 September 1942) wrote, "Twenty centuries after the dawning of nationalism in Gaul, in the same place where the French spirit knew its first victory, under the monument raised in 1901 to the memory of the Arverni leader Vercingetorix, Marshal Pétain, president of the Légion, sealed the crypt that will shelter, as the most precious of treasures, the French soil collected in the mother country and the colonies, from all the places where breathes the spirit of France."

The Légion was intended to play a crucial part in the policy of social containment. After the collaborationists in the government gained a foothold in the summer of 1941, the Légion became the Légion Française des Combattants et Volontaires de la Révolution Nationale, open to nonveterans and intended to assume an active sociopolitical role. At the same time, a radical wing, the Service d'Ordre Légionnaire (SOL) formed in October 1941. Despite the reservations of the Légion's director, François Valentin, it received the official sanction of the French state and was integrated into the organization of the Légion in January 1942. At the end of the process, on 30 January 1943, the SOL evolved into the Milice Française, a political and paramilitary police force instituted by Laval after the occupation of the southern zone and the dissolution of the army of the armistice.

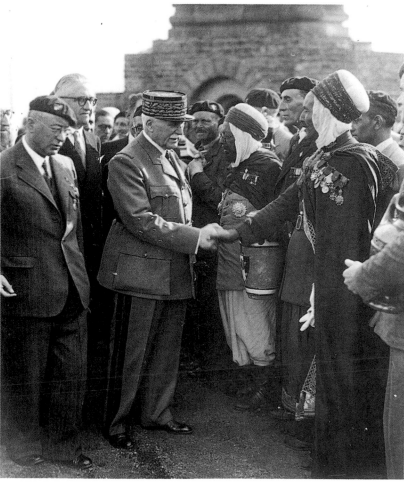

above: General Campet, head of the marshal's military secretariat, takes a bit of soil from the gardens of the Pavillon Sévigné in Vichy, destined for Gergovie, August 1942.

below: In front of the entry to the crypt in the monument to Vercingetorix, Pétain greets the Légionnaires of the empire, who carry an urn filled with "earth, the cement of French unity"; Gergovie, 1942.

opposite above: A poster for the Légion's first anniversary (left) features the "flame of the union," which is shown being carried through Lyons (right), August 1941.

opposite below: A delegation of Légionnaires from Ariège Department pass a tribute to the marshal on the place La Fayette in Toulouse, June 1942.

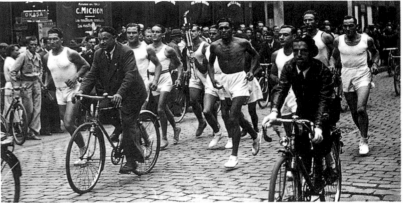

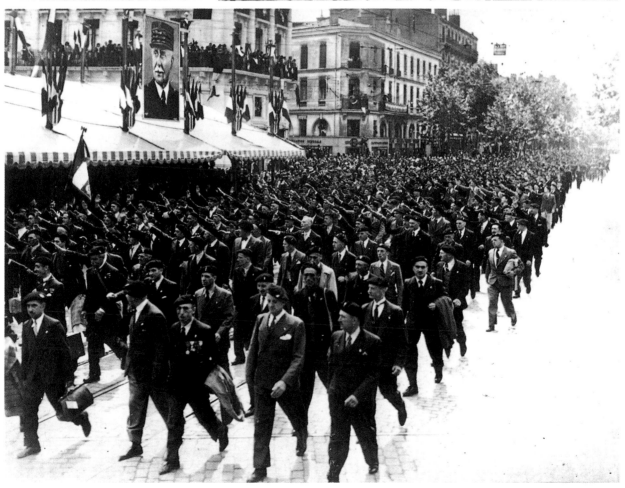

The youth movements.

Scouting strongly inspired the major youth movements. One of Pétain's most loyal supporters, Father Forestier, was chaplain for both the Scouts de France and the Chantiers de la Jeunesse. Every year, at the initiative of General de la Porte du Theil, all twenty-year-olds (in the southern zone) had to join one of these Chantiers, or youth camps, for eight months; this took the place of mandatory military service. In 1941, almost 150,000 belonged to three different contingents. In June, Marshal Pétain solemnly presented the flag of the Chantiers to their leader during special festivities with everyone in uniform: white gloves, loose green shorts, and green shirt for the youths, beige for the leaders. This was the only mandatory organization for the containment of youth. The movement known as Compagnons de France, also born in defeat, on 25 July 1940, briefly made an attempt to play a role.

When G. Pelorson became secretary-general of youth, he tried to take the youth organizations one step further. He told his executive staff, meeting in Paris on 3 August 1942, that the government needed a unified youth, ready to play its part in helping France achieve an advantageous position in the new Europe, and advocated consolidating all the various youth groups into one. The project foundered in the face of opposition by the youth movements and the Church.

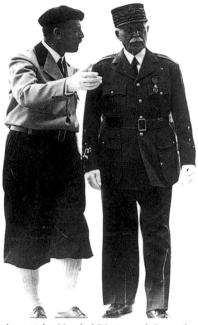

above right: Marshal Pétain and General de la Porte du Theil at the festivities of the Chantiers de la Jeunesse, June 1941.

above left: A poster published by the Ministry of Information in 1941 or 1942 advertises the Chantiers de la Jeunesse with the message "France Forever."

below: The marshal with the Compagnons de France in Randan (Puy-de-Dôme).

opposite: A training center for youth of the "Savorgnan de Brazza" national units in Lapalisse (Allier), June 1944.

FRANCE
DU JOUR
CHANTIERS DE LA JEUNESSE

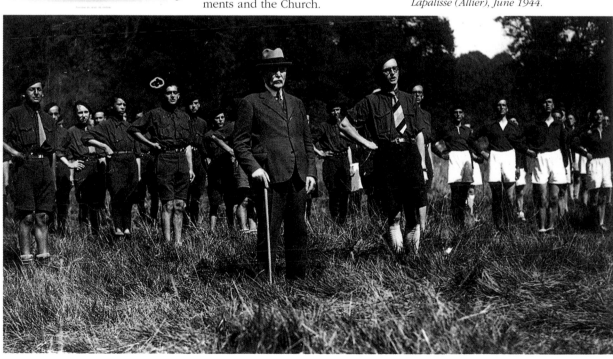

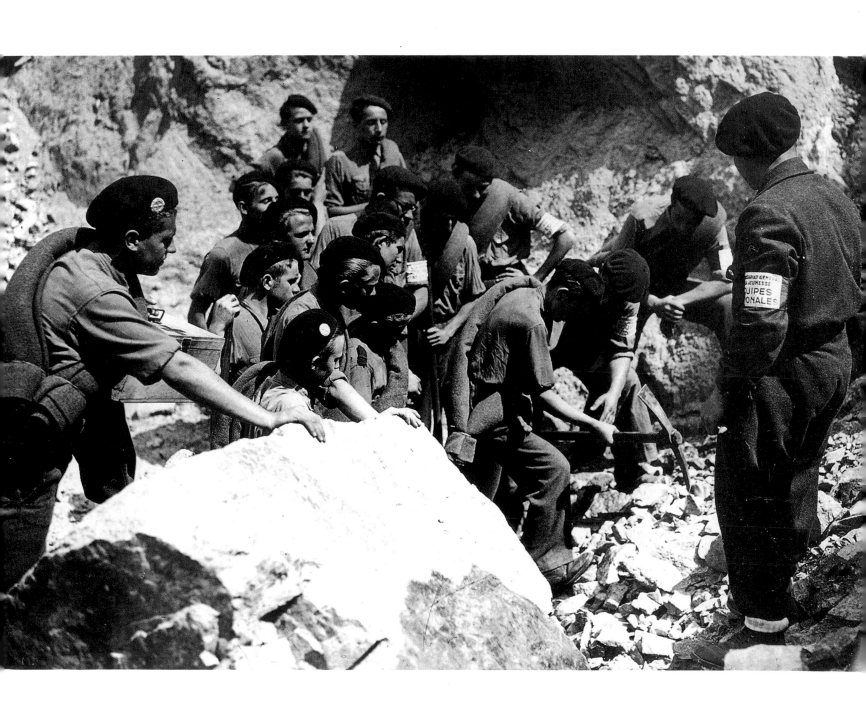

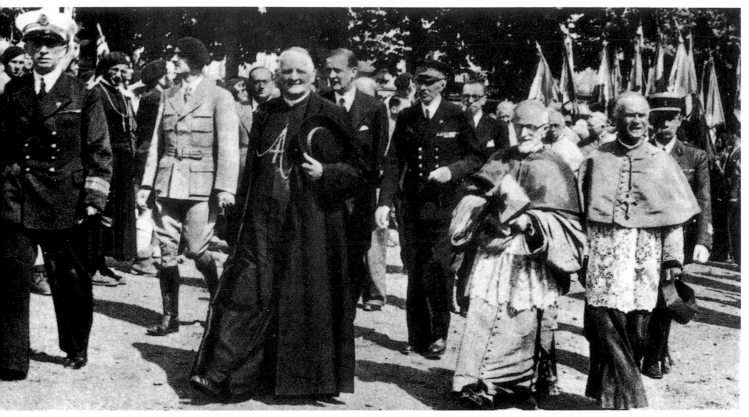

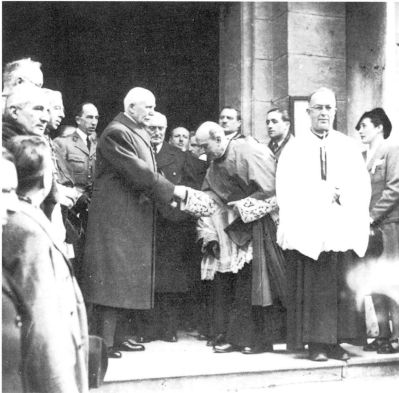

above: *Representatives of the government and the Catholic leadership—Cardinal Gerlier, the archbishop of Lyons, and Monsignor Valério Valéri, the papal nuncio—celebrated the beginning of the Marian year in a procession in Puy-en-Velay, 15 August 1942.*

below: *Pétain and Darlan outside the church of Saint-Louis in Vichy, perhaps in 1942.*

opposite: *Pétain and representatives of the clergy in front of the church of Saint-Ouen in Rouen, after the bombardments of April 1944.*

The Catholic hierarchy.
Thirty-five years after the formal separation of Church and State, the Catholic hierarchy took its revenge. Pillar of the French government, it became an echo chamber of the principles of the National Revolution, which made use of a series of organizations that were not all or equally enthusiastic. But the Church published a completely unambiguous statement on 24 July 1941: "We venerate the head of state, and we ask that all French citizens immediately rally around him in unity. Unity remains, as always, a principle of power. We encourage our flock to take their places at his side in the restorative effort he has undertaken on the three domains of family, work, and fatherland, in order to realize a strong, unified, coherent France. For this great project, we ask them to join their efforts with those of their fellow citizens."

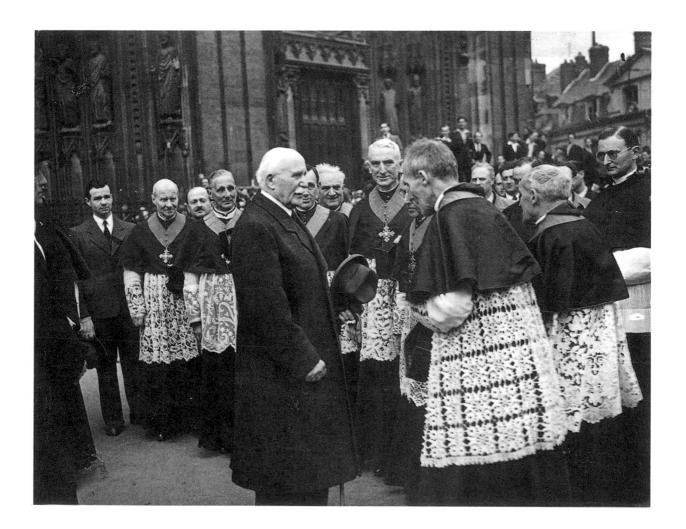

" Aux heures les plus sombres c'est le regard
paisible et décidé du paysan français qui a soutenu
ma confiance ".

Maréchal PÉTAIN

AU SEIN DE

LA CORPORATION

LE PAYSAN FRANÇAIS
JUSTIFIERA LA CONFIANCE
DU MARÉCHAL

*This leaflet for the Corporation Paysanne carries a
quote from the marshal: "In the darkest hours, it is
the calm and resolute gaze of the French peasant
that has buoyed my confidence."*

Working for France

The image of work conveyed by Vichy must be read on two levels: the level of ideology and that of necessities imposed by circumstances. The regime intended to link "moral" and "redemptive" values to work, one of the essential elements of the National Revolution. "The work of the French is the supreme resource of the Fatherland," proclaimed the leader of the French state. At the same time, the forms of work favored by propaganda also responded to the needs of a period marked by a war economy and shortages, aggravated by the occupation.

Above all else, Vichy exalted laboring on the land. The peasant, represented in various chores that have punctuated the year for centuries, the cycle of his labors, was presented as a model to society as a whole. The sower scattering seed on the soil, the reaper whose scythe lay low the ripe wheat—his magnified gesture demonstrated his familiarity with tools. The simpler his image, divested of any kind of mechanized aid, the better suited it was to illustrate the virtues preached for all by the National Revolution. Even when he employed more recent equipment—the tiller behind his plow, the reaper on his harvester-binder, the one pulled by oxen, the other by horses—he still performed essential tasks by hand. He thus remained connected to that purportedly noble form of human toil, handwork, which demands of its practioner a know-how handed down through generations since ancient times. The work of the peasant was featured in order to express a traditionalist—or, rather, reactionary—conception of society as well as to reassure the French that their race would abide, provided that they return to their basic "values." At a time when France, crushed by defeat, feared for its future, it offered a symbol and token of endurance.

From a secular confrontation with the land, the peasant drew "these ancient virtues that make a people strong." For "the land, it does not lie," unlike men and their industrial and urban artifices. It gives food and the basic essentials to those who cultivate it, for themselves and their fellow countrymen. But circumstances, climatic or other, make these fruits unreliable and cultivate in the growers patience and resolute resistance, similar to the effect of the trials of war. "The cultivator must foresee, calculate, fight. Disappointments have no hold over this man in whom the necessary instinct

for work and a passion for the land dominate. Whatever happens, he faces it, he holds his ground; he is a leader."

The peasant, object of this self-interested panegyric by Pétain, was neither an agricultural worker nor a landowner of a sizable estate but a farmer who worked his own small plot, at the time still the dominant category among the French peasantry. To the human qualities already evoked, he added that of the head of his own business—a quality no less appreciated by the National Revolution.

The artisan displayed analogous virtues. In a village or a city, alone or with several workers, he, too, worked with his own hands in his small workshop, and he alone was responsible for running it. Like the peasant, he learned his trade, probably from his father. In addition, Vichy saw him as someone to fulfill the mission of teaching the young within the framework of its corporation.

Corporatism was the official doctrine of Vichy when it came to the organization of work. Artisans were invited to create professional divisions as a source of oversight, through their representatives and with the guarantee of the state, to ensure the sound practice of their trade following the traditions of good workmanship. The doctrine postulated a community of interests between bosses and workers within each profession, rejecting the concept of class struggle.

The Corporation Paysanne was established through a law of December 1940. Here as well, the principle consisted of the autonomous administration of a group of activities connected with agriculture—the cultivation of a small plot of land, the production and transformation of its crops—by the representatives of these diverse activities. A national corporative council oversaw it at the executive level, while regional and local "trustees" covered the base. The state, which gave the organization force of law, was represented at its center by a commissioner. Just as professional representation had to assume a strict equality between small and large farmers or landowners, the role of the state had to restrict itself to this legal pledge and a simple oversight. In actuality, however, the large landowners immediately began to carve out for themselves the lion's share of leadership powers, to the detriment of the small farmers. Above all, pushed by the exigencies of shortages, the corporation became, contrary to its basic principle of autonomy, an auxiliary to the proliferating bureaucracy established to ensure the requisition and distribution of agricultural products. It did not take long for the peasants to view the corporation, under the strict trusteeship of a minister simultaneously responsible for agriculture and food sup-

ply, as a simple intermediary intended to make them more amenable to the requisitions imposed on their products and the rationed distribution of agricultural supplies. The principles proclaimed by Vichy in the area of work, like so many others, were constantly contradicted by the politics of reality, either because they were intended to function as a smoke screen to mask contrary practices or because they were simply unable to withstand the constraints of reality.

Stripped of the moralizing virtues surrounding the ideological commentary, the restitution of artisanal work to a place of honor, like that of the land, otherwise responded to a very concrete need in time of war and occupation. The reappearance of vanished practices offers a striking demonstration. If harvesting was done once more with the scythe, if women everywhere once more spun wool, and if, in the countryside, the factories that had been converted to other uses once more produced cooking oil, it was because with importations curtailed by blockades and industries shut down or diverted from civilian goods, essential products could not be furnished in sufficient quantity.

Shortages made their effects felt everywhere. In order to survive, people had to find a way to obtain provisions outside legal channels. They found them through what has come to be called the black market, a phenomenon demonized by Vichy iconography, yet quite real. In fact, however, it is necessary to distinguish between the genuine black market—trade organized for venal purposes—and the gray, or "pink," or "friendly" market. The latter, much more widespread, occurred each weekend as the inhabitants of a neighboring city or town descended on the countryside in search of some eggs, a bit of butter or meat, which the peasants agreed to sell them for high prices or in exchange for products brought from the city.

Here the inequalities between country and city emerged. Many historians have spoken of the country taking revenge on the city. It is true that the peasants, who produced and themselves consumed a part of their own production in the still numerous regions that cultivated foodstuffs, did not suffer from hunger, and the deposits they made in their savings accounts bear witness to the benefits brought them by the parallel market. They also contributed, often voluntarily, to keeping the cities fed, through sending legally permitted food parcels to relatives or harboring the children of besieged cities. They were much more liable to save what money they earned, since they had few things to spend it on. Yet they, too, suffered from shortages, notably of agricultural supplies: gasoline or diesel fuel, fertilizer, insecticides, twine. They found their workload greatly increased, and the

forced return to handwork, far from exalting their "peasant soul" so dear to ruralists of the time, they experienced as an additional burden. For the peasants, as for their fellow French citizens, the period of occupation, far from being a golden age, was a period of hardship and shortages, all the more burdensome because of the requisitions imposed by the government to feed the French people, to which were added those of the occupiers.

Scattering seed, 1941.

Yves Durand

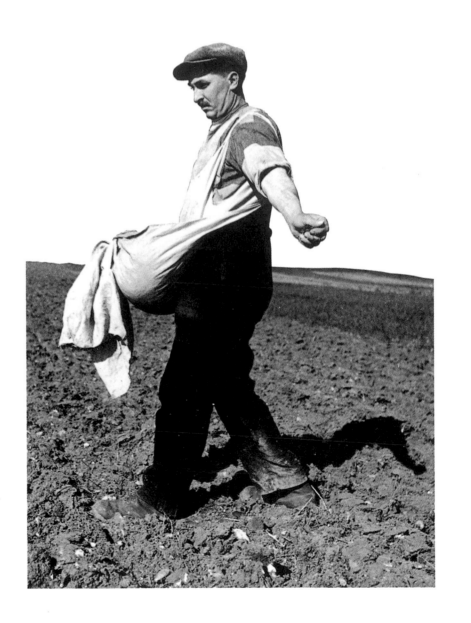

Afin que revive la Terre de France, debout paysans! Tous avec le Maréchal!

So that France may revive.
The sower, with his ancient gesture, gives to the land—which does not lie—the seed that will grow into the harvest, a promise of recovery for eternal France . . . and food for the French. The man with the scythe or the pitchfork worked on the harvest, his tool in his hand, guided by the "good shepherd" and the seven stars of the marshal.

above: The propaganda drawing titled The Seven Stars of the Good Shepherd *urges peasants to rise and follow the marshal in order to revive the "Land of France," published in* La Terre Française, *a Parisian newsweekly, 11 January 1941.*

right: Cutting wheat, summer 1941.

opposite: A new harvest is threshed before the reserves of the old has been depleted, June 1943.

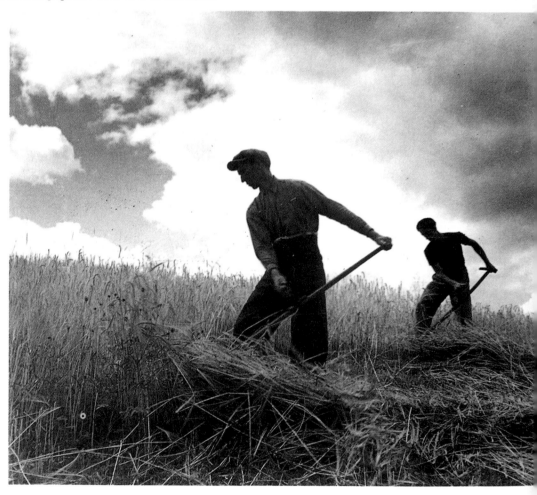

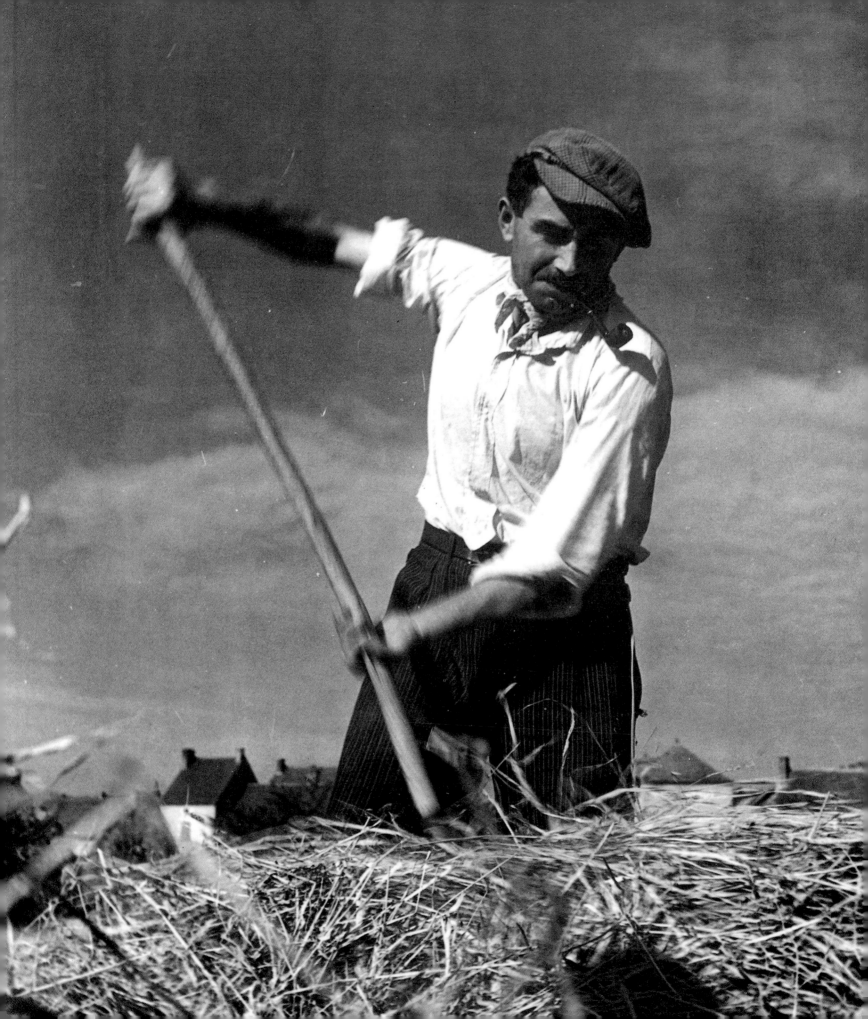

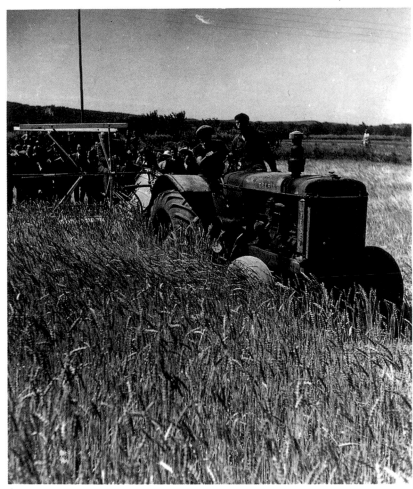

Working on the land.

Tractors were rare and lacked gasoline or diesel fuel or employed gasogenes on a few large farms; harvesters lacked twine for binding. The peasant on his mechanical mower pulled by two horses, forced to resort to cutting in loose swaths and bundling by hand, had little interest in the "beau geste." He had no choice but to submit to these old methods because of shortages of agricultural supplies, which affected production and increased his labor.

opposite left: A demonstration of tractors equipped with gasogenes in Boucé (Allier), September 1943.

opposite right: Officials and notables attend the beginning of the harvest.

A reaper pulled by a horse, 1941.

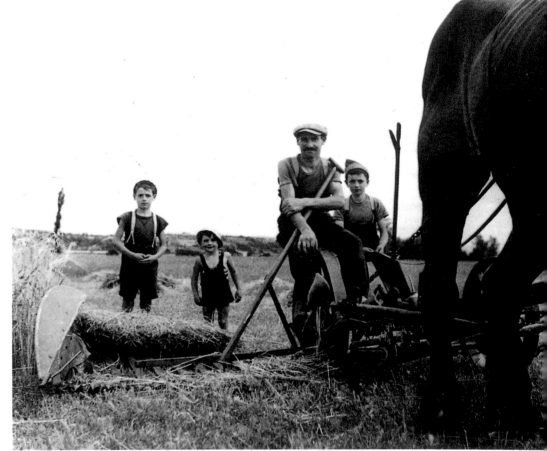

Model for the National Revolution.

The peasantry was an "organized" profession and the object of the self-interested attentions of the agriculture ministers, who also bore responsibility for the thorny problem of provisions. Under the sign of the slow and peaceful toil of oxen—and the marshal's watchful eyes—a minister announces the establishment of the Corporation Paysanne. Two other ministers "in the field" at a time of agricultural shortage inspect the ears of wheat at firsthand while attending the gathering and threshing of the sheaves.

above: Jacques Le Roy Ladurie, minister of agriculture and food supply, attends the first threshing of wheat in Seine-et-Oise, August 1942.

below: Pierre Caziot, minister of agriculture, in the wheat fields, July 1941.

opposite above: Winter chores, December 1943.

opposite below: Max Bonnafous, minister of agriculture and food supply, gives a speech to establish the National Corporative Agricultural Council, Paris, 31 March 1943.

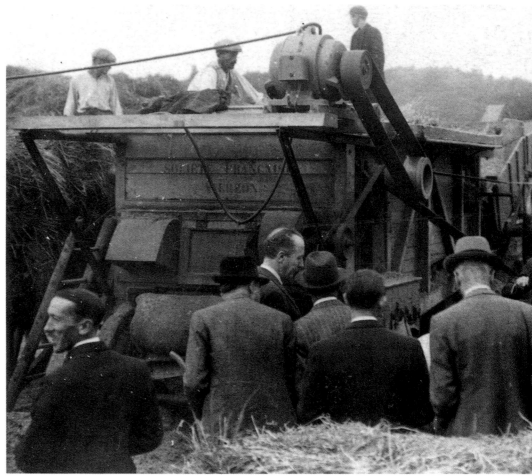

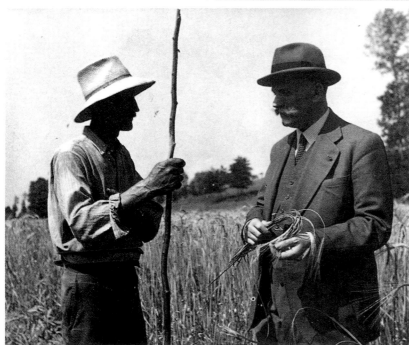

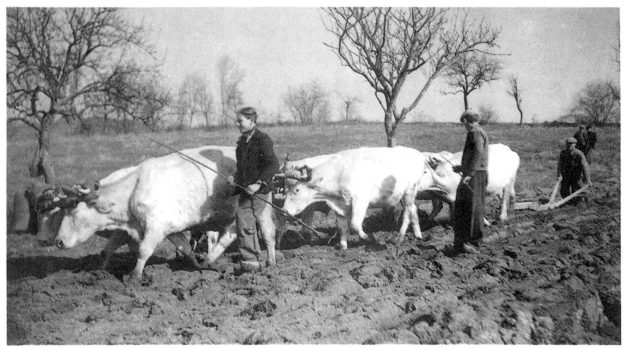

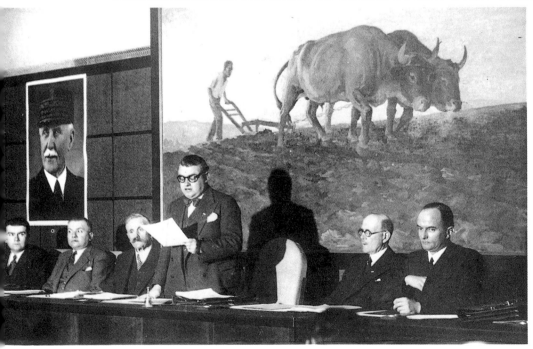

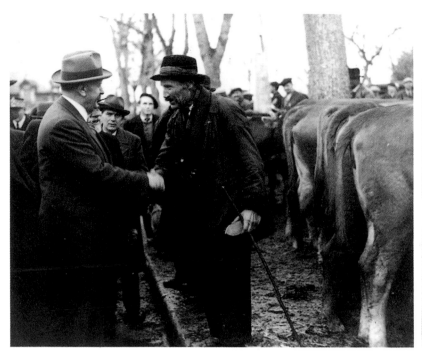

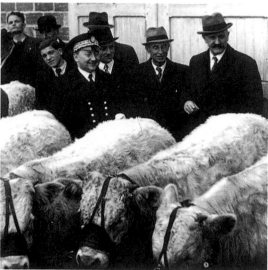

The country feeds the city.
Ministers, prefects, and provisions collectors from the city evaluate the livestock at the fairs and requisition from the farms young steer marked for the slaughterhouses, poultry, and eggs—products meagerly rationed to urban families, hit much harder by the war and food shortages than rural inhabitants.

above left: Pierre Caziot, minister of agriculture, greets a peasant during the annual livestock fair held in Rodez, December 1941.

above right: The minister and the prefect of Loire Department look over steer from Charolles being judged at a fair in La Pacaudière, near Roanne, November 1941.

below: Officials collect provisions for war victims from a farm in Nanteuil-les-Meaux (Seine-et-Marne), October 1942.

opposite:
"In all areas hit by bombardment, canteens will provide meals for those who have lost everything."
November 1943.

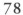

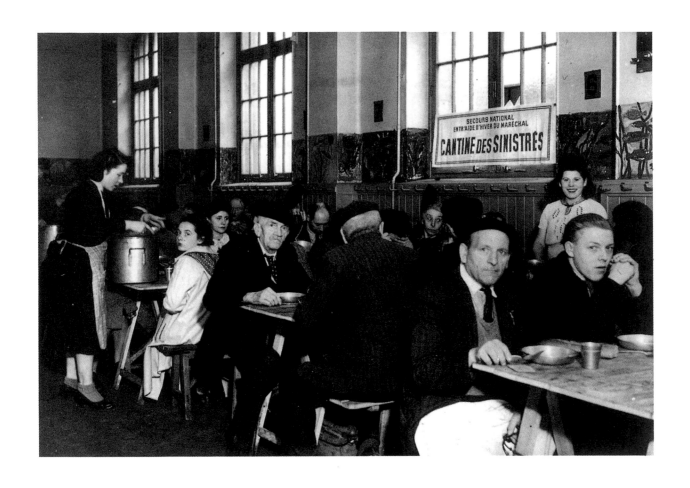

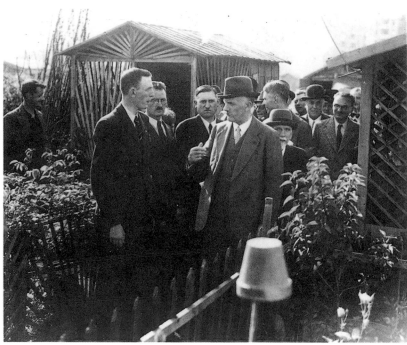

"Return to the land" in the city and the distribution of its produce.

In the numerous, albeit tiny, "workers' gardens," civil servants and workers who could not afford to avail themselves of the gray or black markets because of salary freezes turned to growing food for their own personal use. Teachers, on the other hand, retrained in order to instruct their students in the art of hoeing vegetables. The distribution of milk and prepared foods proved equally problematic, especially severe for urban mothers, who somehow had to ensure that their babies received their indispensable ration of milk and also find something to fill the pot on the stove every day. Nonetheless, the birthrate increased in the middle of the war: a puzzle for the demographers.

above: Pierre Caziot visits the gardens of workers in Lyons, May 1941.

below:
"A reform in rural pedagogy: our future teachers at the school of agriculture in Chesnoy (Loiret). There they are, gardening."
November 1943.

opposite above: Max Bonnafous visits a distribution center for prepared foods in a lower-class neighborhood in Paris, February 1943.

opposite below: In February 1943 René Bouffet, prefect of Seine Department, visits a clinic for mothers in Colombes, "where more than 1,500 bottles of fresh milk are distributed every day."

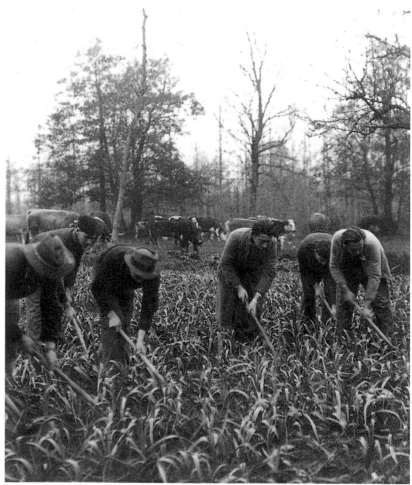

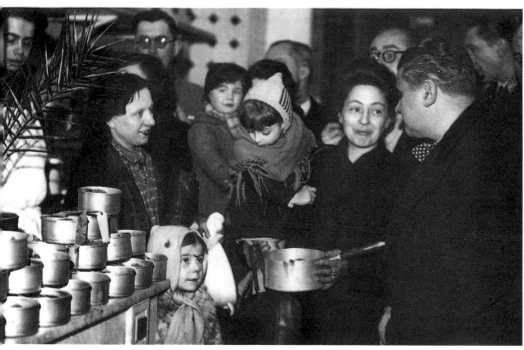

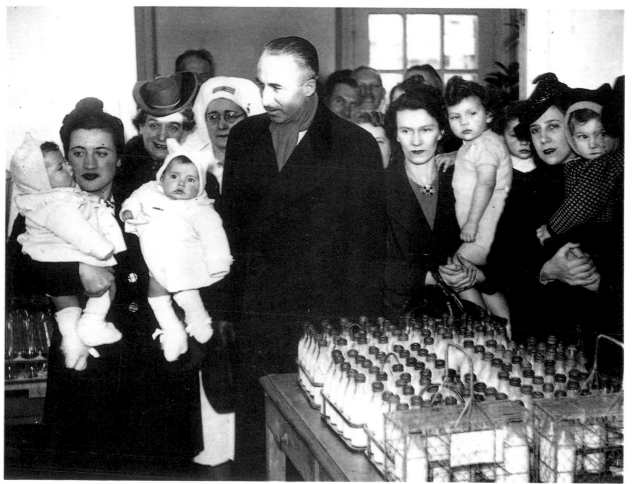

Children from the city are sent to the country.

While it was impossible to grant Alphonse Allais's wish and "transfer the cities to the country" to solve the problems of urban dwellers, at least their young inhabitants could be sent there. Housed for several months with country folk, they shared with their young rural companions of a summer a life hardly idyllic on dilapidated farms. However, they benefited from the open air and more food than they had gotten at home. While there, admonished that they "mustn't forget mama and papa," they had to write home regularly, under the inevitable gaze of grandfather marshal and with the help of a big brother from Compagnons de France.

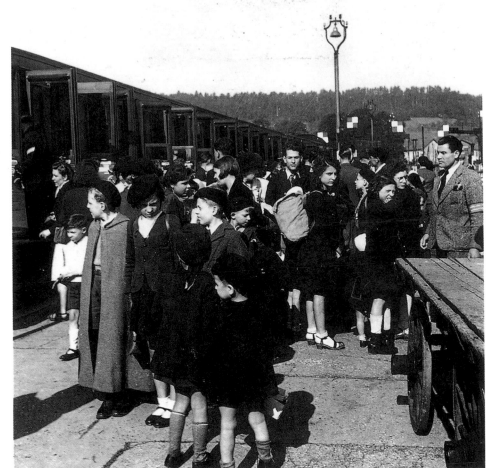

above: Two hundred and fifty children of prisoners of war from the Paris region, evacuated in the Jura, arrive in Lons-le-Saunier, July 1943.

Life on the farm (below), as recorded in 1942. A member of Compagnons de France from Auvergne (opposite) oversees the correspondence of refugee children, April 1942.

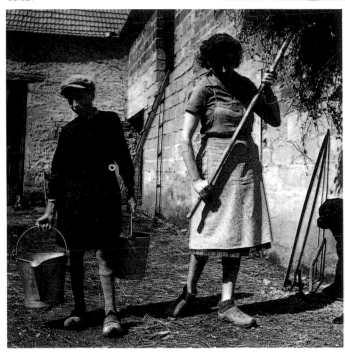

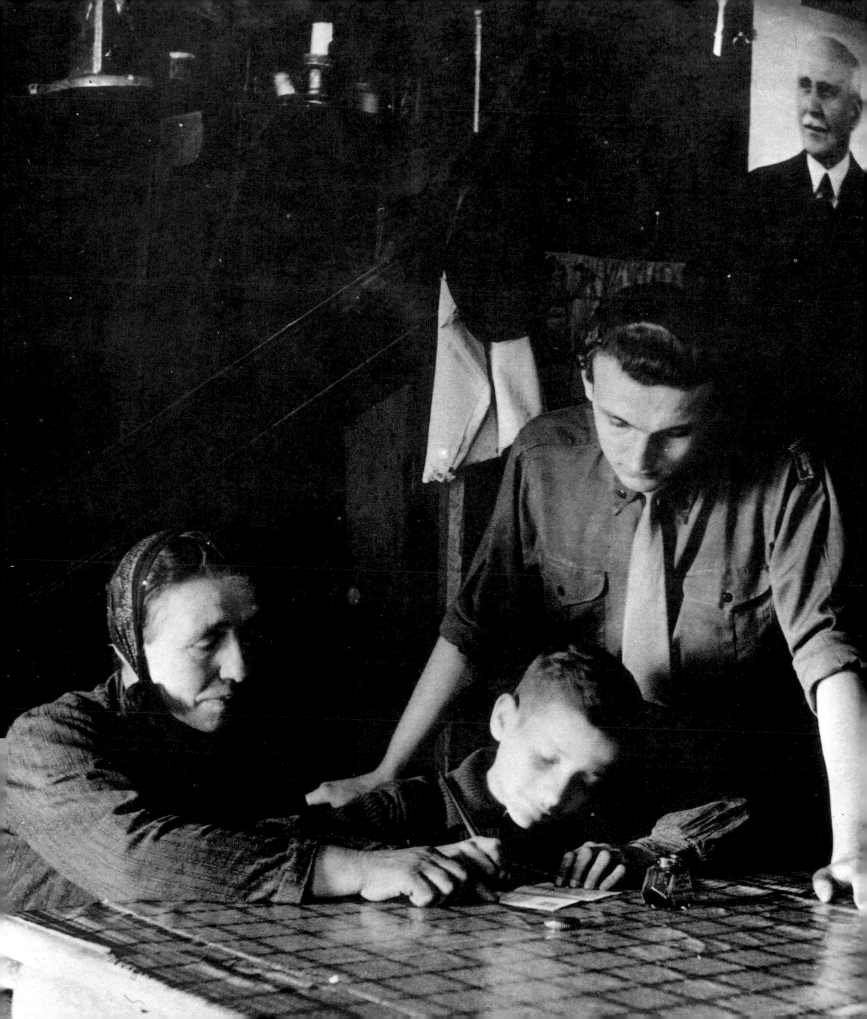

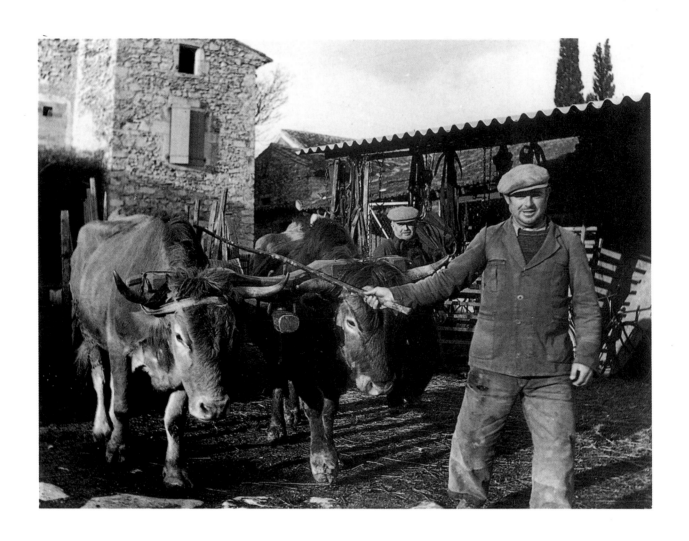

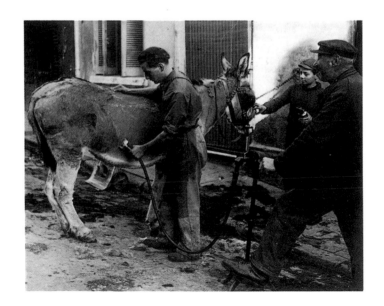

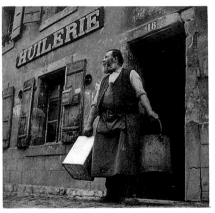

The charm of village life.

The old ways, deemed appealing by outsiders, could be resuscitated of necessity. The effort to become self-sufficient mitigated the shortages—of fuel, cooking oil, textiles. Peasants had never ceased to split their own wood in forested areas, but the old factory that had produced cooking oil had been closed. So they put their old manual presses back into working order and crushed rapeseed or poppy seeds, which the peasants resumed cultivating, having stopped long ago with the arrival of peanuts from Senegal.

opposite above: A village street in February 1942.

opposite below: Clipping a donkey, December 1941.

above left: The M. family of Veauce (Allier), with twelve children, qualified for the Cognacq award, December 1943.
"While papa shows his young son Henri the art of splitting wood, Marcelle, who takes the place of the oldest son, saws firewood with a practiced hand."

above right and below: A factory that produces cooking oil, July 1942.

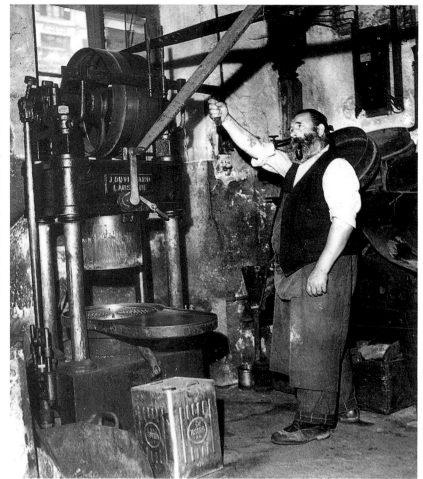

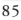

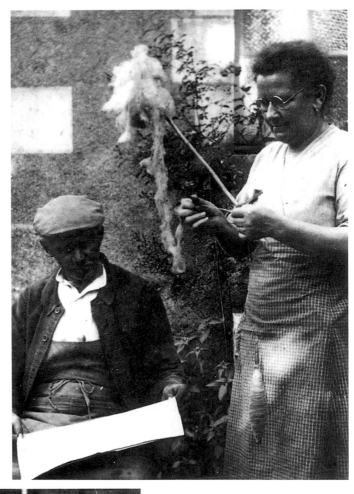

Rural artisanship.

"The France of tomorrow will revive the ancient artisanal traditions that in past years made its fortune and its glory." The maker of wooden shoes at his bench, the thread spinner with her distaff: the skills of the peasant and the artisan were restored to a position of honor. On the farm or in the market towns, everyone tried to produce at home supplies hard to come by, such as cotton and imported leathers and whatever materials the occupying forces took for themselves.

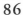

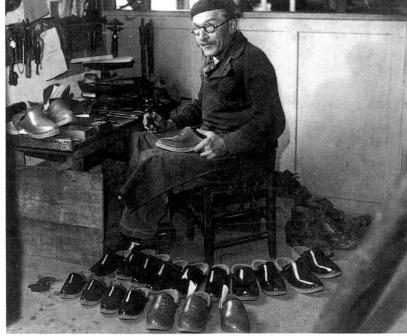

above: Touraine, July 1942.
"Revenge of the past on the present: the distaff and the spindle of our great-grand-mothers have regained respect. There are few families that do not put them to use."

below: A maker of sabots, or wooden shoes, September 1942.

opposite: An old peasant spins thread, November 1942.

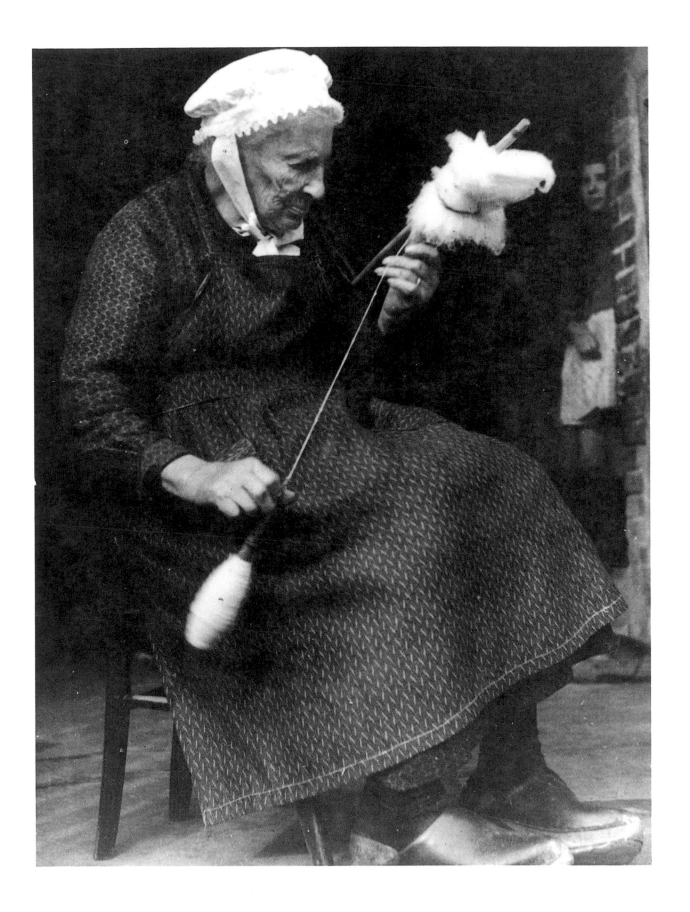

Apprenticeship in the old ways.
Traditional skills were taught to young people in carpentry or shoe-making workshops held in training centers for boys and "rural centers" of the "commission of peasant revival" for girls. Such skills were clothed in the virtues endowed on the use of manual tools and well-executed individual work by the regime, which urged a return to the old ways as a solution to social problems. In the city, middle-class women took to the spinning wheel in imitation; like the peasant women, they made their own wool—for the same strictly practical and circumstantial reasons.

above: An urban woman at the spinning wheel, October 1942.

below: Girls of the rural family center in Le Chevalon (Auvergne).

opposite above: A boy learns carpentry skills at a training center.

opposite below: Secretary-general of Youth Gait visits the Center for Professional Training of Aubervilliers, April 1944.

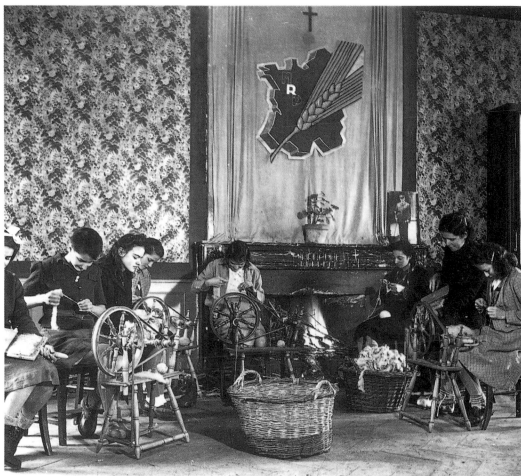

The artisanal community.

The highest acknowledgment of hand-made work was an exhibition of the products, such as that depicted below of work by apprentices (in the berets), under the ubiquitous portrait of the head of state. The National Revolution offered the model of the family enterprise even to industry. For the clock maker (opposite), the "work community" perfectly matched that of the home—the "natural community," according to Vichy ideology. The father exercised a double authority, as head of the family and of the business, over his wife and their two children, who constituted the business's only workers. Thus, he not only set an example for his family, he also served as one of the first to exemplify the new "national work mandates." Factories, however, were rarely photographed in the marshal's France. They called for men to run the machines and young people to learn early the worker's hard life.

opposite: M. A., a master artisan from Moulins, May 1943.

right: The La Vallée training center for weaving in Amplepuis (Rhône), February 1944.

left: Bouvier-Ajam, president of the Institut d'Etudes Corporatives et Sociales (Institute for Corporate and Social Studies), opens an exhibition of student work in a professional training center in the Paris area, January 1944.

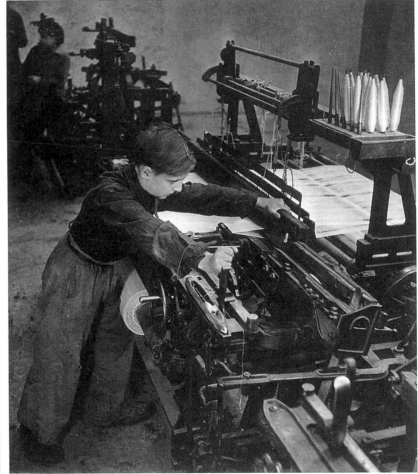

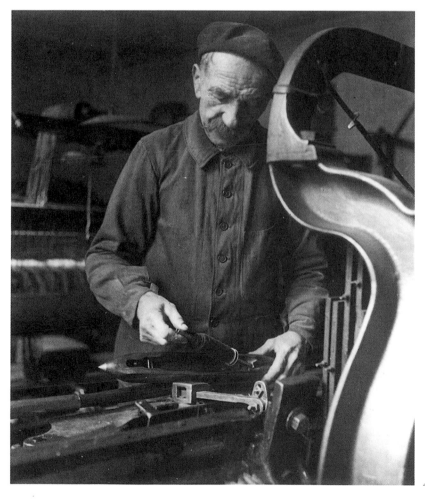

A weaver in his studio in Chantemerle, 1944.

Working for the Occupying Power

Industrial labor—collective, mechanized, and therefore "dehumanized"—served as a kind of countermodel to Vichy ideology, which also presented itself as anticapitalist. However, the members of the French team responsible for business never took such a strident position. These "technocrats," tied to the most powerful industrial and banking groups, occupied all the economic ministries. In spite of its ruralist discourse, Vichy was essentially preoccupied with the problems of the relations between labor and management in industry. To prevent their development, judged dangerous for the established order, the regime attempted to give the two sides equal treatment through a policy of corporatism. Whereas the Corporation Paysanne was established without significant discussion in 1940, what was called the labor charter gave rise to acrimonious debate before its realization in October 1941. The organizations envisioned by the charter, in which labor and management would have equal representation on the basis of a "collaboration of classes," had standing only in the realm of social issues. Anything to do with economic development remained in the hands of industry leaders, and from August 1940 the general organization of the industrial sector was entrusted to their representatives, in association with those of the government, in the form of "organization committees." When the labor charter was published, the increasing pressures from the occupying power on industry pushed the corporatist association of capital and labor to the background.

As soon as it settled in, the occupying power made the industries in the occupied zone—and also those of the "free" zone—work for its own economy. After requisitioning a significant portion of French industrial production and seeking to include, with the acquiescence of a solid majority of Vichy's leaders, this sector of activity in a "European" economy dominated by Germany, the German leaders demanded that French workers be sent to Germany. By 1942 the recruitment of volunteers, begun in 1940, proved insufficient for

German needs, due to the unexpected resistance put up by the Soviet Union. Fritz Sauckel, the German area commander who was in charge of harnessing foreign labor, wanted contingents of French workers ordered to Germany for mandatory service. Pierre Laval negotiated a formula, invented by the French in 1940 and rejected at the time by the Germans, called the Relève, or relief shift. He undertook to fill the required quota if Germany, in exchange for three "voluntary" skilled workers, would release one French prisoner of war.

Of the 1.6 million soldiers transported across the Rhine River after their capture, 95 percent, after having "matriculated" from a German stalag, were dispersed in work gangs: on farms, in workshops, on construction sites, in factories, in mines in Germany. More than a million were still there at the beginning of 1942. Germany then needed skilled workers taken from French businesses to replace its own workers mobilized for the Russian front. The Relève was created to satisfy this need, all the while maintaining the fiction of its voluntary nature. In this instance, the Vichy administration was engaging in a narrower and more official form of collaboration with the occupying power than ever before. Laval extolled the "benefits" when a few thousand freed prisoners of war returned in August 1942.

This "volunteer force" did not satisfy the Reich's needs. In September 1942 a law established compulsory work service in Germany for men and women old enough to work. Put into effect starting in February 1943, it mobilized young people in every population category, taking entire age groups, while the return of prisoners of war ceased. The situation generated an all but unanimous hostility against both the occupying power and the Vichy government, which more than ever before was seen as the former's accomplice. Work thus became in 1943 an essential factor in the shift of public opinion in favor of the Resistance, which in order to protect French workers from deportation to Germany had to emphasize and coordinate its struggle against the occupying power and against Vichy.

Yves Durand

Miners in the region of Clermont-Ferrand, January 1941.

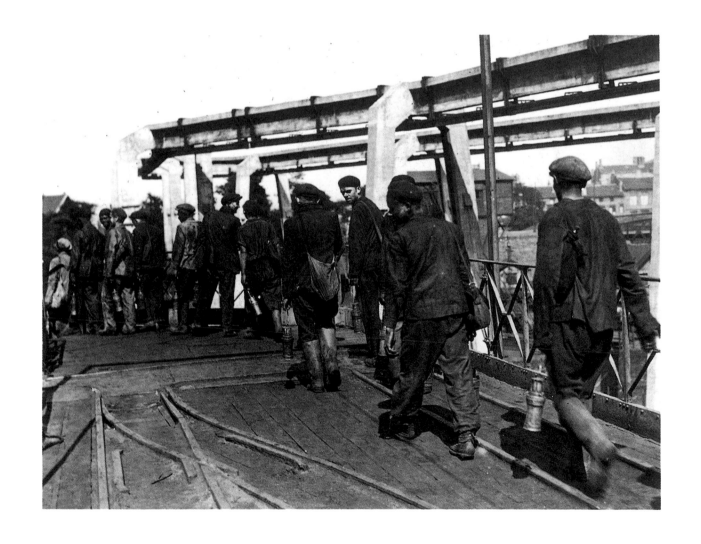

Industrial work and corporatism.
On the slopes of the Auvergne Mountains overlooking the Truyère River, workers construct a dam, largely by hand. The French government continued the large-scale projects begun before the war to cope with the crisis and to provide France, which had little coal, with hydroelectric power. Moreover, Vichy wanted to solve the problem of "relations between labor and management" in industry through corporatism, as it had for the peasants. However, the labor charter, published in October 1941, that the old man pictured below holds in his callused hands appeared at a completely inopportune moment. The circumstances and real preoccupations of the time reinforced the workers' conviction that, on the contrary, inequality and the struggle between the classes were alive and well. At most, the old worker would discover a few fruits of abiding labor struggles, from which he might partly benefit: a minimum wage and a pension.

opposite: A view of the mines in the region of Saint-Etienne, January 1942.

above: A road is built on the Grandval dam construction site, December 1941.

below left: Construction work near Lyons, in a photograph published in La France Travaille, *1941.*

below right: An old worker reads the labor charter.

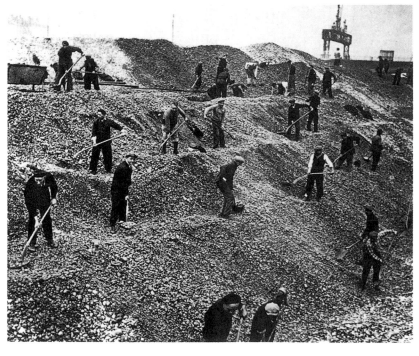

BEKANNTMACHUNG
über die Bewirtschaftung von Hafer.

ARTIKEL 1. — Der gesamte, im Departement Eure-et-Loir vorhandene gedroschene und ungedroschene Hafer ist hiermit beschlagnahmt, mit Ausnahme:

a) des für die Saat zur Frühjahrsbestellung 1941 benötigten Hafers;

b) des Futterhaferbedarfs im eigenen Betrieb.

ARTIKEL 2. — Ein Verkauf von Hafer ohne besondere Genehmigung ist nur zulässig an die im Departement Eure-et-Loir eingesetzten Beschaffungskommissionen, Cooperativen und zugelassenen Händler.

ARTIKEL 3. — Pro Arbeitspferd und Tag dürfen im eigenen Betrieb nur 3 kg Hafer verfüttert werden. Eine Verfütterung von Hafer an Rindvieh und sonstiges Vieh ist verboten.

ARTIKEL 4. — Die Verfütterung von ungedroschenem Hafer ist verboten.

ARTIKEL 5. — Der Haferausdrusch ist spätestens bis zum 5. April 1941 zu beenden. Alle nicht für den eigenen Betrieb benötigten Mengen sind an die Beschaffungskommissionen abzuliefern.

ARTIKEL 6. — Verstösse gegen die Bekanntmachung gelten als Sabotage und werden kriegsgerichtlich geahndet.

Chartres, den 5. März 1941.

AVIS
concernant la règlementation de l'avoine.

ARTICLE PREMIER. — La totalité de l'avoine existant dans le département, battue ou non battue, est réquisitionnée en vertu du présent avis, à l'exception :

a) de l'avoine nécessaire aux ensemencements de printemps 1941 ;

b) de l'avoine nécessaire aux besoins en nourriture des animaux dans chaque exploitation.

ARTICLE 2. — Il n'est permis de vendre de l'avoine sans autorisation spéciale qu'aux Commissions de réception instituées dans le département d'Eure-et-Loir, aux Coopératives et aux marchands autorisés.

ARTICLE 3. — Dans chaque exploitation, par jour et par cheval au travail, il ne doit pas être donné plus de 3 kgs. d'avoine comme nourriture. Il est interdit de nourrir avec de l'avoine des bovidés et tout autre bétail.

ARTICLE 4. — Il est interdit de donner comme nourriture de l'avoine non battue.

ARTICLE 5. — Le battage de l'avoine doit être terminé au plus tard pour le 5 avril 1941. Toutes les quantités qui ne sont pas nécessaires aux besoins propres de chaque exploitation sont à livrer aux Commissions de répartition.

ARTICLE 6. — Les infractions à cet avis sont considérées comme sabotage et passibles de la juridiction du Tribunal de guerre.

Chartres, le 5 mars 1941.

Der Feldkommandant,
EBMEIER.
Major.

Chartres. — Imprimerie DURAND — 3-1941.

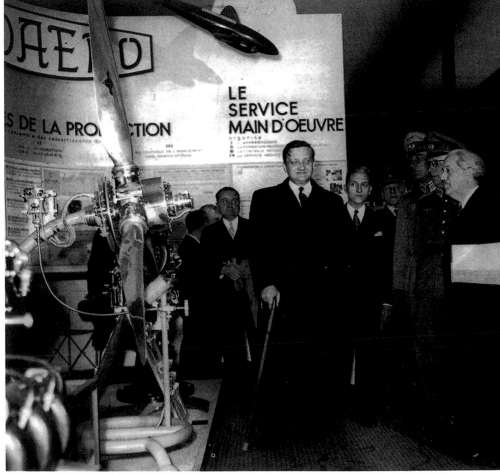

French industry and Germany.

The Germans were far more interested in the products of French industry than in French agricultural products, such as oats for their horses. At the Lyons fair, the minister of industrial production, Jean Bichelonne, admired a prototype for an engine, undisturbed by a troublesome entourage. But in an exhibition of commerce and industry in Paris, he seems to have been called on to cater to the representatives of the Wehrmacht as they coveted the airplane propellers produced by French factories. In shops in the occupied zone, the Germans did not hesitate to oversee and examine for themselves the manufacture of motors they had claimed for their war machine.

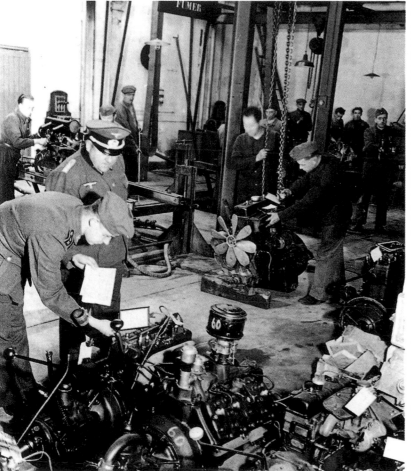

opposite above: A regulation, in German and French, outlines the strict rationing of oats for workhorses only, under threat of severe penalty.

opposite below right: Jean Bichelonne looks over the booth of the SNCF (Société Nationale des Chemins de Fers Français) workshop-school at Epernay at the Lyons fair, September 1942.

opposite below left: Bichelonne and Pierre Cathala, the minister of finance, at the Grand Palais in Paris, October 1943.

Germans inspect a factory in the occupied zone (above and below).

Collaboration through work.

As a result of Vichy's policy of collaboration, French workers—like the machines they made—were invited to go to Germany. Fernand de Brinon, the Vichy government's representative in Paris, and Verger, industrialist and president of the Comité d'Organisation de l'Electricité, escort a German officer of high rank to a training school for electricians. Following Pierre Laval's appeal for workers to enlist for service in Germany on 23 June 1942, workers were signed up in a Parisian office under an image of Hitler. Lemoine, prefect of Marseilles, inaugurating a hostel for the families of workers sent to Germany, sings the praises of this manifestation of French-German collaboration beneath a photograph of the handshake at Montoire. And posters shamelessly boasted of the contribution the French worker was making to the "fight for Europe" against the menacing Bolshevik bear.

above: Fernand de Brinon stands between French industrialist Verger and German officer Rademacker, November 1941.

below left: In Marseilles, 8 January 1943, Prefect Lemoine inaugurates the first hostel "for the children of those participating in the Relève."

below right: The center for recruitment and lodging at the Pépinière barracks in Paris, end of June 1942.

opposite: The poster of 1943 assures the worker that "in working for Europe, you protect your country and your home."

100

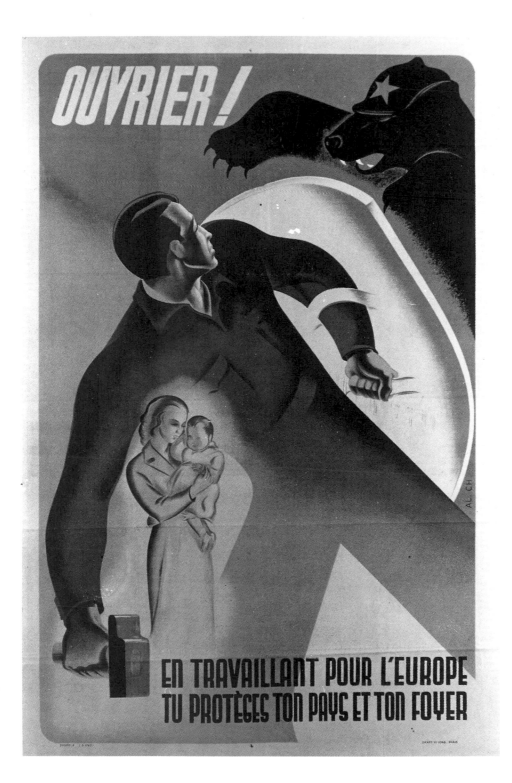

The Relève.

For every six French workers leaving for Frankfurt in Germany, two French prisoners of war would return: that was the Relève, or relief shift. The graffiti praising the Relève, Pétain, and Laval on the train carrying returning prisoners did not appear on the negative; they were added by the Vichy propaganda machine. When they reached Germany, French workers found themselves housed in barracks in the shadows of the factories where they were to spend their days. Though lacking barbed wire, they closely resembled prison camps. Even with the influx of French workers, a million prisoners of war continued to labor in German construction sites, workshops, factories, mines, and farms, they, too, constrained to toil to benefit the economy of Hitler's Germany. This was the true fruit of a collaboration that served only the interests of Germany.

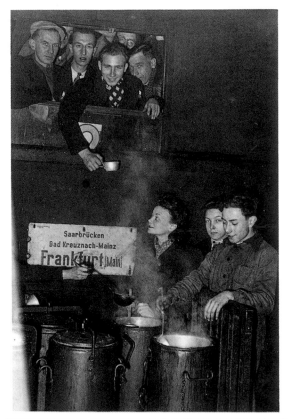

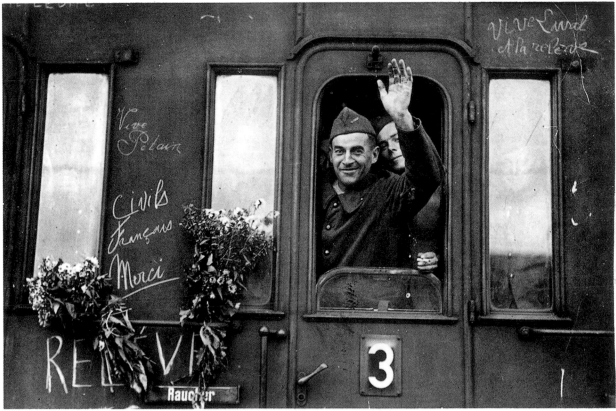

opposite above: At the Gare de l'Est in Paris, the French Red Cross distributes hot broth to departing workers, January 1943.

opposite below: Freed prisoners of war arrive in Compiègne, summer 1942.

above: French workers "traveling in Germany" reach their destination, summer 1942.

below: French prisoners of war build a road through the mountains in Buchau in the Tirol (photo: H. Défougère).

The prisoners of war.

Some French prisoners of war came back to France and were welcomed in "houses for prisoners" and "aid centers." But the great bulk of prisoners remained in Germany at the end of 1943 to face their fourth winter . . . and there would be a fifth. These men in exile and their families experienced a seemingly endless stretch of anguish, their only connection the occasional packages lovingly assembled and sent from the tiniest villages in France and the letters laboriously written on Sunday, the only day off, on a table in the stalag. These were read with identical fervor by aging parents on the farm and in the crowded barracks in Germany.

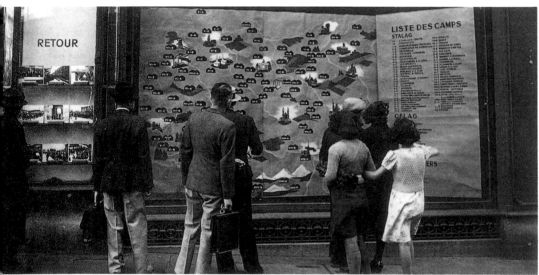

above: A display window of a House for Prisoners of War in Paris.

below left: Packages are prepared for shipping, December 1942.

below right: A poster of 1943 announces the "fourth winter" of waiting for prisoners of war to return and encourages the populace to "gather in the Aid Centers for Repatriated Prisoners."

opposite above: Prisoners write their Sunday letter from Camp II A in Dahme, Mecklenburg (photo: A. Demaneuf).

opposite below: Parents read a newly arrived letter, December 1943.

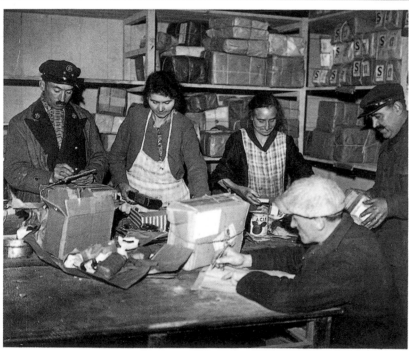

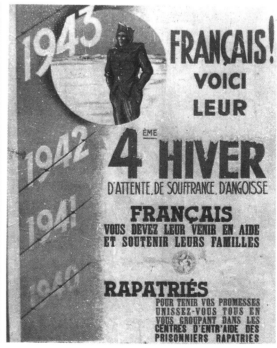

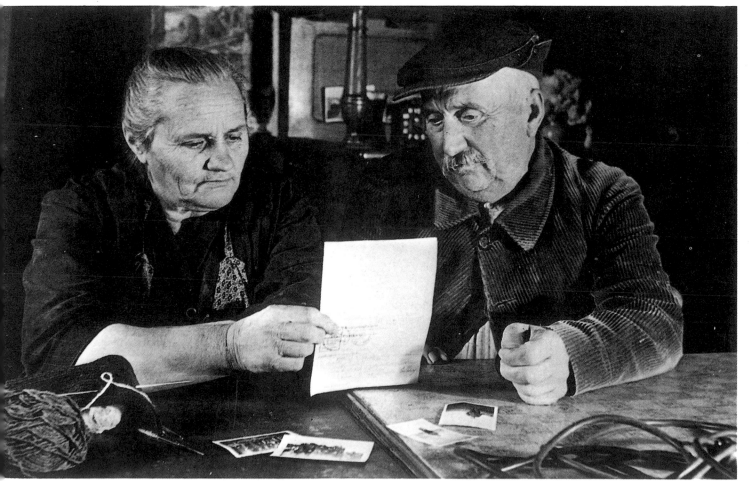

Reading in a prison camp.

Engulfed by Daily Life

Four years of grappling with material existence, each day a bit more uncertain because of shortages: between 1940 and 1944, the average French citizen spent most of his or her time trying to find something to put in the pot for dinner. Daily life strongly resembled an obstacle course that had to be negotiated in the search for necessities and in which resourcefulness and ingenuity were prerequisites for survival.

The victor, to begin with, did not take long to exploit the vanquished country; in granting itself the right of unlimited requisitions starting in May 1940, it opened the door wide to abuses. Once the armistice was signed, the Germans legally carried on the tradition of the conqueror, taking pillage to an institutional level: they bought at greatly lowered prices and exacted excessive allotments for maintaining their troops. The "Hitlerian suction pump," combined with the greed of the Vichy government, drained French wealth to feed the German war machine. On top of this, the partitioning of the country, the interruption of the traditional networks of exchange, and the slowdown in production all led to a harsh economy of shortages. Formerly prosperous, France suddenly became poor.

The degree of severity differed from region to region and year to year. In general, life proved harder in the city than in the country; Montpellier, Toulouse, Lyons, and Nancy all vied for the title of most disadvantageous location. While the inhabitants of Lille, Roubaix, and Tourcoing experienced famine starting in 1941, the Parisians suffered the most serious food shortages in the summer of 1944. Provinces traditionally devoted to a single crop, like Languedoc, fared poorly. Daily life proved extremely complicated for all, as ordinary products such as thread, wool, tires, and bicycles disappeared from the shops in the fall of 1940. Basic agricultural materials were lacking (seeds, twine, iron and nails for horseshoes), as well as fodder and oats for farm animals.

The war invaded every aspect of the day—soap that did not clean, weak coffee, fish patty with rutabagas instead of steak with fries—while a flat bicycle tire presented a major crisis. Occupation soon became synonymous with restrictions, since in order to deal with

shortages, and under pressure from the Germans, the Vichy government was forced to institute rationing. Bread, pasta, and sugar became subject to rationing starting in August 1940, and the next month the French received ration books. A year later, the coupon ruled; starting in January 1941, the ration coupon was extended even to shoes and clothes, renewable each year.

Although shortages brought some positive benefits, causing a clear drop in the number of people who died from alcoholism and heart disease, on the whole they had serious consequences for the health of the French: underweight, lack of resistance, and outbreaks of tuberculosis (at a rate of 50 percent in Nord-Pas-de-Calais, 74 percent in Bouches-du-Rhône, and 11 percent for all other regions). Children were the primary victims of malnutrition; at the end of the war, 19 percent of Lille's schoolchildren suffered from rickets. Statistics collected in 1944 on the condition of fourteen-year-olds in the Paris area revealed deficiencies in weight of about 16.5 and 19 pounds and in height of 3 and 4 inches. Adults who lived in cities saw their average weight drop from 163 pounds in 1940 to 144 in 1944.

Privations caused by the war did not affect all French citizens equally. Farmers and merchants fared much better than people whose income came from investments or pensions, old people, and the wives of prisoners of war. Urban dwellers survived by finding ways to complement the ration books; for some, "family packages" that arrived from the country made all the difference. Failing this asset, they had to find other solutions, an assignment that favored the most resourceful, who exerted themselves strenuously to ferret out the inaccessible. Gradually, a parallel, or black, market evolved where anything could be found for a price. "As goods become scarce, the black market extends its networks, the pool of people who buy from it endlessly increases, the problems they encounter, exorbitant prices among others, exacerbates the antagonism between city and country," asserted a report of 1943 by Renseignements Généraux. Disparities among regions were emphasized. For example, "in the north of France, calories obtained through the black market were the most expensive." It is difficult to measure the real impact of this method; a study of the provisioning services showed that in 1944, the official market distributed from 1,200 to 1,500 calories per person according to region, but that purchases in the black market allowed a consumption of 2,000 calories, from 25 to 40 percent of total foods. However, a great number of

traffickers undoubtedly took advantage of the need of some and the complicity of others for their personal enrichment. The virtuous Vichy propagandist worked up a fine indignation against such proceedings, and the economic authorities condemned the black market, to no avail; to the very end, it retained the attraction of forbidden fruit. The heads of families reasoned that, after all, their purchases meant less for the rapacious Germans. The government reversed course in March 1942, promising it would not pursue "infractions committed in the course of providing for the family."

In order to replace unavailable goods, a huge press campaign was launched and a sort of ongoing contest set off among inventors, who came up with all manner of miracle recipes. Honors went to the one who made the best coffee from lupine seeds or sweetbrier, the best sugar substitute from acorns. At least twenty formulas for soap, each as bad as the next, were proposed.

The government itself set an example in encouraging the development of the ersatz. With its blessing, broom fibers or hair were transformed into a flimsy fabric. Nonetheless, some inventions, such as fibranne and rayon, became widespread after the war, benefiting their producers during the dark years. The France-Rayonne factory, built in Roanne in 1941 under German direction, long remained one of the foremost European producers of artificial fibers.

Despite the restrictions and the anxiety that weighed on everyone, the country assumed a bold front. The horse races at Auteuil and Longchamp went on as usual and, as before the war, presented an image of elegance. Haute couture and fashion were inseparable from the context of occupation and restrictions. Vichy established a complicated and unwieldy administrative system of apportioning the available rare raw materials in which the top designers benefited from supplementary allocations. A voluminous set of fussy, absurd laws was passed to impose conservation. The government and its civil servants devoted a great deal of time to debating the length of hems and promulgating decrees forbidding the production of jackets with hoods or pants with cuffs. The top designers had the number of designs limited to one hundred in the spring of 1941, then seventy-five in 1943. In addition, each collection had to reduce the proportion of outfits that used wool, employ a consequently larger proportion of substitute materials (fibranne and rayon), and include lace, tulle, and embroidery in order to maintain artisanal traditions. No pattern could exceed

a set yardage. Despite these conditions, hardly conducive to creativity, many couturiers succeeded in carrying on in the artistic tradition, spurred by the examples of Lucien Lelong, then the leader of the haute couturiers' union, Jeanne Lanvin, Maggy Rouff, Marcel Rochas, Jacques Fath, and many others.

Making a virtue of necessity, in its propaganda the government emphasized that the adaptation to everyday realities, like the perpetuation of traditions, was a sign of French vitality. The French people, however, would long retain from those years of occupation the memory of the German presence, of shortages and lines, of hunger and cold.

A shop window in Lyons announces, "No more merchandise," November 1940.

Dominique Veillon

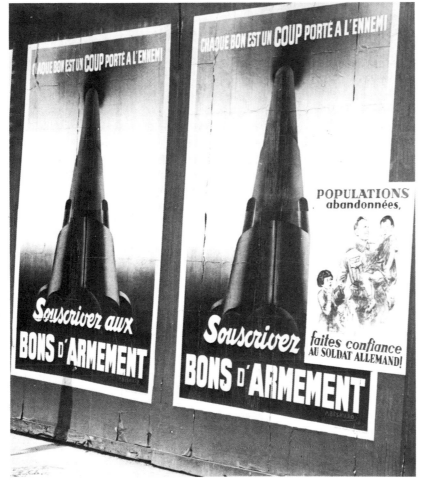

A land under the thumb.

Wishing to be seen in a favorable light, the former enemy did not stint on its propaganda: the abandoned populace was invited to "trust the German soldier!" The point it wished to convey was that the invader was not only decent but actually compassionate. In the same spirit, the conqueror facilitated the return of those who left during the turmoil and came back with the restoration of order. Certain routes were earmarked for these refugees, who were also awarded special rations of gasoline. Long convoys formed, held up at designated points while papers were checked.

Nonetheless, the French people quickly understood the realities of occupation. The demarcation line that separated the country into two zones and the administrative annoyances to which the military authorities (Kommandantur, Ortskommandantur) subjected them infected their lives. As soon as a placatory measure was decided, French propaganda broadcast it on behalf of the Germans. Thus, in Moulins, when French citizens (except for Jews and "undesirables") had their freedom of movement restored to them on 1 March 1943, a great many reporters and photographers were called on to capture the scene and demonstrate that a large crowd had gathered to take advantage of the new arrangement to cross the bridge linking the Madeleine neighborhood to the city of Moulins.

above: The town crier transmits the Ortskommandantur's instructions in Suresnes, end of June 1940.

below: Posters advertising war bonds and, at right, one urging the populace to "trust the German soldier!" in 1940.

opposite above: The first day permitting free passage over the demarcation line in Moulins, 1 March 1943.

opposite below: At the French border in Saint-Aignan-sur-Cher, two German soldiers check the papers of refugees returning north, August 1940.

Salvage!

Shortage and *salvage* were among the most widely used words of the period. Since almost nothing new was available, everyone became inured to salvaging everything. A decree of January 1941 forbid the population to "throw out, burn, destroy, except in cases involving public health, old metals, papers, feathers, bones, skins, leathers," and collection campaigns were ordered in the cities as well as the country. The public collection of nonferrous metals (lead, tin, nickel, copper) was a failure, despite a clever photographic campaign that implied the opposite. Few people voluntarily surrendered their old kitchenware, doorknobs, or curtain rods, as invited. The collection of old papers, with the participation of schoolchildren, proved more successful. The clothing coupon, placed in circulation starting in July 1941, did little to mitigate the textile shortage. The minister of industrial production turned to a complementary system: a huge publicity campaign urged people to exchange their old clothes, blankets, and rags for textile points.

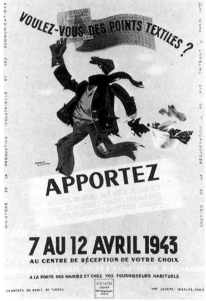

above: Old papers are collected in a school, December 1942.

A poster of April 1943 (center) asks, "Do you want textile points?" and tells how they can be gained in exchange for old clothes; an actual exchange (below) takes place in September 1942.

opposite: Nonferrous metals are collected in Paris, November 1941.

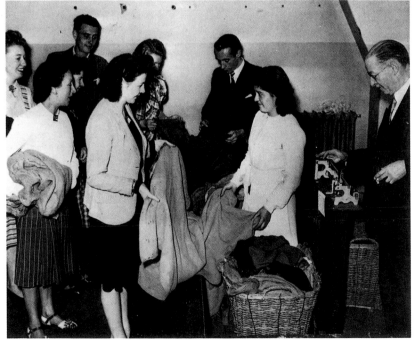

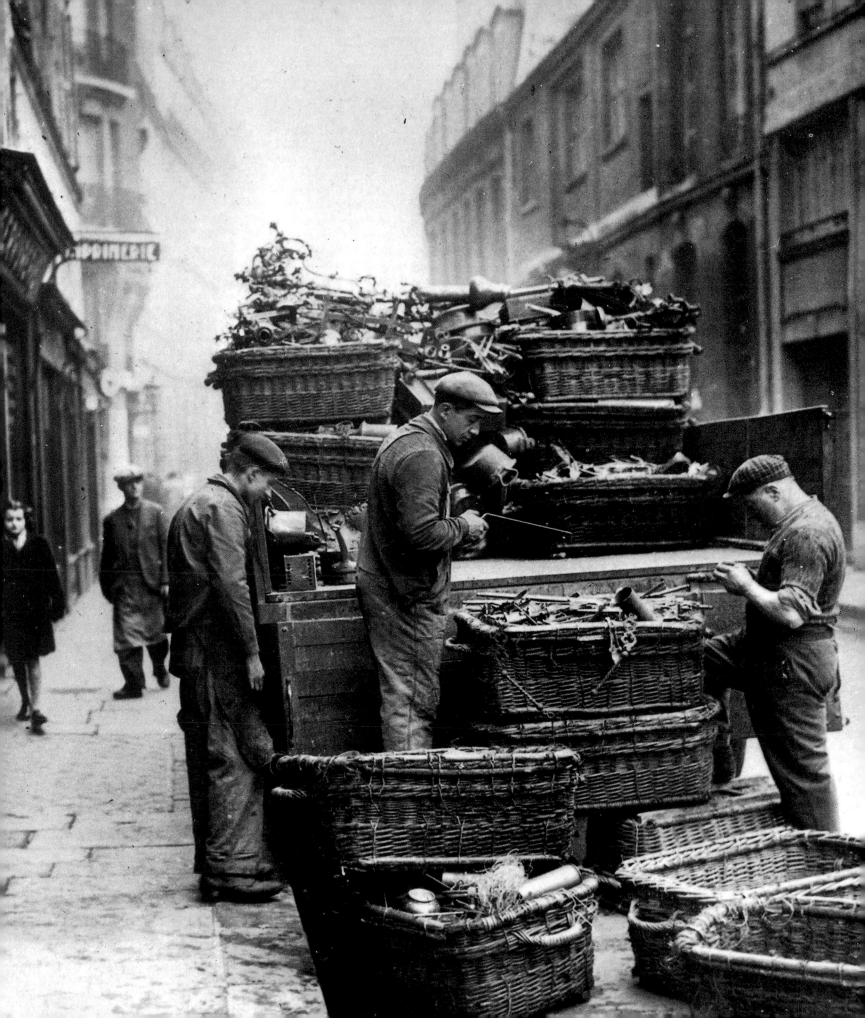

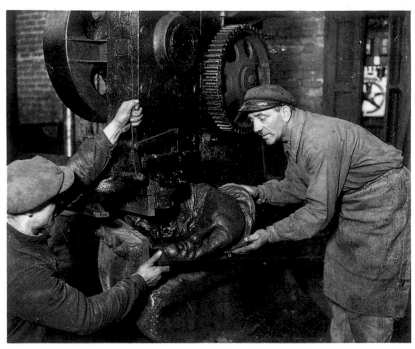

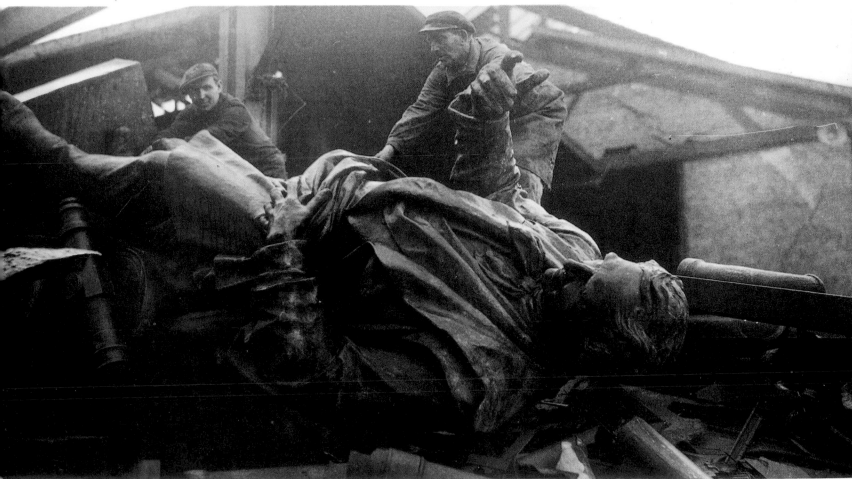

Metal at any price.

As the months passed, the occupation became more oppressive; Germany constantly hungered for more raw materials to feed its war economy. Once the stocks of metals ran out, the German authorities resorted to some unusual solutions, such as ordering bronze statues taken down and melted in order to reuse the metal. Startled and upset, Parisians saw the statues of Victor Hugo and François Arago, highly symbolic republican figures, and of many others removed. Anticipating protests, the propaganda machine argued, supporting documents at the ready, that these statues were badly done, not true works of art. In their effort to collect copper, these same Germans, through a Vichy government measure in September 1942, offered a premium to those who brought in copper. They would be given stamps allowing them to obtain a liter of wine for every two hundred grams of copper provided. Few found this proposal tempting. Finally, in order to save materials, street signs were made in Bakelite instead of the traditional enamel. The names chosen for the new signs belonged to "positive" heroes, such as Jean Chiappe, prefect of police, who had a weakness for ultrarightist leagues (in 1941 his avenue took over a section of the avenue Henri-Martin, today avenue Georges-Mandel), and Edouard Branly, a physician who died in 1940, actually a genuine scientist and modest man who was often, along with Louis Pasteur, offered as an example to youth.

opposite above: The head of Victor Hugo is crushed, December 1941.

opposite below: The statue of François Arago, nineteenth-century scientist and politician, enters a salvage center in Paris, December 1941.

above: Posters offering a liter of wine in exchange for two hundred grams of copper, 1942.

below: Street signs are made up with the names of "positive" heroes, Paris, January 1941.

New raw materials.

In order to cope with the shortages, anything became grist for the mill; the most unexpected of materials, such as hair or Spanish broom, were tried as textiles fibers. A decree of 27 March 1942 ordered the salvage of hair from all hairdressers. Once the hair was cleaned and degreased, it was combined with 20 percent of fibranne to add support to a very special fabric. This was made into slippers: five to six tons of treated hair per month yielded fifty-five hundred yards, permitting the fabrication of forty thousand pairs. The raising of angora rabbits saw a revival. A law passed on 18 September 1941 made it compulsory to harvest Spanish broom, grown in the southeast. It was hoped that its fiber, after treatment in Mazamet and Marseilles, would replace flax and hemp, even cotton and wool. Scarce and poor in quality, soap became the object of fierce haggling. One recipe called for twenty-two pounds of bones to make about seven pounds of "soap"; others combined lichens and lime or flour and horse chestnuts.

above: A government poster offers a bar of soap "in exchange for one kilogram of bones."

below: Spanish broom is stacked before being treated, September 1943.

opposite above: A factory of "hair cloth" in Calvados, June 1942.

opposite below: Angora rabbits are raised for their fur, February 1944.

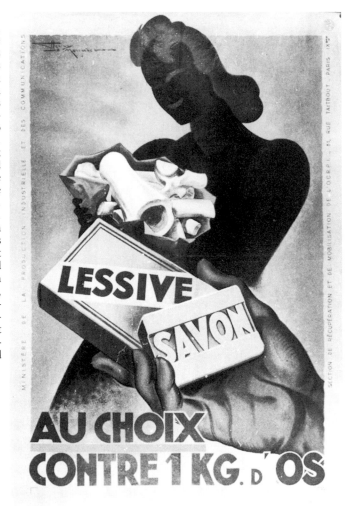

Artisan-inventors.

German requisitions of leather seriously affected the work of bootmakers, shoemakers, and artisans, who had to use what they found at hand. In the spring of 1941, shoe stores displayed shoes with wooden soles in their windows. Veritable publicity campaigns promoted this new product. An exhibition of "the shoe 1941" took place in Paris in July, its goal to champion "the relief shift of leather by wood." It presented the latest models in fabric, woven straw, and synthetic leather. In 1944, with shortages even worse, some artisans resorted to cutting and gluing old felt hats to make sandals.

Ingenuity also triumphed in the realm of agriculture. To save horses from famine, viticulturists of the south developed a by-product of the vine they thought could replace oats. And the farrier, no longer having iron for shoes at his disposal, "was forced to put on horses' feet a horseshoe covered with rubber, which unfortunately did not last as long as the old kind."

opposite above: A shoe store in Lyons advertises its shoes with wooden soles in the summer of 1941.

opposite below: The latest in shoes are exhibited in Paris, July 1941.

above: A shoemaker uses old hats to make sandals, Paris, February 1944.

below left: Grapevines being recycled in the Midi to feed horses, May 1943.

below right: A horse gets a rubber-coated horseshoe, October 1942.

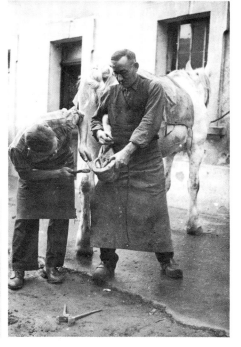

"Nothing is irreplaceable."

The Grenoble fair of June 1941, devoted to substitute products, received generous coverage in the press. The latest techniques for making gasogenes, soap, cooking oil, and resins could all be found there, but the most popular booth by far turned out to belong to the Lyons factory that produced cloth from fibranne. It displayed "clothes from wood . . . from Scandinavian forests, made with fibranne, a fiber drawn from cellulose." The photograph's caption added, "although the imitation of wool was perfect, the fabric was a bit less warm and called for certain special pains in its degreasing."

Two years later, an exhibition held at the Grand Palais "on substitute products and ways to save materials" attracted few people. The emphasis had been placed on the presentation of objects and manufactured articles with new methods and conceptions of manufacture that made savings possible.

Pierre Caziot, minister of agriculture and also in charge of provisions, visits the Grenoble fair (above) and the fibranne exhibit (opposite), June 1941.

below: The Grand Palais exhibition of substitute products, June 1943.

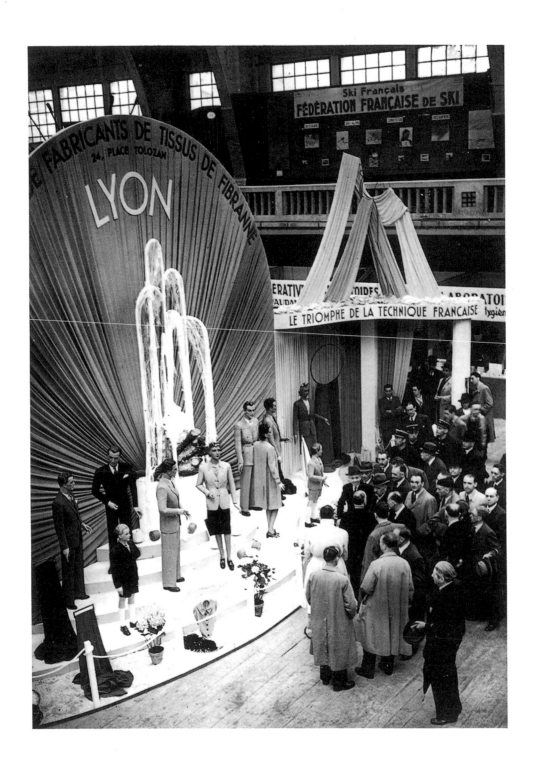

To survive . . . wait.

For four years, hunger and cold occupied the forefront of the average French citizen's concerns. Among the most characteristic images of the time was unquestionably that of the line, a test of nerves that sometimes threatened to turn into a riot against the "priorities" (those allowed extra provisions). Lines were long everywhere, even to obtain a meager ration of bread (from 125 to 375 grams). On the establishment of the rationing system, the French were divided into eight categories, from E (those under the age of three) to V (those over seventy), and those who did hard physical work and pregnant women had the right to supplements. Everyone was allocated a set quantity determined by age and needs, in theory—an insufficient ration in any case, since it ranged from 1,200 to 1,800 calories. Each region in France experienced its critical moments. For Paris and its suburbs, the weeks before the Liberation were among the most difficult: there was no milk to be had, nor meat, nor vegetables.

In 1944, a new hot plate called the paper hot plate (developed by a prisoner of war in his stalag) made its appearance with the disappearance of gas and coal. It could even be set on the table. It worked by means of paper pellets placed in a cylinder and set aflame; 80 grams of pellets could boil a small pot of water.

right: A poster (possibly of 1941) urges people who wait on line, "do not become angry with the 'priorities,'" but "give way with good humor . . . the French way."

left: A paper hot plate, July 1944.

opposite: A line for a bakery on the rue Lepic in Paris, 18th arrondissement, July 1944.

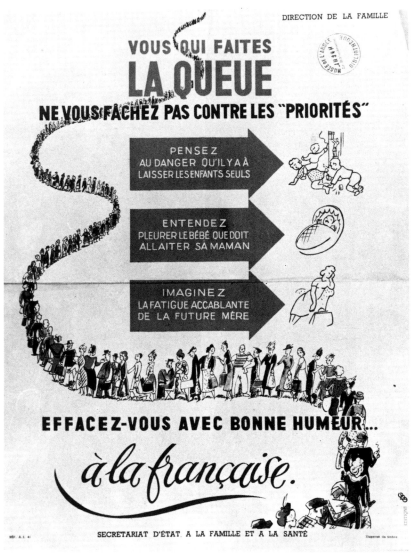

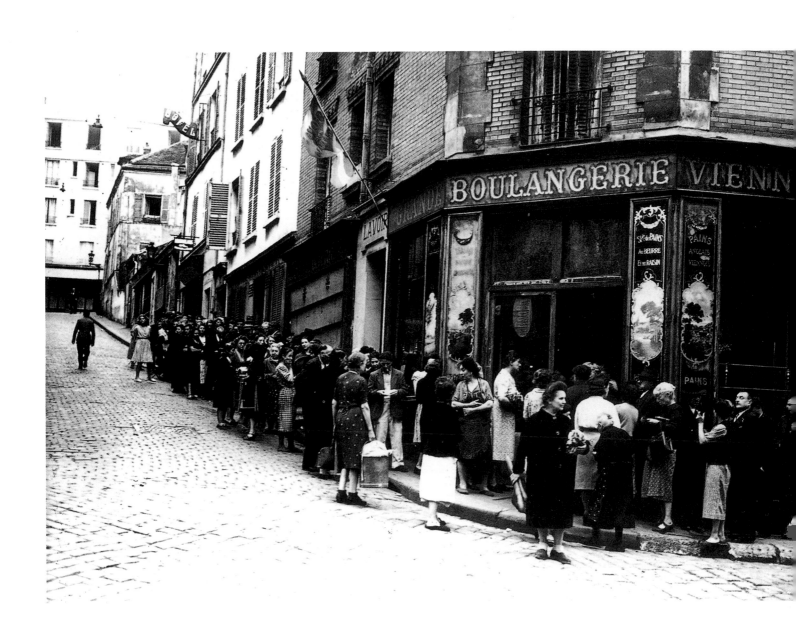

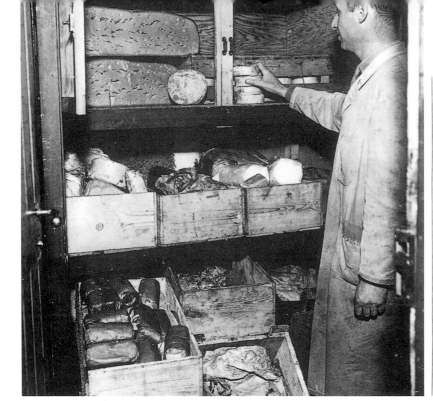

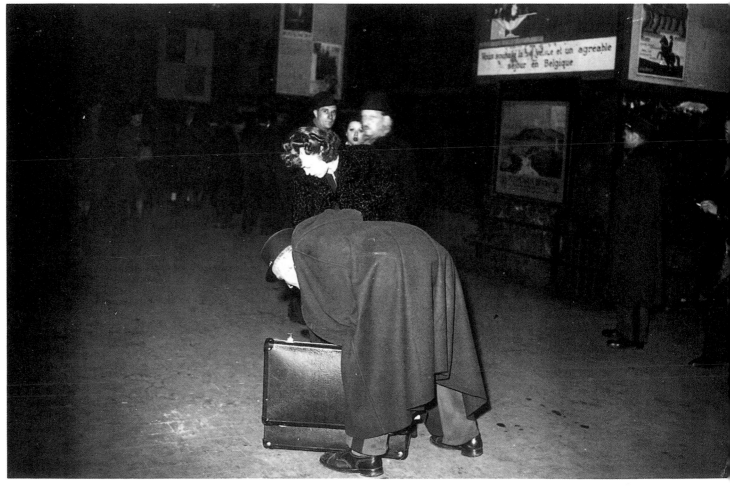

Black markets.

In vain the government warned the population, added more police checks, employed propaganda; the black market was a roaring success for those who could pay the high prices. The term first appeared in the 1942 edition of the *Petit Larousse* with the following definition: underground market where the objects are sold at higher than official prices. Some products sold for twice or four times the official price. For example, an egg costing 1.75 francs in Paris in 1941 went for between 5 and 11 francs on the black market in 1942, which was more than the hourly wage of a skilled worker in the Paris region. A kilogram (2.2 pounds) of butter went from 250 francs in May 1942 to 350 in January 1943, and the same weight of coffee cost from 1,000 to 2,000 francs. Buyers or sellers who were caught had to pay a stiff fine and had their merchandise confiscated. The majority of French people was obsessed with eating and keeping warm, and many of them did not hesitate to travel miles in search of some hypothetical provision. The barter system also had its devotees, who exchanged a kilo of butter for two of sugar or four packs of cigarettes, a ham for a tire . . .

opposite above left: A center for confiscated goods, dairy division, in Paris, 1st arrondissement, May 1943.

opposite above right: A cartoon from Candide *pokes fun at the barter system, 19 May 1943.*

opposite below: A police check at the Gare du Nord in Paris, November 1942.

right: The 1943 poster warns the public, "The black market is a crime."

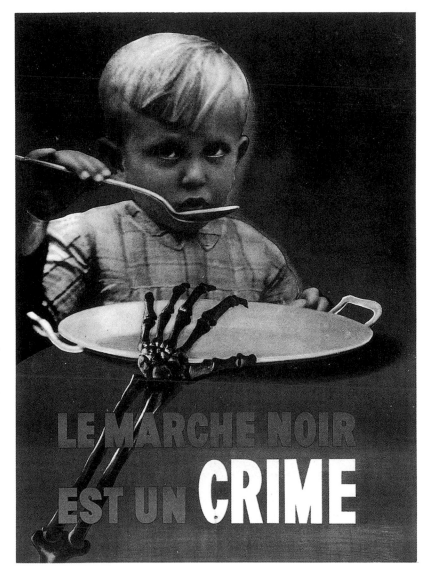

LE MARCHE NOIR EST UN CRIME

127

Transportation crisis.

During the occupation, automobile traffic was limited to certain categories (doctors, provisions), meaning the rest of the population had to shift for itself. In Paris, just as in the provinces, the most anomalous vehicles made their appearance. Antique coaches pulled by horses replaced buses that had formerly waited at the city gates to serve the racecourses. In big cities, bicycle-taxis were available, for a high price. This vehicle consisted of a more or less comfortable small trailer towed by a bicyclist. Of the 3,500 Parisian bicycle-taxis in operation, only 800 charged the regulatory 9 francs per person, 12 francs for two, the others asking whatever they could get away with. Although the gasogene-powered vehicle was not new, during the war it evolved greatly (in 1941 there were 50,000 such trucks or cars; in June 1944 there were more than 120,000). Instead of using gasoline, it ran on a combustible gas obtained by burning wood, cut into small pieces, in the boiler at the rear of the vehicle.

But this period saw the triumph of the bicycle, above all; in 1944, two million were counted in Paris.

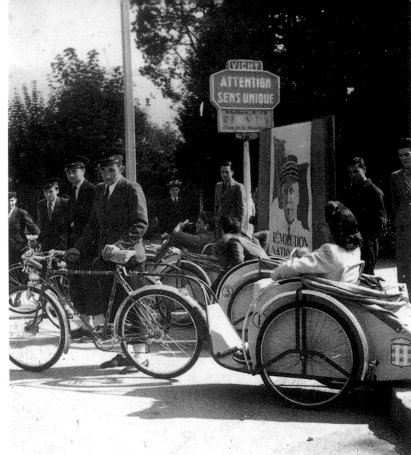

above: The first bicycle-taxis in Vichy, September 1941.

below left: A bicycle-taxi in Paris, February 1943.

below right: A gasogene-powered car, 1943.

opposite above: A cartoon satirizing "traffic restraint" from Pour la Victoire, *10 October 1942.*

opposite below: Horse-drawn carriages bound for the Auteuil racecourse, February 1943.

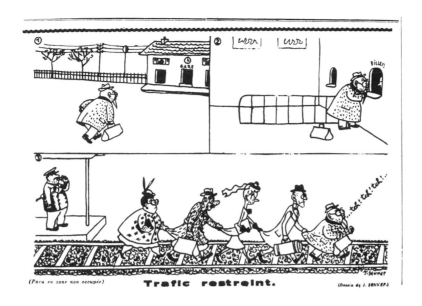

Trafic restreint.

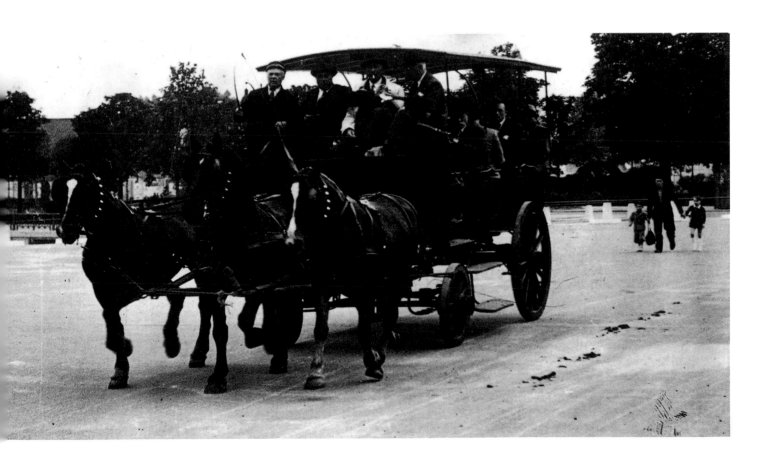

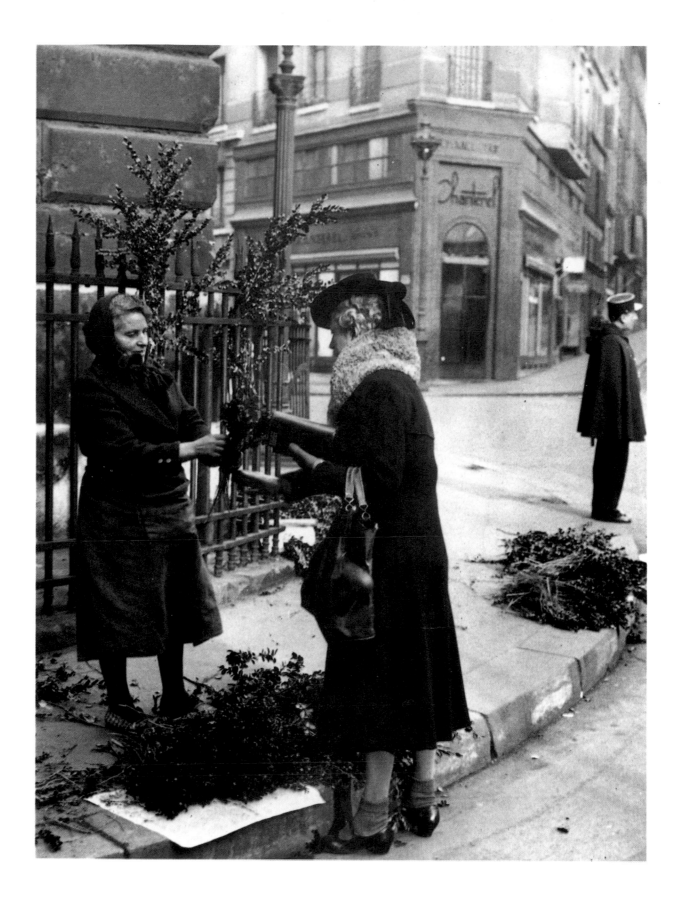

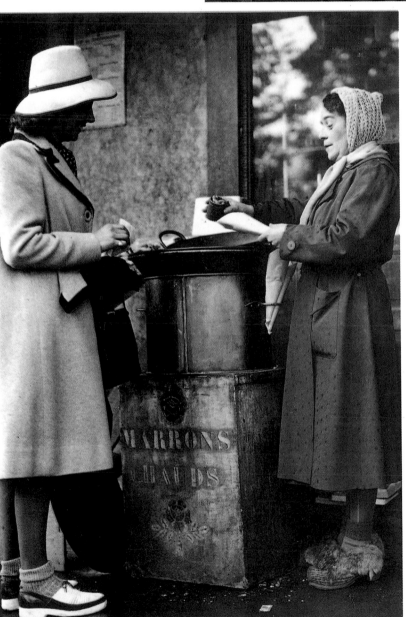

Life goes on.

For all the problems that assailed the population, life continued to the rhythm of the seasons, marked by immutable rites that the press liked to emphasize to show that, clearly, nothing changed under the occupation. People continued to dress up; on the Sunday before Easter, boxwood was sold at the doors of the church; and on May 1, the traditional lily of the valley (or May lily) "found a smiling purchaser in every Parisian woman." In autumn, the chestnut vendors offered their warm packets just as before.

Yet the war was always there, upsetting customs, bringing new sights into view: bride and groom borrow the subway for their wedding. This wedding group, in June 1941, obligingly smiled for the photographer's lens.

opposite: On Palm Sunday, a woman buys a branch of boxwood for the Easter service behind the church of Notre-Dame-de-Lorette, Paris, April 1944.

above: A wedding in the Métro, the Parisian subway, June 1941.

center: Hot chestnuts appear on the first cold day in Paris, end of October 1941.

below: Lily of the valley is sold for May Day 1944 on the place de l'Opéra, Paris.

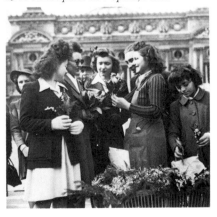

Elegance will be seen.

Despite the draconian regulations that might have smothered it, haute couture maintained its position, to demonstrate that Paris surely remained the fashion capital of the world. The couturiers took advantage of every occasion to show the public their latest designs, relayed by the press. On the traditional day of *drags* (a race that simulates a hunt) at Auteuil, French elegance resurfaced: "22 young women made up a joyous bouquet, of varied colors, a bouquet enlivened with grace that was soon the goal of photographers" (*L'Oeuvre*, July 1941). *Paris-Midi* instigated a fashion contest on bicycle at the Armenonville pavilion. The greatest couturiers participated, proving that they, too, could adapt to the times. The indispensable bicycle

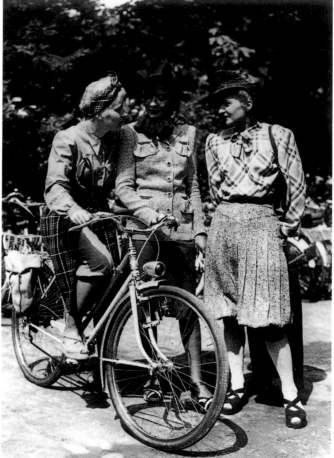

called for a simple and practical outfit, the very definition of the skirt-culotte.

Given the restrictions, ingenuity came to the fore, transforming an ordinary dress into an artful one through accessories, and designers competed to best one another in inspiration. Hats never experienced such success. They came in all shapes, all materials. It was as if the women wanted to compensate for the gloomy atmosphere of the period by the extravagance of their toppings.

132

above left: A scarf hat and a felt confection meet at Auteuil for the opening of the racing season, February 1941.

above center: A day of elegance on bicycle in Paris, 23 July 1941.

above right: A dress by Gisèle Tissier makes use of clever accessories, July 1941.

below: Elegant ladies put their best foot forward at the Auteuil racecourse, July 1941.

opposite: A hat by Agnès, 1942.

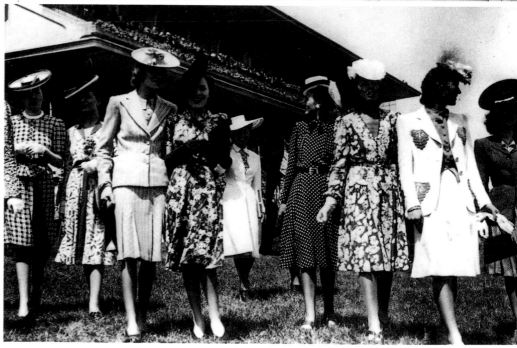

At the couturier Robert Piguet, the actress Arletty
tries on dresses she would wear in her next film,
Boléro, November 1941.

Culture(s)

The ambiguous attractions of the "retro style" has planted in the majority of French minds an image of a culture under Vichy dominated by a group of openly collaborationist intellectuals and artists. It is true that in occupying Paris, Germany gained the means to oversee a good part of France's cultural production and diffusion. To cite only one troubling example, the entire publishing industry, located in Paris, resumed its normal activities without a moment's hesitation, which could only mean it immediately complied with the orders of the occupying forces, including lists of forbidden works and a variety of pressures to "reorient" catalogues in the correct direction. Nonetheless, the cultural values of the Nazi vanquisher did not win the largest audience, and this was true to the very end. Naturally, liberal, progressive, democratic values fared poorly as well. This was the moment for a return to Tradition, in all its forms, an excellent solution to win over that segment of the French population that had always reacted with conscientious objections to the modern world. Yet the very conditions of the expression of this counterculture (as in counterrevolution) were such that in the end this brief experience, more than a straightforward failure, would bring about a series of contradictory and unforeseen results, leaving more traces in French culture than expected.

All the language that emerged from the Vichy government proclaimed the reaction against the previous state of France, described as decadent, unconnected to the country's roots, cosmopolitan. In aesthetic terms, the public powers suddenly rediscovered the virtues of a classicism from which the Third Republic had just managed to distance itself. The head of the fine arts bureau, an important appointment by the government, Georges Huisman, Jew and radical socialist, champion of Picasso and Le Corbusier, was replaced by Louis Hautecoeur, an art historian who specialized in the "Grand Siècle," the seventeenth century in France.

The sycophants of the regime, however, failed to popularize a specific "marshal art." The renewal could not, as wished, come from the province and the country. Despite the talents of some of the con-

tributors (Jean de La Varende) and the assumed (Henri Pourrat) or involuntary (Jean Giono) rediscovery of others, regional cultures were all lumped in the category of "folklore." Never before had the power of the state been so centralized as in those years, through the combination of dictatorial policy and the exigencies of occupation. Yet even in its support of rural values, the new regime came up against a number of unforeseen obstacles. On the one hand, it discovered that it was easier, but without much ideological effectiveness, to steer the French people to the national myths, a path previously blazed by the Third Republic, than to impose on them by force a long-marginalized clerical culture. On the other hand, even more surprisingly, certain manipulations of the past (for example, the attempt to exploit Charles Péguy) were suddenly challenged by a spiritualist faction (such as the periodical *Esprit*) briefly allied to the National Revolution on the basis of a misunderstanding.

Moreover, this was a terrain that forced Vichy, to its embarrassment, to follow in the footsteps of the Popular Front. In the era of Léo Lagrange, youth hostels, and Popular Aviation, the already established concept of "physical education" and the totally new and polemical "organization of leisure-time activities" had taken the form of a democratic response, in defiance of totalitarian regimes. The goal of collective regeneration through youth and "the path of nature" remained. But in the language of Vichy, authority replaced the voluntary and nationalism replaced populism. Thus, side by side with the Chantiers de la Jeunesse there flourished various cultural associations underwritten by the government, such as the Compagnons de France, the youth movement inspired by the Boy Scouts, and Jeune France, an association of young artists and cultural militants.

Making a virtue of necessity, Vichy encouraged outdoor activities (within the limitations of the curfew and the innumerable impediments to free travel) that were inexpensive (itinerant theater, choral singing, crafts) and "decentralized" across the departments, principally in the southern zone, where an entire segment of the film industry had retreated and which several young theater companies traversed. One of these, La Roulotte, allowed Jean Vilar to explore the "cultural action."

Such cultural activism met a strong social demand. This sometimes flowed in the same direction that the new regime had in mind, when it exhibited the obligatory steeping in the national past and pre-

sumed solid values. A penitential literature flourished during this period, often flavored with Catholic references. The popularization of history created an honors list of a France regularly purified by several heroes. The cinema prudently took refuge in adaptations of the classics. In the theater, the "noble" style earned more appreciation than ever before; the playwright Paul Claudel finally saw productions *(Le soulier de satin)* and a dramatic author who wrote prose in the rhythm of alexandrines, Henri de Montherlant, was discovered.

Yet even more often, creation overstepped the boundaries of convention. With Louis Aragon and Paul Eluard, poetry gradually acquired a faculty for double meaning, and certain poems even appeared from underground. On the stage, as well as in the bookstore, the interesting, up-to-the-moment young authors were Jean-Paul Sartre *(L'être et le néant, Les mouches, Huis clos)* and Albert Camus *(L'étranger, Le malentendu, Le mythe de Sisyphe)*. In film, the vacuum left by the departure of numerous directors abroad could not begin to be filled by a Vichyist generation. The young people who replaced them were either leftist-inclined (Jacques Becker, Louis Daquin) or displayed a dark outlook (Claude Autant-Lara, Henri-Georges Clouzot), transforming a costumed melodrama *(Douce)* or a police thriller *(Le corbeau)* into a violent denunciation of bourgeois society. Ambiguity reached its apex onstage with Jean Anouilh's *Antigone,* in film with Marcel Carné's *Les visiteurs du soir* or Jean Grémillon's *Le ciel est à vous,* simultaneously applauded by partisans of the regime and those of the Resistance (to which Grémillon belonged), who interpreted them in diametrically opposite ways.

This kind of paradox is subject to generalization. In its efforts to spark a spiritual renaissance, the authoritarian and traditionalist Vichy regime ended up nurturing opposing values. A good example of this unanticipated loss of control is the association Jeune France. The "young painters in the French tradition" that it promoted were actually tomorrow's avant-garde (Jean Bazaine, Alfred Manessier); the musical and broadcasting research that it brought to life would give birth to the "Studio d'essai" after the war, led by Pierre Schaeffer. And Jeune France would be dissolved by the same public powers that created it. The same fate awaited the school established at Uriage to train administrators of the New France, under the auspices of spiritualists of various kinds (including Hubert Beuve-Méry and Emmanuel Mounier). It was as if the act of assembling various young people for

several months in an isolated place (situated, naturally, in the pure mountain air) and having them reflect on the future of their country could only lead them to choose the Resistance—the choice made by almost all. At the time of the Liberation, a certain number of strategic areas in French cultural life were the expression of this group, from the association Peuple et Culture to the newspaper *Le Monde* and the publishing house Editions du Seuil.

At the time, however, many intellects were troubled by the equivocality inherent in their circumstances, in which they found themselves maintaining cultural relations with the German occupier. Only a thin line separated a "normal" exchange from a favored exchange, a charitable visit to prisoners of war from a visit to German colleagues, even when the latter had moved to Paris, such as Herbert von Karajan or Arno Breker, a disciple of Aristide Maillol and a sculptor recognized by Hitler.

Whatever the case, it is necessary to realize that in the cultural milieus, the rarest form of behavior was, as expressed by Vercors in his "novel of French resistance," the "silence of the sea."

Pascal Ory

Model airplanes at the Vichy-Rhue airfield, September 1942.

The show goes on.

Public or private, French cultural institutions, with few pangs of conscience, provided the continuity that the new state expected of them. The Académie Goncourt went on officiating in Paris, at the Drouant restaurant. Like the rest, it recognized the National Revolution, by electing the Pétainist Jean de La Varende and awarding its first prize after France's defeat to a book strongly inspired by the "new spirit," *Vent de mars* by Henri Pourrat, a native of the Auvergne. The very official ceremony took place in Chamalières.

The new head of the bureau of fine arts, art historian Louis Hautecoeur, was extremely leery of the modern aesthetic, as evidenced by the works exhibited at the Musée d'Art Moderne, which opened in 1942. His superiors in the bureaucracy, in charge of national education, were men increasingly engaged in politics, such as the notorious collaborationist Abel Bonnard. The essential elements of the administration remained in Paris, which continued to serve as the cultural capital, where no important move could be made without the occupier's endorsement.

Such examples of continuity were not simply ordinary events without consequences. Vichy's authoritarian regime managed to impose various reforms that remained after the war, facilitating a democratization of structures. Thus, it created the first state service for film, which, together with a professional association, formed the basis for the Centre National du Cinéma.

above: Members of the Académie Goncourt at the Drouant restaurant's exit (left to right: René Benjamin, Sacha Guitry, Roland Dorgelès, and Champion), December 1941.

below: Paris, March 1944.
"M. Devries, president of Associated Prisoners of War, presents to M. Moreau, commissioner-general of prisoners of war, the film Ademaï, bandit d'honneur, *which will be shown in the prisoner-of-war camps, attended by Noël Noël, the film's star, and L.-E. Galey, director of the Cinéma."*

opposite above: Abel Bonnard and Louis Hautecoeur inaugurate the Musée d'Art Moderne in the Palais de Tokyo, 6 August 1942.

opposite below: The reopening of the Louvre, 30 September 1940.

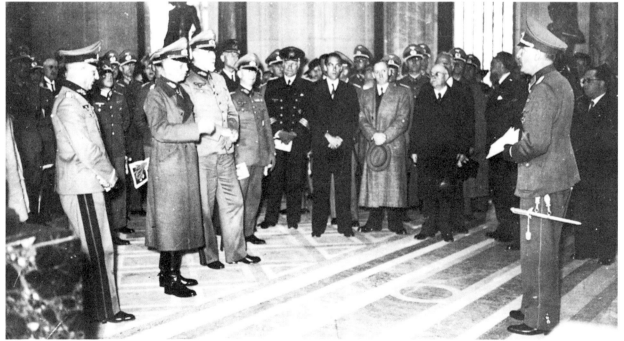

Creative vitality.

In terms of creativity, this brief period, in retrospect, appears exceptional in breadth. This activity was quantitative: with circumstances favoring a return to meditation or diversion, publishers and bookstores managed to sell their entire stocks, and theaters and movie houses were besieged. It was also qualitative: the new names Anouilh and Montherlant, Sartre and Camus confirmed their promise or grew in stature. In the film studios, distinguished veterans, such as Marcel Carné and Jean Grémillon, and gifted newcomers, such as Claude Autant-Lara, Robert Bresson, and Henri-Georges Clouzot, undoubtedly experienced their best years. The first great film of the Liberation—and unquestionably the masterpiece of French cinema of its time—*Les enfants du paradis*, is also, through its date and the (difficult) circumstances of its making, the last film of the occupation, as well as the swan song of an aesthetic.

opposite above: Jean Cocteau's La machine à écrire *is shown in rehearsal at the Hébertot theater, with Jean Marais, Gabrielle Dorziat (center), and the author (holding the script).*

opposite below left: Theater devotees wait for tickets to become available at the Grand Casino in Vichy, July 1942.

opposite below right: Director Claude Autant-Lara (with pipe) stands next to Odette Joyeux during the making of the film Sylvie et le fantôme.

Marcel Carné directs Jean-Louis Barrault and Arletty in the movie Les enfants du paradis, *January 1944.*

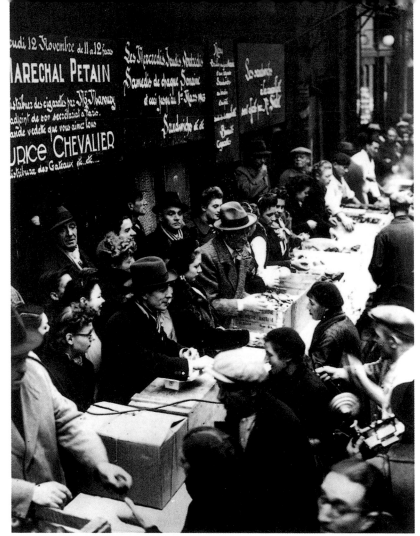

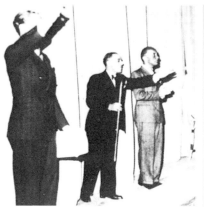

Artists become involved.

The times did not encourage the individualistic culture of the artist cultivating his own garden. Artists and scientists, mediators and actors, devotees and creators, with a sincere conviction born of the trauma of 1940, donated their services on all fronts to a charity that always began at Vichy, although, of course, it benefited prisoners of war and war victims.

opposite above: Maurice Chevalier distributes hot broth, cookies, and cigarettes to the needy in Paris, November 1942.

opposite below left: Jean Nohain holds up Pétain's cane at an auction to benefit prisoners of war, October 1941.

opposite below right: The company of the Opéra de Paris at the Vichy train station, April 1942.
"The members of the ballet practiced in front of their train."

above: Paris, June 1944.
"For the benefit of their less fortunate colleagues, renowned artists offered their works to be sold at auction at the Galerie Charpentier."

below: Sacha Guitry and René Benjamin (at rear) gaze at a check written by Marshal Pétain for the director André Antoine, Paris, February 1942.

145

An art of tradition.

The Vichy regime encouraged returning to venerable forms of expression; the favored choice was religious art, executed with a traditionalist technique, in the regional vein, using traditional artisanal techniques. Vichy's desires in this area coincided with the majority of artists and artisans. Vichy also revived the "academic" tradition of the patron that the declining Third Republic, especially the Popular Front, had begun to question.

left: A drawing class meets at the Hôtel Salé (now the Musée Picasso), which was used as a training center for artisanal trades.

right: Sculptor François Cogné poses with the model for one of his works, exhibited at the Salon des Artistes Français in Paris, April 1942.

opposite above: Painter Reynold Arnould, winner of a Grand Prix de Rome, works on a painting in his villa Il Paradiso in Nice, April 1942.

opposite below: At the Salon d'Art Religieux, Paris, April 1942.

Writers of "deep France."

Between the intelligentsia of the Resistance and that of the collaboration, there is a tendency to lose sight of those who were the most representative of the tastes and ideologies of "deep France," the intelligentsia of Vichy. Some of the more renowned figures included, in the literary camp, Jean de La Varende and Henri Pourrat; in the ideological camp were Charles Maurras and his disciple Henri Massis, who ensured the master's thought as filtered through the marshal, for whom he wrote several texts, as did another open disciple of Maurras, René Benjamin.

Paul Morand combined all those characteristics to a high degree: he was a celebrated writer, and not simply by traditionalists, as well as a sometime diplomat. His career reached its summit in August 1944 in Switzerland, where Vichy had just appointed him. But before he arrived there, he carried out various official functions of the regime, such as assuming the presidencies of two important organizations in those times of shortages and dictatorship: the committee that apportioned paper for publishing and the committee on film censorship, where he was not a moderating influence.

opposite above: Paul Morand, 1942.

opposite below: Jean de La Varende, member of the Académie Goncourt, December 1942.

above left: In Marseilles in April 1943, Charles Maurras gives his lecture "How to Revive France."

Henri Massis (above right, wearing a hat) and Henri Pourrat (below), as they were photographed for the brochure New Lives in French Intelligence, *1942.*

Sport, a new culture.

Among the means employed by the National Revolution to effect the "recovery of France," physical education, in the full meaning of the term, immediately took on an important role. Was this in imitation of authoritarian and totalitarian regimes? Or a natural outlet often followed by officers from the army, such as Colonel Pascot, Laval's commissioner of sports, and by former scouts, such as the majority of the leaders of Chantiers de la Jeunesse and Compagnons de France? Undoubtedly, but also the regime's pursuit, dictatorship-style, of the open-air politics democratically established by the Popular Front, which points to the development of a naturistic spirit over an entire period. Vichy exalted it and colored it with a militarism and a moralism that even attacked as "decadent" the milieu of open-air concerts.

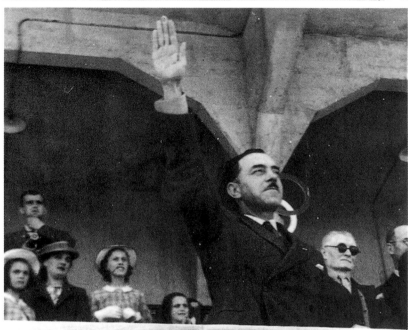

above: A training course for physical education instructors, May 1941.

below: Colonel Pascot, commissioner-general for sports, salutes the athletes during a student athletics championship, Vichy, May 1942.

opposite above: The inauguration of a playing field at Vic-le-Comte (Puy-de-Dôme).

opposite below left: Annual celebration of the Caf'Conc' in Parc des Princes, August 1942.

opposite below right: Annual celebration of "Feminine Athletic Rayon" at the Métropolitain stadium in Croix-de-Berny, July 1941.

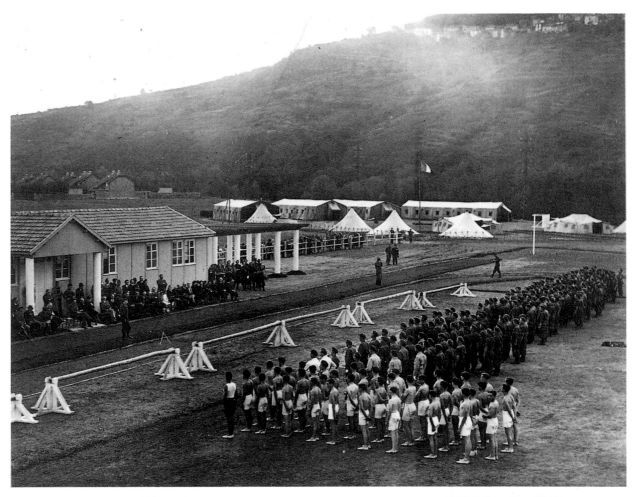

Precursors.

Beyond the well-publicized political aspirations of the French state lay many ambiguities, some of them positive. In openly breaking with the established order and appealing to youth against the adults who had failed, Vichy inadvertently promoted, here and there, the pursuit of modernity by other means. Here, the "young theater," between scenic renovation and decentralization, won recognition for Jean-Louis Barrault and allowed Jean Vilar to make his debut; there, "young painting," which, under the camouflage of the Vichy vocabulary and the "French tradition," trained the postwar avant-garde, notably, Jean Bazaine and Alfred Manessier. As another example, the need to reconstruct forced the authorities, against their inclinations, to focus on what would later become an issue of paramount importance: urban planning.

above: Pioneers of decentralization: the Comédiens Routiers, a group led by Léon Chancerel.

below: A rehearsal of Suppliants *by Aeschylus, directed by Jean-Louis Barrault, in the Roland-Garros stadium, July 1941.*

opposite above: Paintings are hung for the "salon for those under thirty years," November 1941.

opposite below: Abel Bonnard and the prefect of Seine Department discuss a model of Paris at the Salon des Urbanistes, Paris, April 1942.

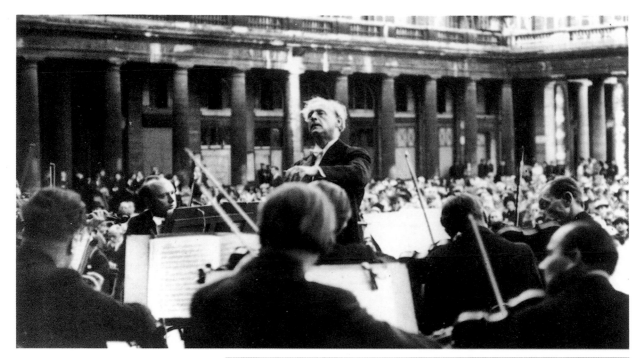

Franco-German art.

The French authorities supported numerous Franco-German cultural contacts, and respected personalities of the popular or fine arts in France welcomed their German cohorts—pianist Alfred Cortot was also Vichy's deputy for musical issues—while they or others went to Germany for well-organized visits that Nazi proganda put to its own use.

above: During Mozart week, organized by the Institut Allemand de Paris, the Chamber Orchestra of Berlin performs in the courtyard of the Palais-Royal, July 1941.

below: Alfred Cortot (front) and Wilhelm Kempf give a recital at the Orangerie in the Tuileries, where an exhibition of Arno Breker was being shown, August 1942.

opposite above: Movie stars (from left to right: Viviane Romance, Albert Préjean, Danielle Darrieux, Junie Astor, Suzy Delair) go off to visit Germany, March 1942.

opposite below: Ballet dancers from Munich pose in front of the Paris Opéra, January 1943.

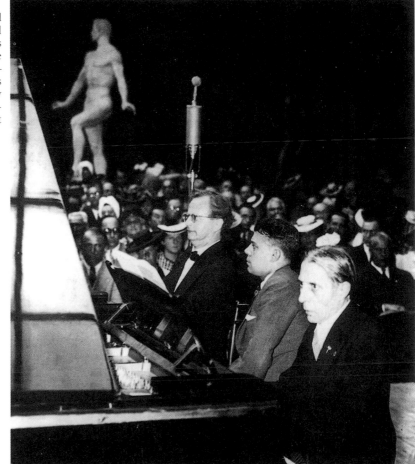

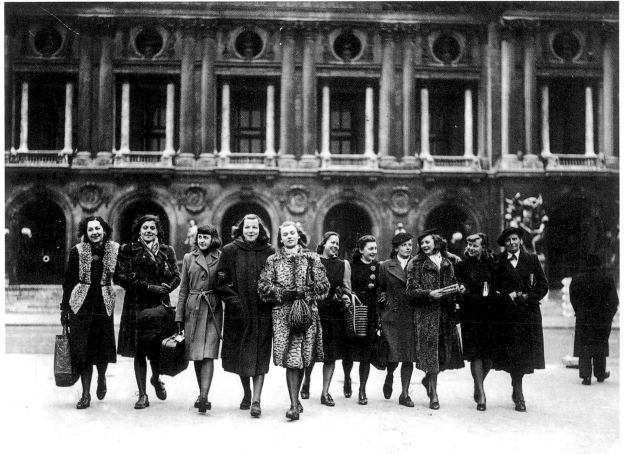

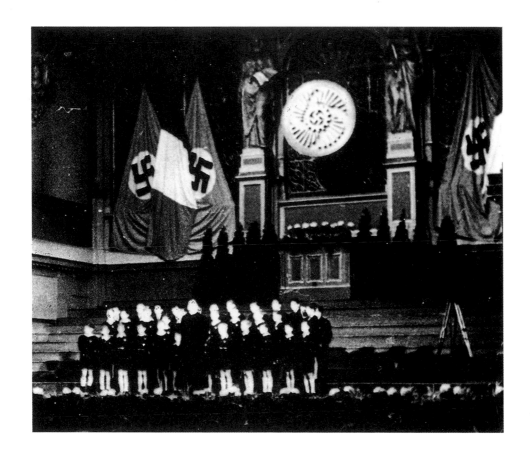

*Recital of the Petits Chanteurs à la Croix de Bois
at the Berlin Philharmonia, July 1943.*

The Extremists

At the beginning was the collaboration; at the end, collaborationism. Act one of the collaboration consisted of the signing of the armistice; the word already figures in the text of that solemn act, which forced the French government to give financial, logistic, and political support to the German power. There is no question that Marshal Pétain, a man who helped to conquer Germany in World War I, had little sympathy for the "Boches." It is also clear that Pierre Laval, the pure product of a republican meritocracy and an experienced parliamentarian, was in no way a "fascist." The direction of the regime as it evolved was toward an increasingly close alignment of the conservatives and opportunists of the southern zone with the extremists of the northern zone.

In the fall of 1940, it was Pétain who popularized the term *collaboration*. In 1944 it was again Petain who accepted in his government an important pro-German radio broadcaster (Philippe Henriot), an avowed fascist theoretician (Marcel Déat), and the head of the Milice, a man who a few months earlier swore an oath of loyalty to Hitler as a symbolic member of the Waffen-SS (Joseph Darnand). The career of the last is emblematic of Vichy's responsibility, in the slide toward collaborationism, for the number of men who came from the nationalist right and felt compelled by their loyalty to the head of state to put their patriotism before their hatred of democracy. A militant of the right-wing leagues, Darnand appears to have hesitated before his "duty" in the summer of 1940 and, for a moment, considered going to London to join the Resistance. Instead, he took control of the Légion Française des Combattants, then the Service d'Ordre Légionnaire, then the Milice Française.

This process of purging and radicalization gives a good idea of the ambivalent relations that the extremists maintained with Vichy; starting with their "reconvergence" on Paris in the fall of 1940, these men never missed an opportunity to criticize Vichy's archaism. At the same time, the two camps never broke completely with one another. On the contrary, the relationship seemed to work in inverse propor-

tion to their strength: as the Pétainists grew weaker, they found they increasingly needed the support of this group, clearly a small minority and profoundly divided, but sustained by a clear goal.

In comparison with a collaborator, the collaborationist could be defined as a French citizen who wanted to do more than simply "work with" (that is, for) the Germans and who did not hesitate to support and demonstrate the necessity of such a collaboration. Support and demonstration: the collaborationist groups all took on this double duty, of propaganda and emblematic action.

After several months of groping, Germany and its partisans arranged a program aimed at winning over every specific social category. The group Collaboration recruited among the liberal professions, business management, and artists. The lower classes had their own CIOS (Comité d'Information Ouvrière et Sociale) or COSI (Comité Ouvrier de Secours Immédiat), whose apparent leaders were old socialists, Communists, or labor leaders, all of whom had become systematic adversaries of the "agents of Moscow." Thus, they became agents of Berlin. Other associations sought to channel the animosity toward "Anti-France." These were offered an anti-Bolshevik committee, an anti-Freemasonry information bulletin, and an institute to study the "Jewish question." The last organization, which boasted the participation of the writer Louis-Ferdinand Céline, combined "thought" and "action" by underwriting a large exhibition at the Palais Berlitz called *France and the Jew* and by facilitating the transfer of "Aryanized" goods to its members.

Between the cadre out of public view and the national political organization could be found independent movements that had clearly "gone to the enemy"—militants of the Parti National Breton, adherents of the Nazi Party in Alsace-Moselle, annexed to the Reich. More standard, in the main, were the political parties authorized by the Germans to carry on their activities in the occupied zone. Some of these claimed an older pedigree: the Parti Franciste of Marcel Bucard went back to 1925, the PPF, or Parti Populaire Français, to 1936; others did not materialize until after France's defeat. Like their big brothers in Rome and Berlin, they revered a charismatic leader; displayed a totalitarian outfit favoring shirts, armbands, standards, and raised fists; and, when they had the numbers, held huge meetings in the stadium, seating separately the "Jeunesses," an organization of young women, workers, and a crew of "enforcers" ready for action.

Among the ten or so candidates for the role of single ruling party, only the Rassemblement National Populaire of Marcel Déat and the Parti Populaire Français of Jacques Doriot had any stability. The former recruited among the middle classes and was secular in spirit. Its goals were to fight for a united Europe and a populist dictatorship. A man of many ideas, Déat, however, had no talent for handling people. Over time, the influence of the RNP lost ground to the only French fascist party of any breadth, the PPF. The latter had occasion to demonstrate the effectiveness of its original mixture of extreme right activists disappointed by Charles Maurras and Colonel François de La Rocque and former militants of the Parti Communiste Français (PCF) converted to a ferocious anti-Communism. From these past experiences, the leaders of the PPF retained an organizational method and a feel for popular speech, which makes it easier to understand why at the end of the road the main collaborationist organizations still active were considered, rightly or wrongly, as infiltrated by followers of Doriot.

Did any of these groups have any real power in French society? It cannot be disputed that their voice met only a feeble echo, even among themselves. Pétain, to the end, remained popular. Doriot and Déat never were. Their true dilemma lay elsewhere: even the Germans did not want to see them come to power. Until a true German Europe could be realized, a traditionalist dictator such as Pétain would prove vastly more effective than a discredited Quisling (Vidkun Abraham, fascist of Norway), as Pétain had the ear of his nation.

Germany thus conceded the extremists the power to domineer public opinion, at first in the occupied zone, then increasingly in the southern zone after 1942. The extremists therefore controlled the only Parisian radio station, Radio-Paris, and Philippe Henriot spoke over the airwaves of the national station, Radio-Vichy. Newsreels gradually fell under the direction of the occupied zone. And in 1944 the majority of Parisian newspapers were the property of a German trust.

Moreover, the language of the extremists was fairly new. Barely audible before France's defeat, from that moment they were carried by a strong conviction until at least the end of 1944: the future of the world was bound to be fascist. Glorifying essentially right-wing values (vitalism, elitism, nationalism), they began to express them in leftist vocabulary (party, state, social question). In comparison with the original Vichy government, collaborationism was not authoritarian but

totalitarian, always regretting that it missed the opportunity in 1940 for a single party; it proclaimed itself "national socialist," whereas Vichy preferred to emphasize corporatism and paternalism; and, finally, as opposed to a nationalism of "France alone," it offered the sole formula of a "new Europe," the community of equal and complementary nations.

Kept from real power, the collaborationists seized the opportunity to prove to their patrons as well as to French society the sincerity of their European sentiment by encouraging France to join Germany in war. The Germans, however, had little enthusiasm for the idea. As long as they were winning, they had more need of economic help than an alliance they would have to pay for, little as it would cost. Thus, they proved choosy when, the first day of the attack against the Soviet Union, the French collaborationists launched a "Legion of French Volunteers against Bolshevism" (Légion des Volontaires Français contre le Bolchevisme, or LVF). Out of about eight thousand candidates to go to the eastern front, the Germans took only half.

With time, they would become less particular. The Brigade, then the Division Charlemagne, hastily assembled in Germany in the fall of 1944, took in the remains of the Milice, the LVF, the Brigade Frankreich, and so on: seven thousand desperadoes went off to turn themselves into mincemeat on two fronts, and some of them ended up defending Hitler's bunker.

This "modern," "realistic," "virile" doctrine, fascism could put up with setbacks but not with its least unexpected outcome: to be conquered by those it despised.

Pascal Ory

A gallery of collaborators surrounds a representative of Germany: Fernand de Brinon, the Vichy government's representative in Paris; Rudolf Schleier, consul general of the German embassy in Paris; Pierre Laval; Eugène Deloncle, a follower of Maurras who began an anti-Communist group; and Marcel Déat at Versailles, 31 August 1941.

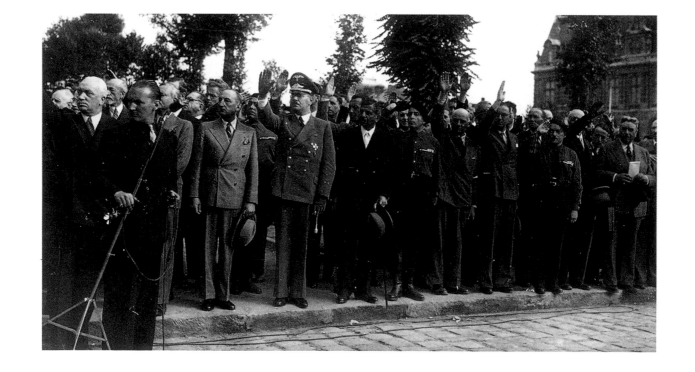

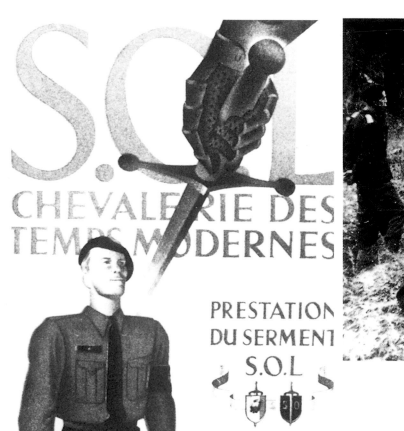

The meshing of gears.

The continual slippage that in less than four years led so many Vichyist patriots to the most radical collaboration is well illustrated by the successive distillations that in January 1943 led to the creation of the Milice Française, a supplementary armed force of the French state, to "maintain order." At the beginning, in 1940, the right consisted of a large but vague collection of veterans, the Légion Française des Combattants, Vichy's only attempt at a single party, a goal it finally abandoned. However, the activist wing of the group, led by Joseph Darnand, had no intention of limiting its mission to rituals at war memorials and meals for undernourished children. It created the Service d'Ordre Légionnaire (SOL), which swore "to fight against democracy, the Jewish leper, Gaullist dissent." After the last mutation, the Milice (thirty thousand adherents, about five thousand of them Francs-Gardes, active in the field) left a bloody, indelible smear in the French memory.

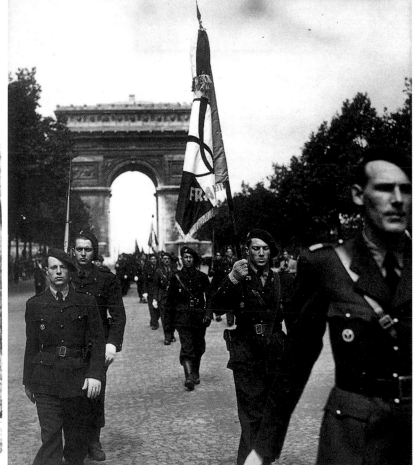

opposite above: In Vichy, February 1943, the head of the Légion Française des Combattants of Allier
"inaugurates the first restaurant for undernourished children of 6 to 12 years."

opposite below left: A poster by Roland Hugon for the Service d'Ordre Légionnaire proclaims, "Chivalry for modern times," published by the Technical Services of Propaganda, Vichy.

opposite below right: The Franc-Garde in Limousin.

above: Wearing a Milice uniform, Philippe Henriot speaks at the Grand Casino in Vichy, September 1943.

below: After the oath-taking ceremony, the Franc-Garde marches down the Champs-Elysées.

163

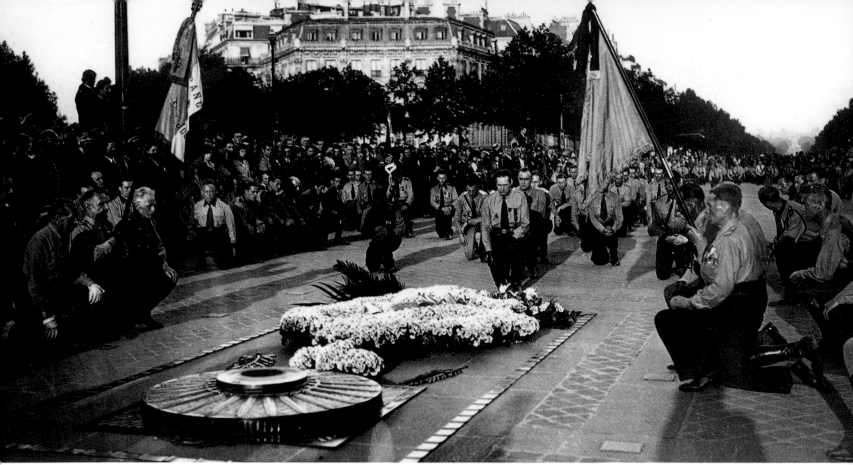

The small organizations.

Although Vichy forbade all organizations in the southern zone it had not explicitly authorized, the Germans allowed groups that clearly supported collaboration (foremost among these the group Collaboration, which recruited among the "elites" of economy and culture) or that subscribed to fascism: autonomist parties in Flanders and Bretagne and especially national parties opposed to the single ruling party. Some, like the small group Parti Franciste of Marcel Bucard, were remnants of prewar right-wing leagues. Others arose from the new circumstances, such as Marcel Déat's Rassemblement National Populaire (RNP).

The holy word *totalitarian*, the parade exercise, and the cult of the leader were common to all these organizations. They were divided by a bitter competition for public favor, which largely escaped them, and by their pursuit of favor from Germany, which viewed them with condescension.

Notre Jeunesse trace à la Bretagne un avenir meilleur
JEUNES BRETONS, RALLIEZ LES ORGANISATIONS DU

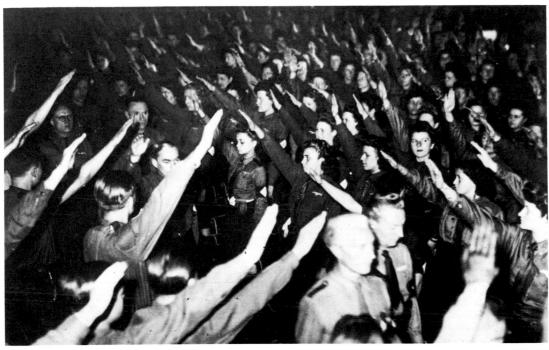

opposite above: Marcel Bucard's Francistes kneel before the Tomb of the Unknown Soldier, Paris, 3 July 1943.

opposite below left: A recruiting stand for the French Waffen-SS run by the youth organization of the group Collaboration, Marseilles.

opposite below right: A drawing for the organ of the Parti National Breton (PNB), L'Heure Bretonne.

Images of the RNP: Déat makes his entrance at a meeting at the Palais de Chaillot, September 1943 (above); the camp in Saint-Ouen-l'Aumône (Oise), April–May 1944 (below left); and a choreographic group of young women at the Mutualité, Paris, March 1944 (below right).

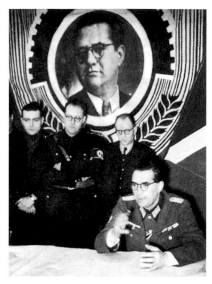

The Parti Populaire Français.

Whereas Déat ended up as a minister of the Vichy government in the spring of 1944—the last weakness of an old marshal—Jacques Doriot was left knocking on the doors of power to the end and had to make do with the uniform of a lieutenant in the German army via the Légion des Volontaires Français contre le Bolchevisme (LVF). A talented orator, the former second in command of the French Communist Party could appeal to a proletarian public as well as such intellectuals as Pierre Drieu La Rochelle or the editors of the rightist newspaper *Je Suis Partout*. His dynamism and sense of organization made it possible for his party, the Parti Populaire Français (PPF), to infiltrate gradually the LVF, the Milice, and various newspapers and to resist losses in the ranks experienced by his rivals whenever the military situation changed.

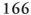
166

above: Jacques Doriot holds a press conference in Paris after returning from the eastern front in February 1944.

below: A meeting of the "Front du Travail Français" at Magic City, February 1942.

opposite: Doriot salutes assault battalions of the PPF Gardes Françaises marching by him on the Champs-Elysées, Paris, August 1943.

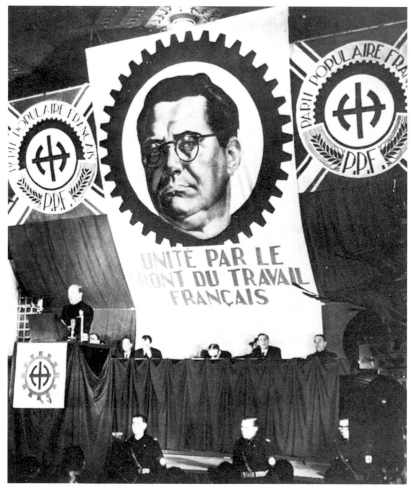

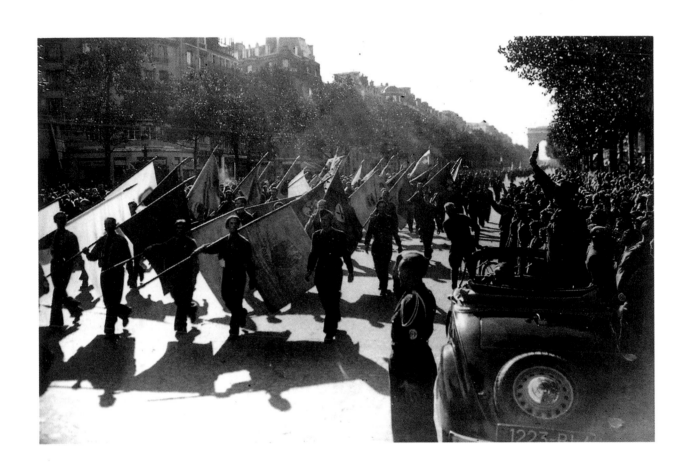

The spokesmen for the collaboration.

Besides the collaborators of the government and for the government—politicians and high-level officials of Vichy, builders and workers called on or forced to work with the occupier—a number of journalists, writers, artists, and scientists translated into doctrine what in the first groups amounted to a more or less zealous opportunism. These are the collaborationists.

Among them could be found, jumbled together, "anti" professionals (anti-Freemasonry, -Semitism, -Anglo-Americanism, and so on), such as historians Bernard Faÿ and Paul Chack; prophets, like Louis-Ferdinand Céline and the old mystic and Hitlerian Alphonse de Chateaubriant; prewar fascists, such as Robert Brasillach, Pierre Drieu La Rochelle, as well as personalities from fashionable Paris who came to the doctrine later. Beyond their diversity, all had considerable means at their disposal to broadcast their ideas, mostly thanks to German influence or resources. They held the reins of all the general news information in Paris—old titles such as *Je Suis Partout*, new ones like *La Gerbe,* or revived ones like *NRF (Nouvelle Revue Française).* And their audience was increased through newsreels and, especially, radio, which presented two strong propaganda personalities, both from Catholic milieus, Jean Hérold-Paquis and Philippe Henriot.

above: Pierre Drieu La Rochelle, Robert Brasillach, Abel Bonnard, and André Fraigneau, returning from Germany, where they participated in a "conference of great European novelists," are met by Bremer of the Institut Allemand and Heller, representing the German authorities, November 1941.

center: Paul Chack delivers a speech at the tomb of Edouard Drumont to mark the latter's hundredth birthday, May 1944.

below: Alphonse de Chateaubriant poses amid the children of prisoners of war, December 1942.

opposite above: At PPF headquarters, Jean Hérold-Paquis, broadcaster of Radio-Paris, signs his book L'Angleterre comme Carthage . . . *in June 1944.*

opposite below: Funeral service for Philippe Henriot, place de l'Hôtel de Ville, Paris, 3 July 1944.

The clientele of the collaboration.

The manipulation of public opinion affected all sectors, beginning with the types of organizations heavily patronized between the two wars: "youth movements," "women's groups," and corporative associations. The example of the small group called Comité Ouvrier de Secours Immédiat (COSI) reveals the precise functioning of the machine; outwardly a cell of worker solidarity, led by former union leaders, it was actually completely underwritten by Germany. The source of the goods it distributed is clearly indicated by the original caption written for the photograph opposite.

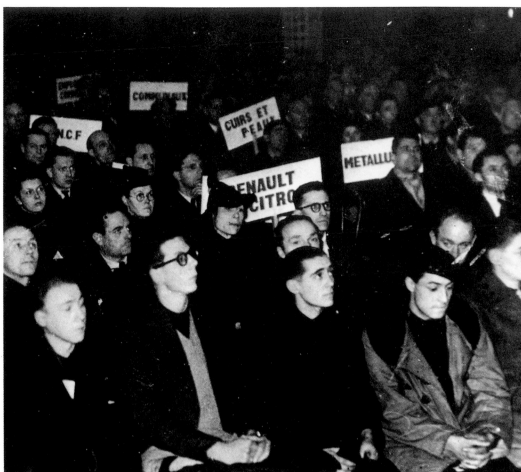

left: A leader of the RNP's young women's group speaks; at her right is Georges Albertini, then secretary-general of the RNP, May 1943.

above right: Worker leaders of the PPF, February 1942.

below right: At a meeting of COSI, July 1943, a banner reads, "The Comité Ouvrier de Secours Immédiat arose from true European socialist solidarity."

opposite:
"The representatives of the occupation authorities this morning presented to COSI an important lot of furniture taken from the requisitions imposed on Jews."
April 1942.

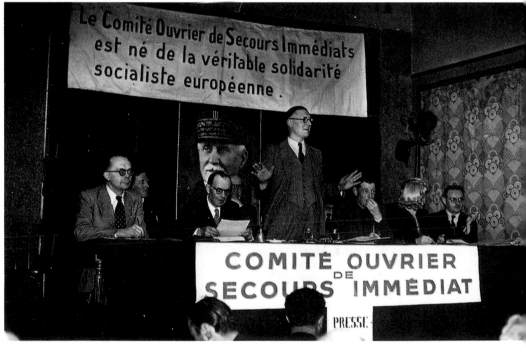

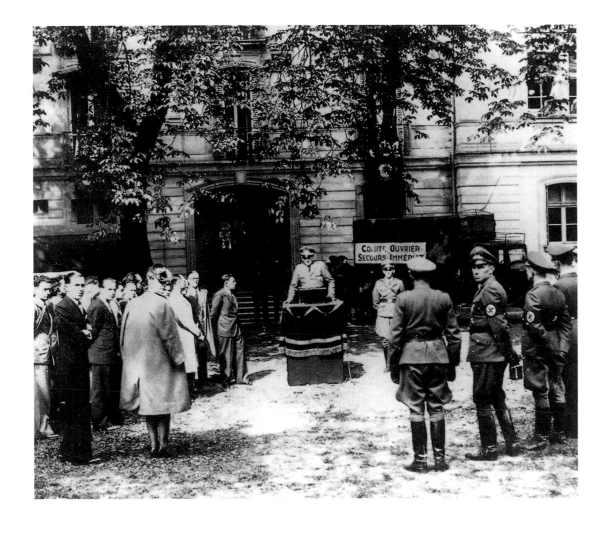

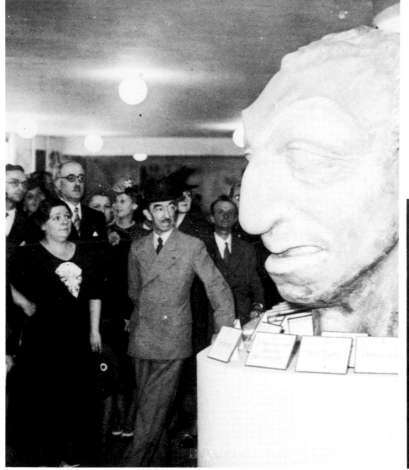

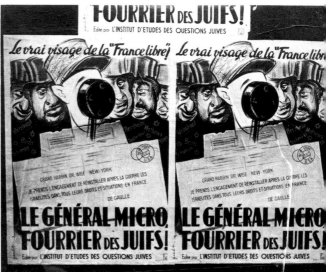

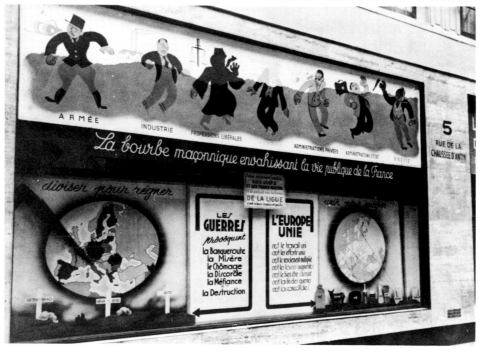

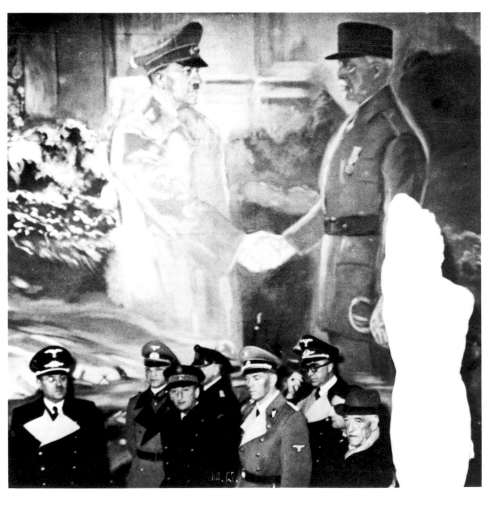

Doctrine in action.

Collaborationists made use of every technique, including splashy exhibitions, to denounce those responsible for French decadence: Freemasons, Anglo-Saxons, Gaullists, Jews. They received assistance from specialized groups, such as the Institut d'Etudes des Questions Juives, to which Céline belonged, or the Centre d'Etudes Antibolcheviques. On this level, the extremists of the northern zone became less and less distinct from an ever more radical southern zone; in Vichy, the "biological" anti-Semites gradually replaced the "nationalist" anti-Semites.

The collaborationists differed from Vichy most notably in their totalitarian, rather than authoritarian, approach. Whereas the National Revolution concentrated on "France, France alone," the concept so dear to Maurras, the former anticipated expanding the dimensions of a "new Europe," seeing the handshake at Montoire, "that grasp that is a vow," as a pledge.

opposite above left: The exhibition France and the Jew *at the Palais Berlitz, Paris, September 1941.*

opposite above right: A poster published by the Institut d'Etudes des Questions Juives castigates Charles de Gaulle's "Free France" as a puppet of the Jews, January 1942.

opposite below: An anti-Freemasonry poster on the street in Paris, 9th arrondissement, May 1941.

Rudolf Schleier, Fernand de Brinon, and Paul Marion (hidden behind Paul Chack) inaugurate the exhibition Bolshevism against Europe*, Paris, Salle Wagram, March 1942.*

173

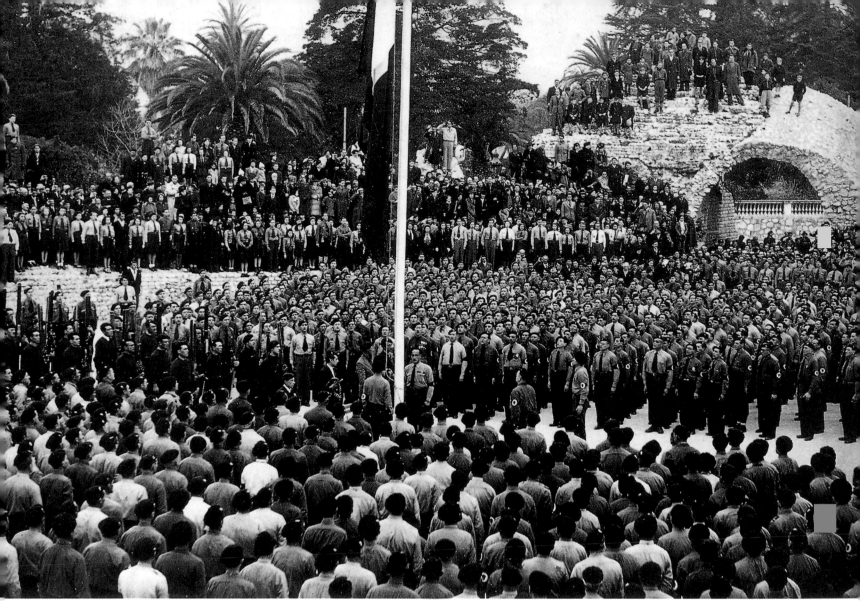

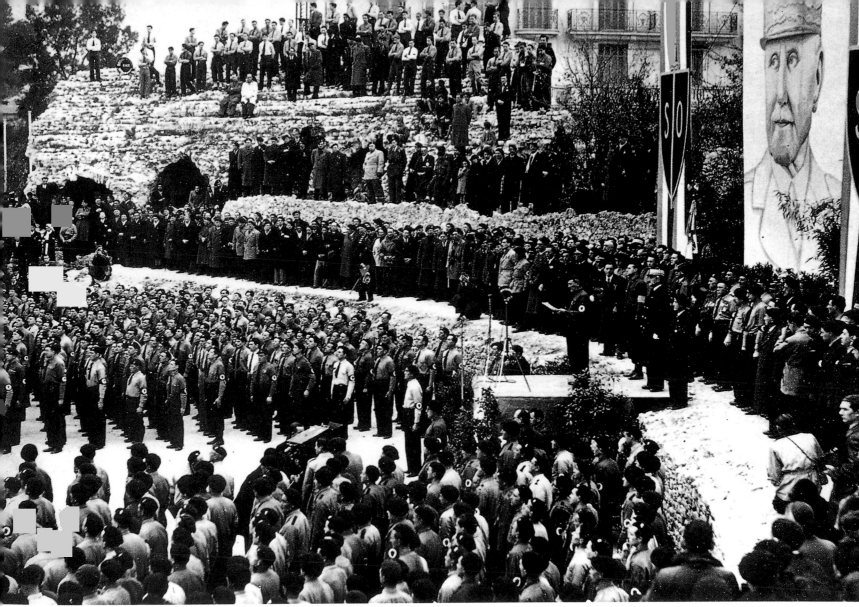

Totalitarian staging.

In occupied France, the totalitarian dream experienced only limited success; nevertheless, its effects on the population make it impossible to dismiss it. The hunt for members of the Resistance contributed to the development of this dawning movement's policing role. As Allied ships sailed toward the French coast, the French state, still in the hands of Pétain and Laval, had already become a Milice state.

above: Joseph Darnand gives a speech to the Service d'Ordre Légionnaire in the Cimiez arena in Nice.

opposite below left: Troops of the Milice train at a national school, Uriage, 1944.

opposite below right: Members of the Milice check identity papers in Savoie, January 1944.

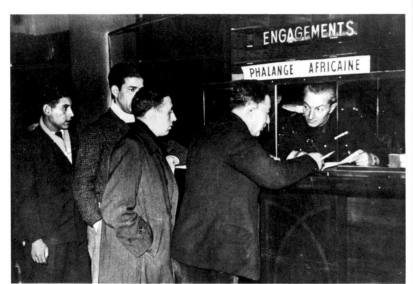

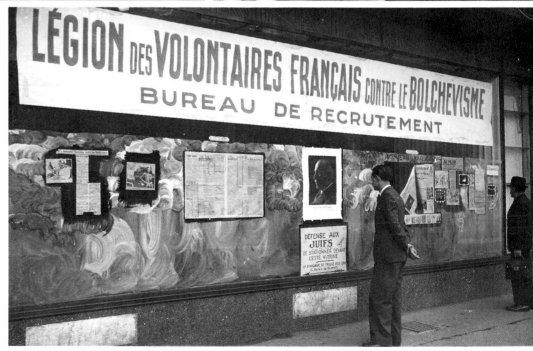

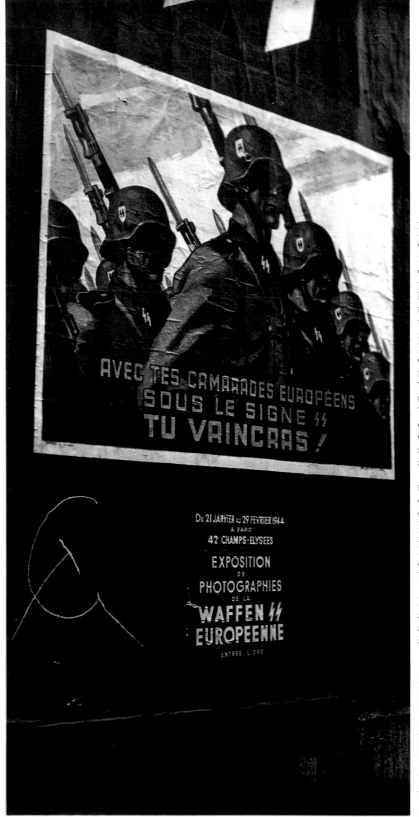

Toward the apocalypse.

After having considered (under Darlan) a military alliance with Germany, Vichy settled for authorizing individual military engagements on the edges of the Axis forces. Despite the pulsating propaganda appeals and because the Germans were so selective at first, the numbers of French who fought for the Axis powers remained low: 3,600 in 1942 for the LVF, fighting on the eastern front in German uniform, and several hundred for the Phalange Africaine who went to Tunisia. In the fall of 1944 a Brigade, then a Division Charlemagne of the Waffen-SS assembled from the remains of the LVF, the Milice, and various German armed groups that included some Frenchmen, a total of more than seven thousand.

Clearly, from their beginning all these enterprises had the more or less official sponsorship of the French government. Among other signs, Pétain himself recognized "the public usefulness" of the LVF in February 1943, and Laval signed the official authorization of individual membership in the Waffen-SS in July of the same year.

Thus, carried along by a rigorous logic initiated by the signing of the armistice, act one of the collaboration, a certain France realized its destiny in an atmosphere of apocalypse.

opposite above left: At the headquarters of the Phalange Africaine in Paris, rue Saint-Georges, November 1942.

opposite above right: French volunteers depart for the eastern front, September 1943.

opposite below: Recruitment office of the LVF, Paris, July 1941.

A poster of 1943 urges enrollment in the Waffen-SS: "With your European comrades, under the SS sign you will vanquish!"

178

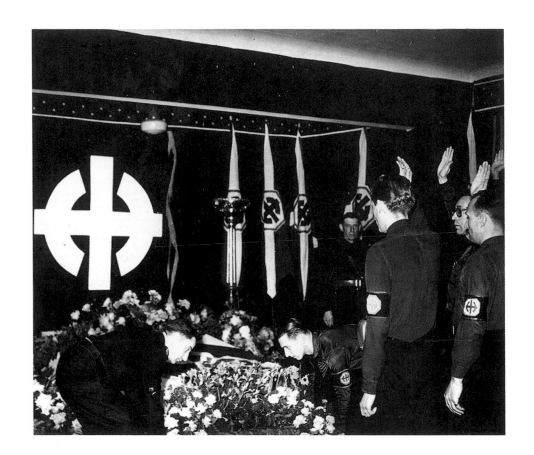

The body of a follower of Jacques Doriot felled by the Resistance is saluted, Paris, June 1944.

The People of the Underground

This metaphor comprehends all those men and women who during those dark years chose to "do something"—that is, to become involved in clandestine activity against, first, the armistice and the occupying force and, second, the French government and the collaboration. This action has most often been interpreted and exploited for partisan ends. The enemies of the Resistance have not laid down their arms but continue to thump out the old political and ideological tunes. Were they shirkers, people simply trying to evade the compulsory work program? They have been variously described as a fistful of men surrounded by fanatics, soldiers in a schoolchildren's army playing the hero, or, most often, militant revolutionaries working for a new tomorrow under the influence of the Soviet Union. At worst, they were characterized as a collection of adventurers and thugs who killed the innocent and caused hostages to be killed by firing squad. Those who glorify the Resistance as a great moment in the national conscience celebrate the men and women who knew how to say no when the traditional elites faltered and the great majority of the French took refuge in a wait-and-see policy, unquestionably ambivalent and, above all, prudent. As to the collective memory, it chooses to retain the image of the liberating French, advancing beside the Allies in the cities and villages of France, and victorious rebels mounting guard on the barricades of the Liberation. The historian must make allowances for these games and tricks of memory in studying the action of the men and women of the underground in France—the limits set here—who decided to fight against the occupying power.

These French people first had to take a decisive step; especially in the beginning, it was a risky enterprise. Their first hurdle consisted of overcoming the trauma of the unprecedented defeat, which had the effect of weakening their social frameworks and guidemarks. And, as Jean Cassou *(La mémoire courte)* wrote, in the best of cases, "everyone retreats home." The fear of tomorrows, a legalistic outlook,

and accommodation encourage leaving it all to a savior, an attitude that appeared realistic; everything, or almost everything, led to the decision to stay home. It is not surprising that many members of the Resistance belonged to minorities. Should we take literally the statement made by Emmanuel d'Astier de La Bigerie, one of the founders of the Libération Sud movement, in Marcel Ophuls's film *The Sorrow and the Pity:* "You could be a resistance fighter if you were maladjusted; we were the failures, outside organized society"? Yes and no, for if the Resistance entrained the idea of ruptures, at the same time it revived old solidarities. It is no coincidence that a certain number of militant democrat-Christians or socialists in the mold of Léon Blum soon became involved. It is true that the Résistant (Resistance worker) had to deny ordinary conformism and agree to transgress, at one moment or another, social norms and rules. He or she also had to analyze the situation in all its complexity, no longer regarding the war through the distorting prism of the mother country to realize that it was worldwide and had just begun. This is what Léon-Maurice Nordmann, who became involved in the Musée de l'Homme group, with quiet conviction, told his German judges who condemned him to death: "We risk death every day on the field of battle; I consider that we are always at war with you."

Three reasons can be distinguished, inevitably schematic in nature, that led people to engage in underground activity. First, the patriotic reflex, more or less tainted with Germanophobia. Second, anti-Nazism. The first is Christian in inspiration (it underlies the ideology of the periodical *Cahiers du Témoignage Chrétien,* which appeared in November 1941), the second relates to analyses made by the Workers International. Finally, the Jacobin variation marries struggle against the invader and desire to republicanize the republic from top to bottom. This interpretation has its own internal contradictions, however. Before finding their way to hard and fast Jacobin positions, a certain number of militants of the Parti Communiste Français (PCF) had to find their way around the Comintern's denunciation of the "imperialist war" (fall 1939, spring 1941). Other Résistants who had immediately rejected the collaboration of the French government allowed themselves to be seduced by certain themes of the National Revolution and did not disengage from Vichy until the end of 1941.

It should be noted that the Resistance in France pretty much kept its distance from the Free French until 1942. This distance

undoubtedly had to do with technical and logistic reasons but also, if not more so, from reciprocal misreading, even mistrust.

So many reasons, and so many problems to overcome, in order to set up networks and movements. Claude Bourdet, one of the founders of the Combat movement, in the southern zone, provided definitions for both and explained the distinction in his book *L'aventure incertaine:* "A network is an organization created for specific tasks, essentially, information, sabotage, also often the escape of prisoners of war and especially pilots fallen behind enemy lines. . . . A movement, on the contrary, has as its primary goal to build public awareness and organize the population in the greatest numbers possible. It also has concrete goals, of course. . . ." The networks had their moment; they have been tallied at more than 250. For our purposes, we will focus on the movements, especially those most political in character (in the broadest sense of the term). They had the immediate effect of doubling the propaganda of the German occupier as well as the passwords of the increasingly suppressed Vichy government. For this reason, a good number of movements, whether in the northern or southern zone, put out a newspaper, at first mimeographed, then printed.

The path they had to follow started, in 1940, with seeking out the like-minded; in 1941, they tentatively began organizing. In 1942, the image of the Resistance changed in the eyes of the average French citizen; while it still reeked of brimstone, it had begun to jolt the general apathy and gained credibility, so much so that the Reich experienced setbacks: a fraction of the elites who had wavered to this point finally chose the Resistance. In 1943, the establishment of the Service du Travail Obligatoire (STO) had the effect of greatly increasing the number of active fighters in the Resistance and enlarging its audience among the masses. On May 27 of that same year, the meeting of the Conseil de la Résistance (later, the Conseil National de la Résistance, or CNR) in Paris, under the leadership of Jean Moulin, demonstrated that the major movements, despite their different agendas, had become capable of banding together. The Resistance definitely remained a pluralistic and multiform phenomenon, but from then on it could be discussed in the singular.

How many people worked for the Resistance at the beginning of 1944? It is hard to give an exact figure; possibly a million, including, along with the active militants, the various sympathizers, without

whom the people of the underground would not have been able to survive (for example, the people who kept lodging houses and welcomed without a word members of the underground and those whose houses served as "mailboxes"). The anonymous Résistant (the "bunker hand of glory," as Pierre Brossolette put it) tended to be young (although he or she might also have been elderly), male (although women played an important role), and had a diversified social background (with a relative overrepresentation of workers and independent or salaried middle-class citizens).

A good number of these "bunker hands of glory" practiced a "Resistance without heroism," leading a repetitive daily life, mostly spent waiting. This did not save them from risks: denunciation, interrogations using physical force, the firing squad, or deportation to the death camps. Above all, the Resistance was a military operation. The people of the underground assuredly knew how to fight, often effectively. They were willing to do even more, but the English, for whom they served as pawns on the chessboard of important powers, did not trust them sufficiently. For this combat, although it involved fighting with arms, was above all political. Progressively, the Resistance was seen as a possible, then a desirable alternative to a politically discredited regime. Undoubtedly, those Résistants who wanted more than a simple restoration of the government in de Gaulle's hands were disappointed in the wake of the Liberation. But the action of those who decided to erase the humiliation of 1940, their engagement, which often carried with it something of a mystique (in Charles Péguy's sense of the word), could justify their continuing celebration fifty years later.

A Résistant is blindfolded for the firing squad in Vincennes.

Jean-Pierre Azéma

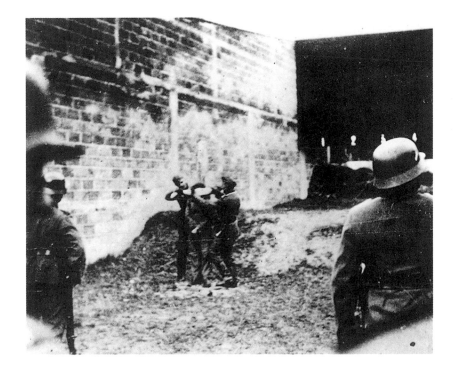

PAYSAN DE FRANCE!

Crois-tu que la destruction des récoltes, que le sabotage des machines ne te frappent pas?

Crois-tu donc que c'est l'Allemagne qui en souffrira le plus?

NE TE TROMPE PAS!

L'Allemagne a, derrière son rempart de l'Est, un territoire plus grand que l'Angleterre et la France réunies.

Ses réquisitions en France, suivant les lois de la guerre, représentent un pourcentage tellement faible de la production nationale qu'elles peuvent se réaliser malgré toute destruction et tout sabotage.

C'est le Français qui souffre de la destruction de la récolte.

La destruction du blé de France, c'est la famine pour le peuple français.

N'ES-TU PAS FRANÇAIS?

Si tes meules brûlent, paysan, ne risques-tu pas de périr avec elles?

The Resistance as seen by Vichy: resisting meant starving France.
In the fall of 1941, prefects, especially in the occupied zone, pointed out crops set on fire, for which they generally blamed the Communist Resistance. Twenty percent of French agricultural production in the occupied zone went to Germany; Résistants preyed on cultivators suspected of selling directly to the Germans or to threshing businesses. In this particular case, especially in 1943, the year these posters were published, Vichy propaganda hit the bull's eye; the great majority of peasants, whatever their feelings toward Germany, were opposed to the Resistance action.

A Vichy poster (above) uses text only to convince farmers that the French citizen would pay most for the Resistance sabotage of crops. Another (below) showed a burning grain stack and a scissors cutting a ration coupon to make the point "less grain=less bread" graphically. A third approach (opposite) showed the culprit in the act, with the simple message "the meddlers are not the ones who pay."

184

APPEL AUX TRAVAILLEURS

Une grande partie des ouvriers désignés pour aller travailler en Allemagne n'a pas répondu à la convocation d'avoir à se présenter aux bureaux d'embauche allemands et au départ des trains.

Même si la séparation paraît à beaucoup, par moments, difficile, ils devront penser à leurs compatriotes qui, par suite de la guerre, doivent vivre au loin depuis des années.

Le travail en Allemagne est-il vraiment si pénible ? Interrogez ceux qui ont travaillé en Allemagne. Ils vous diront que vous avez là-bas entière liberté, bon logement, bonne nourriture et hauts salaires.

Vous y travaillez dans les mêmes conditions que les ouvriers allemands et restez Français.

Vous n'êtes pas seul, mais rencontrez là-bas beaucoup de camarades français qui, comme vous, reçoivent le réconfort physique et moral d'organismes français. Vous conservez les relations avec votre patrie et pouvez y revenir pendant votre permission. Vous voyez et apprenez beaucoup de choses qui vous serviront dans l'avenir.

Français ! si vous êtes requis pour aller travailler en Allemagne, vous devez vous présenter, et aux offices d'embauche et au départ des trains. Ce serait injuste pour ceux qui se présentent pour aller travailler et qui partent en Allemagne, si rien n'était entrepris contre ceux qui refusent de partir. Pour cette raison, on s'est vu contraint de prendre des mesures contre ceux qui, ayant été désignés, refusent de travailler en Allemagne. On les trouvera, où qu'ils puissent être. On s'attaquera d'abord à ceux qui cherchent à influencer les ouvriers pour qu'ils ne répondent pas aux désignations.

Travailleurs désignés ! C'est pour vous garder de désagréments imminents qu'est publié ce dernier appel :

Présentez-vous immédiatement aux Offices d'embauche allemands !

Ceux qui, ayant jusqu'à présent fait défaut, se présenteront pour le départ en Allemagne à la nouvelle date qui leur sera fixée n'auront alors rien à craindre. Quant à ceux qui ne se seront pas présentés **jusqu'au 3 Mars 1943,**

ils devront s'attendre cette fois à des sanctions impitoyables !

DER FELDKOMMANDANT.

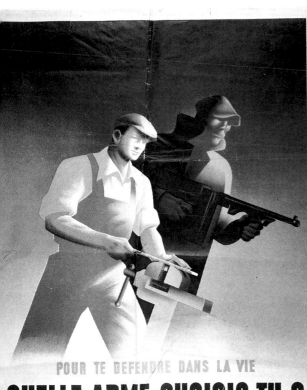

POUR TE DEFENDRE DANS LA VIE
QUELLE ARME CHOISIS-TU ?
LA MITRAILLETTE DU BANDIT
OU L'OUTIL DU TRAVAILLEUR

A poster of February 1943 (opposite), signed the "Feldkommandant," sought to persuade men who had failed to answer their conscription to work in Germany to show up or face "merciless penalties." A Vichy poster of 1944 (above) asks, "What arm will you choose? The machine gun of the outlaw or the tool of the worker?" In March 1944 (below), French and German workers were urged to unite and "work for the defense of Europe."

The Resistance as seen by Vichy: resisting meant stealing from workers.

The transfer of France's labor force to Germany, "mobilized" by Vichy starting on 4 September 1942 (as of 16 February 1943, the Service du Travail Obligatoire applied to three age groups of men), was the object of bitter negotiations between Germany and the Vichy government. More important, it proved a valuable political asset to the Resistance movements, which acted effectively to take advantage of it. Beginning in the fall of 1943, despite the dangers and risks, they managed to turn the majority of those called for the STO into rebels and transform them into soldiers of the underground. In 1944, collaborationist as well as Vichy propaganda seeking volunteers to work in Germany fell almost totally flat.

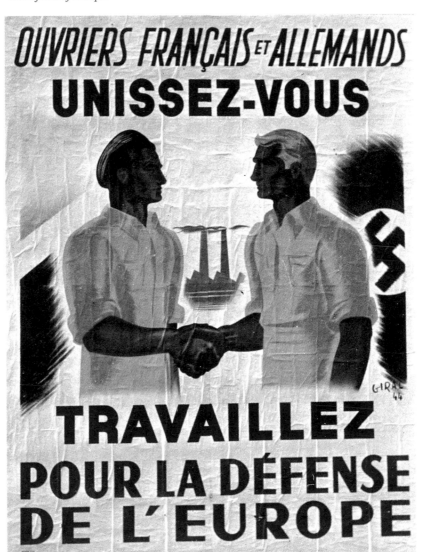

OUVRIERS FRANÇAIS ET ALLEMANDS
UNISSEZ-VOUS
GIRAL 44
TRAVAILLEZ POUR LA DÉFENSE DE L'EUROPE

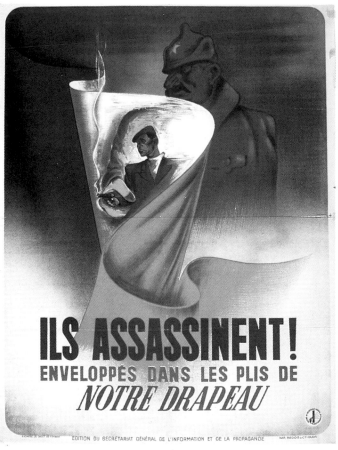

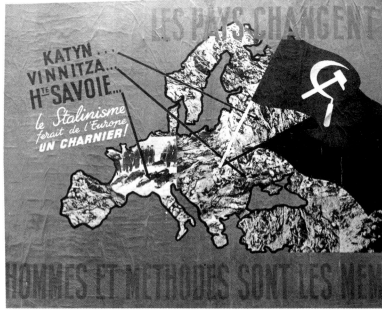

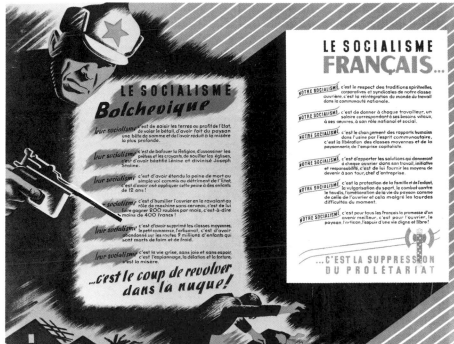

The Resistance as seen by Vichy: resisting meant killing.

Equating the Resistance with insecurity and civil war remained the most effective theme of Vichy propaganda to the end. It influenced not only Pétain's followers but also a good number of fence straddlers. In order to counter the Resistance politically and its denunciation of the state's collaboration with German demands, Vichy set to work describing the Resistance movements as well as the leader of the Free French as puppets of the Bolsheviks and international Communism. The standard reference was to the Katyn communal grave, where the Wehrmacht brought to light the decomposed bodies of 4,143 Polish officers in April 1943. They had been executed, presumably by the Soviets, with a bullet to the nape of the neck.

opposite: Three Vichy posters from 1944 carry anti-Resistance propaganda; "They kill!" asserts one published by the Ministry of Information and Propaganda (above left), while the other two refer to Katyn, claiming, "Stalinism will turn Europe into a charnel house" (above right) and "Bolshevik socialism is a revolver shot in the neck!" (below).

A group of Francs-Gardes digs up the bodies of eight policemen killed several days before the beginning of the attack of the Maquis from Glières. In his commentary on 7 March 1944, Philippe Henriot said, "No French citizen will have read without a thrill of horror of the tragic discovery made in Haute-Savoie by the forces of law and order; eight corpses killed Soviet-style, shot in the back and finished off with a bullet in the neck and found thrown together in a communal grave hastily dug by the 'patriots.'"

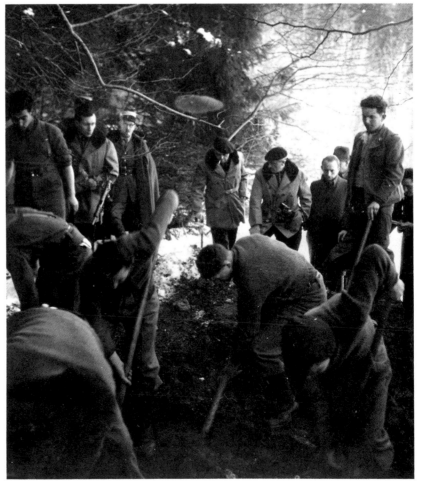

189

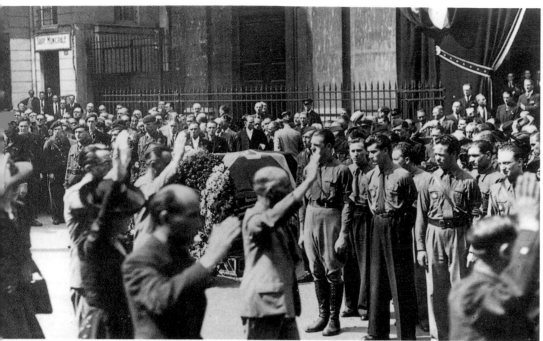

Vichy and the Résistants bury their dead.

The funeral services of the activists of the collaborationist movements, of members of the Milice, and of the forces of law and order killed by Résistants turned into imposing, solemn, and sometimes threatening demonstrations. In a provincial city, obsequies for a known Résistant could become a meeting where patriotic solidarity was openly expressed. More often, however, Résistants buried their dead without any fanfare.

above: Obsequies in front of the church in Auteuil for an activist of the Parti Populaire Français, October 1942.

below: The funeral procession for the policemen killed in Haute-Savoie, Annecy, November 1944.

opposite: The body of a member of the Forces Françaises de l'Intérieur (FFI) killed in the Pyrénées-Orientales is transported.

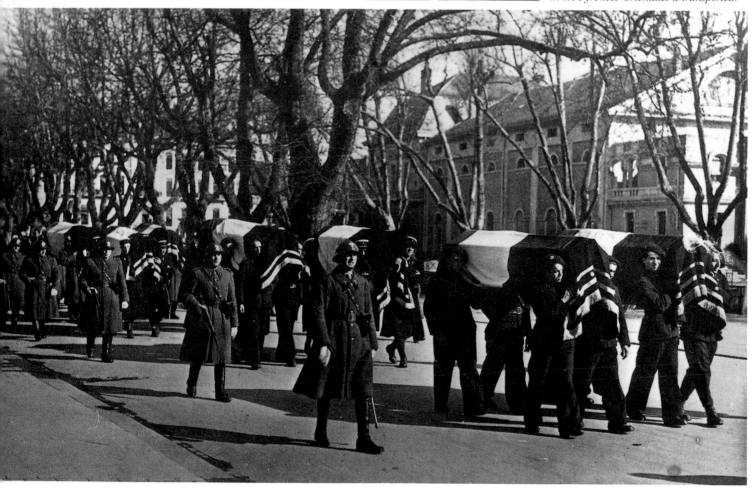

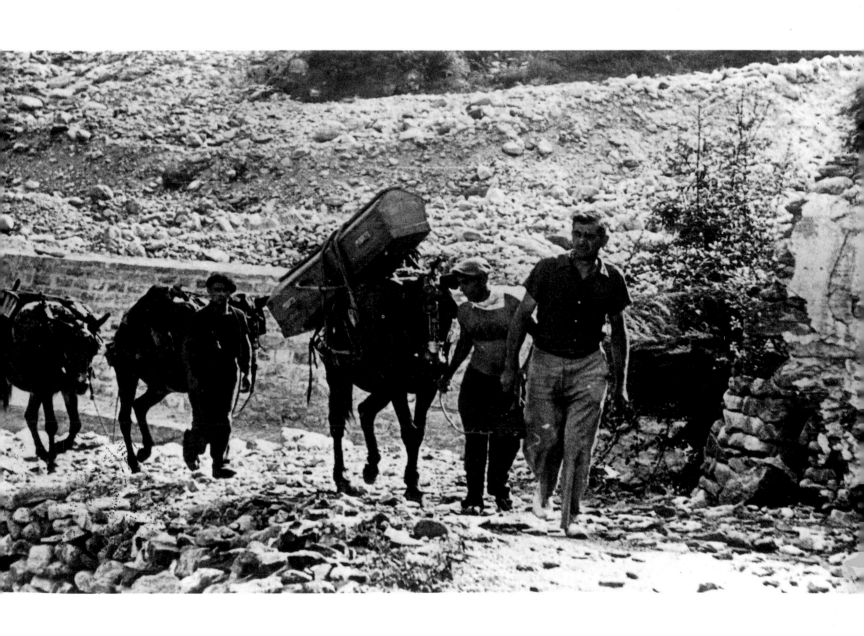

DEFENSE de la FRANCE

ÉDITION DE PARIS
30 Septembre 1943
N.39

JOURNAL FONDÉ LE 14 JUILLET 1941
TÉMOIGNAGE

« Je ne crois que les histoires dont les
témoins se feraient égorger »

PASCAL

LES DÉFENSEURS DE LA CIVILISATION...

PRISONNIERS RUSSES

Documents communiqués par un prisonnier évadé.

ENFANTS DES PAYS "PROTÉGÉS"

Photographies prises en Grèce par l'un des nôtres.

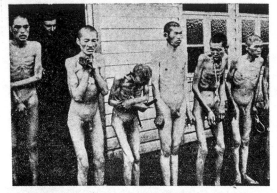

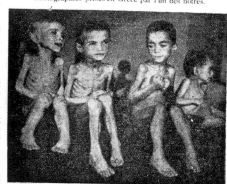

Prisonniers russes réduits par la faim à cet effroyable dénûment.

Remarquer dans l'embrasure de la porte l'Allemand qui rit.

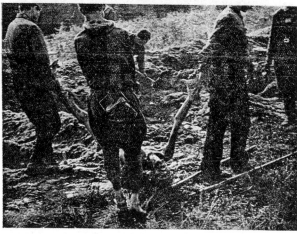

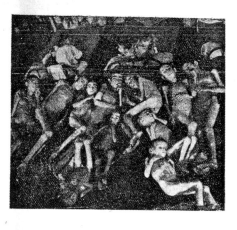

Il faut que toutes les mères de France voient où mène la "protection Allemande" Les innocents, les faibles que la force devrait abriter sont écrasés, massacrés, torturés par la force au service d'aventuriers. L'Allemagne, une fois de plus, s'est déshonorée devant le monde.

Prisonniers russes jetés à la fosse. Un de ces malheureux (Photo du dessous) **EST ENCORE VIVANT.** Sa main se crispe sur le pantalon de l'un de ses bourreaux. Remarquer l'air tranquille et indifférent des soldats Allemands accomplissant leur "tâche".

The Resistance denounces Vichy: first, inform.

Countering adverse propaganda was one of the urgent tasks set by the Resistance movements. Most of them created and distributed a "newspaper." Initially, this was a simple sheet mimeographed on both sides. After several months, the number of copies increased (in 1943, *Combat* and *Défense de la France* disseminated 150,000 copies) and the technical methods improved, as demonstrated here. The broadcasts of the BBC, Radio-Moscow, and Radio-Sottens and the use of newspapers as Allied tracts furnished an appreciable amount of information. But the movements had their own sources; the 30 September 1943 edition of *Défense de la France* published the first photographs in occupied France to give notice of Nazi barbarism.

Français de l'Afrique du Nord :

UNE grande armée américaine, escortée par des forces navales britanniques et américaines, arrive en Afrique française du Nord. Votre territoire sera la base de départ d'où nous foncerons sur l'ennemi en Europe. C'est la première étape indispensable vers la libération de la France.

Hitler, par le truchement de ses serviteurs, Laval et Darlan, a essayé de nous arrêter.

Il a échoué; il porte toute la responsabilité de cette tentative tragique.

La propagande d'Hitler et de Laval nous attribue des desseins territoriaux aux dépens de la France. Nous n'en avons aucun.

La souveraineté de la France sur les territoires français reste, et restera entière.

Nous savons que nous pouvons compter sur votre concours pour frayer le chemin qui mène à la victoire et à la paix.

Tous ensemble, on les aura !

T. 4

opposite: Défense de la France *of 30 September 1943 showed Nazi horrors.*

above: A tract issued by the Royal Air Force (RAF) paves the way for an Allied offensive based in North Africa, November 1942.

below: The Resistance newspaper Combat *of 15 October 1943.*

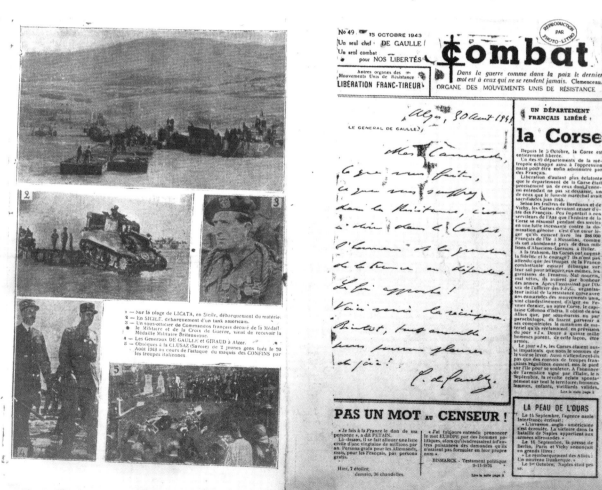

The Resistance denounces Vichy: working in Germany is treason.

The Resistance movements and the underground parties worked hard to dissuade French workers from going to Germany. Three Communist tracts illustrated this counterpropaganda. The first warns workers tempted to "volunteer" against the illusory "new order." The other two take direct aim at the Service du Travail Obligatoire. It should be noted that the risks of bombardment by English planes was genuine: they constituted the leading cause of death among the forty thousand French STO workers (hitting about one in fifteen).

A Communist tract of August 1943 (above) warns, "Don't work for Hitler, for this is what awaits you," showing the factory being bombed; another probably distributed in spring 1943 (below) declares, "Leaving [to work for Hitler] is treason"; a small poster of September 1941 (opposite) satirizes "the beauties of 'the new order.'"

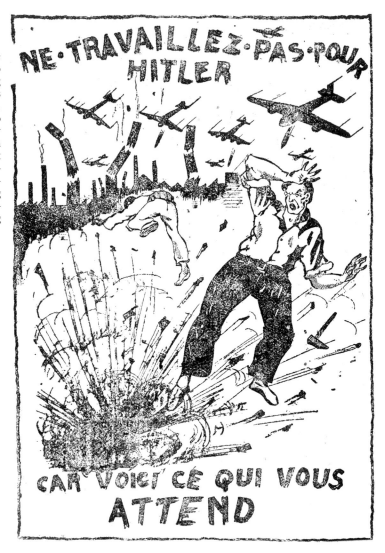

NE·TRAVAILLEZ·PAS·POUR HITLER

CAR VOICI CE QUI VOUS ATTEND

HITLER est au bout de son rouleau il a besoin d'Hommes...

LA DÉPORTATION nous menace

PAS UN HOMME pour Hitler.

Partir c'est TRAHIR.

LE PARTI COMMUNISTE.

LES BEAUTÉS...

- Mais c'est de la monnaie fondante!

L'an dernier, c'était les Stukas maintenant ce sont les Bleinheim!

- Y a pas à dire, tout est prévu même les crans à la ceinture

- Non, ma fille, ça ne doit pas être quelque chose de bien propre

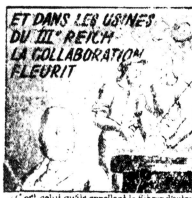

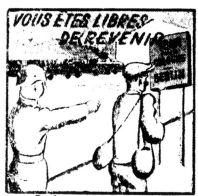

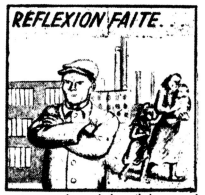

- C'est celui qu'ils appellent le führer d'entreprise
- Pourquoi ne le désignent ils pas par son vrai nom le patron?

Retournez!

qu'on nous donne du travail chez nous! Et pas pour la guerre, mais pour les besoins de la population.

...DE „L'ORDRE NOUVEAU"

Ouvriers, pour vous défendre, pour vos salaires, adhérez en masse aux syndicats!

Supplément périodique

COMBAT ILLUSTRÉ

Dans la guerre comme dans la paix, le dernier mot est à ceux qui ne se rendent jamais.

Clemenceau

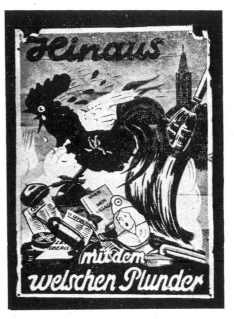

Timbre spécial pour Strasbourg
Cachet pour la création de l'Administration civile allemande en Alsace

LA KOLLABORATION
« Aux ordures tout le bric-à-brac Français »
(Affiche diffusée largement en Alsace)

LE DÉPÉCEMENT DE NOTRE FRANCE

tel que le prévoient les théoriciens, et tel qu'ils l'ont déjà amorcé.

Annexion :

« Par ce plébiscite volontaire et de caractère unique (sic) l'Alsace s'est proclamée appartenir pour toujours à la nation et au Reich allemands. »
(Discours de V. Lutze, chef des S. A. d'Alsace, le 23 mai 1941 à Strasbourg)

Colonisation :

Les nazis revendiquent le nord de la Loire comme ancien berceau germanique aujourd'hui décadent.

« Pauvre Bourgogne . . .

« . . . nous voyons son fier passé germanique qui constitue certainement une part de notre histoire germanique bien à nous.

. . . Et aujourd'hui, en Bourgogne, les Allemands se trouvent de nouveau sur un vieux sol germanique, eux, les soldats du nouvel âge germanique.

. . . Ce qui jadis est tombé en ruines renaît plus grand et plus puissant que jamais et nous aidons à le construire : l'Empire Germanique de Nation Allemande ». (Schwarze Korps, organe officiel de S.S., 27 mars 1941)

Kollaborer, c'est être roulé.

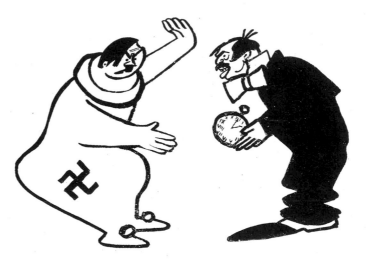

DONNANT, DONNANT.

Hitler : - *Donné-moi ta montre, je te donnerai l'heure.*

La Mésaventure de [Cé]stin Tournevis

... la véridique histoire de Célestin Tournevis, « pionnier de la relève », et de sa ...
... Ouvriers français, mes camarades, méditez-la !

Le traître Laval [li]vreau Hitler les [ouvrie]rs l'Allemagne, [usin]es et comme ...

Depuis des mois tout avait augmenté.... sauf la paye. Laval a fermé les usines. Pauvre Célestin Tournevis ! Pas un sou en poche, et le chômage.

Marianne est sous la botte et la schlague boches. Le gouvernement interdit à Tournevis de se faire réembaucher en France. De belles affiches payées très cher l'invitent au grand voyage.

Malgré l'avis des « RÉSISTANTS » et les consignes de COMBAT Célestin Tournevis part, pour la relève. Le bruit des rails lui murmure un refrain qu'il ne comprend pas bien encore... Mais bientôt son enthousiasme fond sous les bombes de la R.A.F. qui n'épargnent pas les convois d'esclaves.

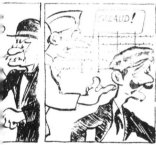 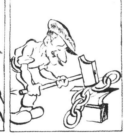

... être fêté [p]uoi ? Les [l']index ce [ou]r la guer[re fils] en ...a gueule.

Les prisonniers rencontrés dans les komandos ne cachent pas leur façon de penser à celui qui pactise avec leurs geôliers et retarde la date de la vraie libération.

Pauvre Célestin Tournevis ! Il ne comprend plus rien à rien. Les mandats ? Ses marks lui suffisent à peine pour vivre. La relève ? Un train d'éclopés qui, en trois mois, est rentré en France.

Dix et douze heures par jour parfois même le dimanche (où sont tes 40 heures, Célestin Tournevis ?), Tournevis, morne, forge sa chaîne qui le retiendra là-bas.

Et puis pas même une chambre à soi; des dortoirs, comme au régiment. On bouffe des clous. Qui donc se tape tout le beurre qu'ils nous volent en France ? Hitler et sa clique, tiens, grand nigaud.

 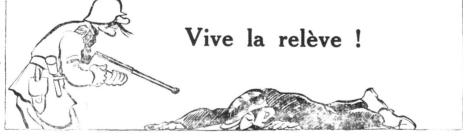

Vive la relève !

[m]entir (Tiens, [n]e pas leur en [t]anks et des [dé]cisifs le [...]ico.

Mais petit à petit, Célestin Tournevis comprend. Il comprend la trahison dont il a été victime, l'odieux travail auquel on le rive et qui doit assurer la domination nazie. Alors, insensiblement, il ralentit sa production, il travaille moins bien, il laisse des pailles dans les soudures. Un jour il a dit Merde au contremaître... Pauvre Célestin Tournevis ! Cela n'a pas été long. Le garde-chiourme de service a vite « réglé » à sa manière le petit métallo français qui ne comprenait rien à la relève.

The Resistance denounces Vichy: collaborating means being duped.

This special illustrated issue of *Combat*, which appeared in the summer of 1942, represented Laval as Maître Jacques in a collaboration that the great majority of French people summed up in the joke, "Give me your watch, I'll give you the time." The title of the cartoon announces, "Kollaborating means being duped." The collaboration of the government seemed increasingly to work in one direction only, for the benefit of the Reich. On the other side of the sheet, a comic strip takes potshots at the Relève, using the character of Célestin Tournevis, established some time previously by the Vichy and German propaganda services to induce French workers to "volunteer" to work in Germany.

Le 20 Septembre 1941
11.30

Monsieur le Bâtonnier,

Je viens d'arriver du Camp de Royallieu, avec nos confrère Pitard et Rolnikas, au quartier Allemand de la Prison de la Santé.

Un officier nous a notifié que par ordre de l'autorité supérieure nous serons fusillés ce matin comme otages.

Nous avons protesté, mais vainement.

Nous allons à la mort satisfaits d'avoir, en toutes circonstances accompli notre devoir, tout notre devoir.

Nous sommes frappés par la fatalité, et la fatalité est, hélas, injuste.

Nous mourons prématurément, mais c'est pour la France. Nous en sommes fiers.

En vous adressant ce mot, je dis adieu à une profession que j'ai aimée; j'aurai été, jusqu'à la fin, le défenseur de la dignité humaine et de la vérité. Je vous prie d'agréer, Monsieur le Bâtonnier, l'expression de mes sentiments respectueux et dévoués.

Antoine Hajje

Dying with head high.

As of June 1940, the German military tribunals pronounced the death sentence for anyone accused of threatening the security of the Wehrmacht. A year later, trying to check the series of attempts on the lives of German army personnel, General Otto von Stülpnagel, Militärbefehlshaber in Frankreich, published the "hostage regulation" on 22 August 1941 and then, in September, the "hostage code," granting the occupying power the right to take into their custody detainees "because of Communist or anarchist activities." Thus, Antoine Hajje, a thirty-seven-year-old Communist lawyer, was executed on 20 September by firing squad with eleven other hostages. He had been arrested by the French police on 25 June 1941 and "placed at the disposition of the German Authorities" on 19 September. Many Résistants, before being executed, had to undergo the abominable trial of interrogation; this happened notably at 11, rue des Saussaies, in Paris, one of the headquarters of the Gestapo, the German secret police.

left: Antoine Hajje's last letter.

right: Gustave Bourreau and Billon were executed by firing squad on 29 November 1941 at La Rochelle; they were accused of having stolen German arms.

opposite: Inscriptions found on the "prison" walls at 11, rue des Saussaies, Paris.

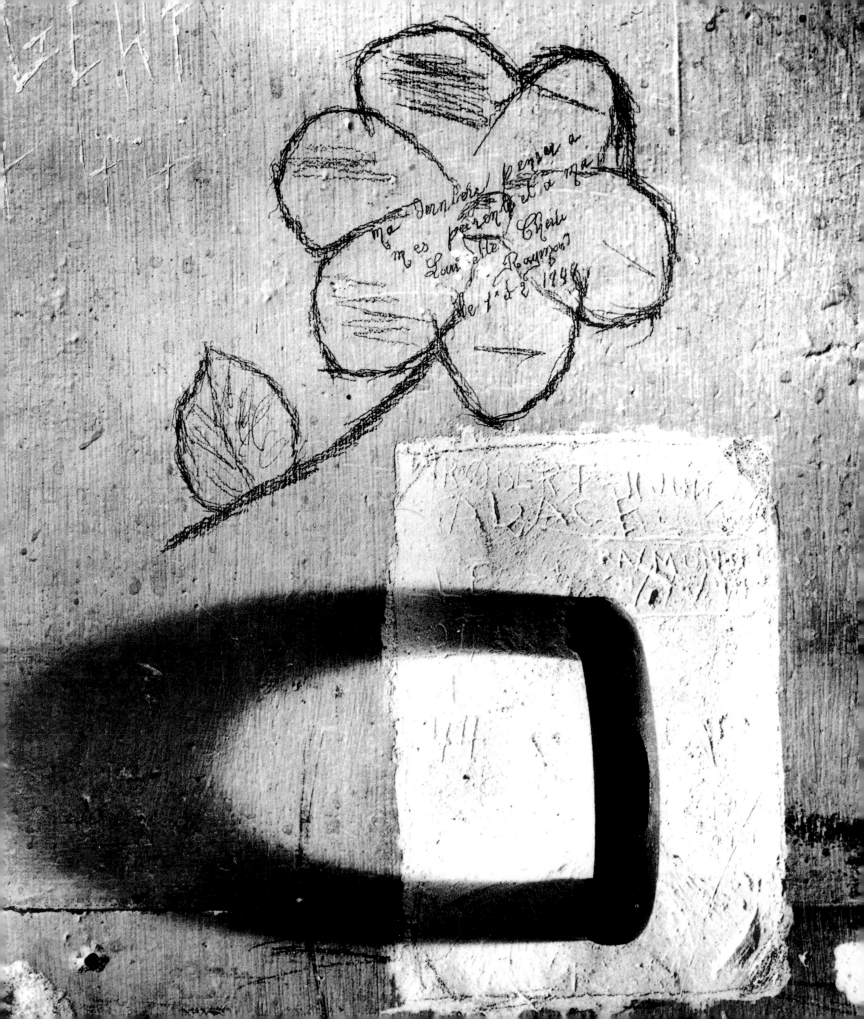

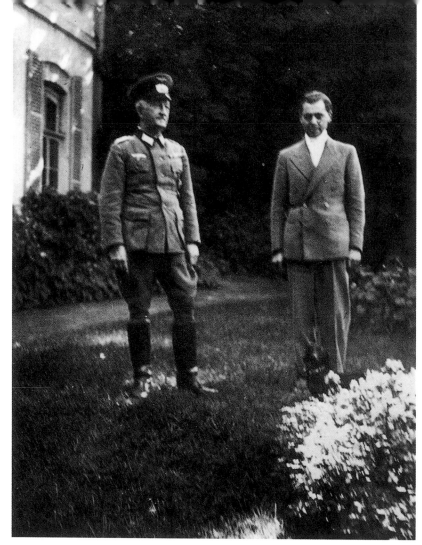

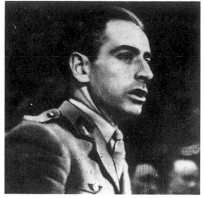

Heroes of the Resistance.

To symbolize the sacrifice of all the captured and tortured Résistants, the names of two men and two women who died during the dark years are presented here. Jean Moulin, before becoming Charles de Gaulle's delegate in occupied France and founder of the Conseil National de la Résistance, was prefect of Eure-et-Loir Department. He remained at his post during the debacle of the defeat in 1940 and chose, during the night of 17 and 18 June 1940, to cut his throat rather than sign a text dishonoring the French army. Danielle Casanova, a dental surgeon, was an activist beyond comparison, a member of the Comité Central Clandestin, where she was responsible for the youth section and women Communists. She was caught in March 1942 and died in Auschwitz on 10 May 1943. Pierre Brossolette, a graduate of l'Ecole Normale Supérieure and a brilliant historian and journalist, went to London in April 1942 and became one of the political brains of the central office of information and action. Arrested in Bretagne in February 1944, he elected to jump from 86, avenue Foch, on 22 March, to avoid speaking under torture. Berthie Albrecht, an exceptional woman who despite her personal fortune became a social worker, energized the movement Combat from the beginning and gave of herself unstintingly. She very likely killed herself after falling into a trap in May 1943.

above left: Jean Moulin (1899–1943), shown in Chartres in August 1940; his scarf hides the wound to his throat.

above right: Pierre Brossolette (1903–1944).

below: Danielle Casanova (1909–1943).

opposite: Berthie Albrecht (1893–1943).

7 Juin 43

Décès 131

Ecrou

Fosse 341

Halbrech Berthe

95

Bulletin de décès AA

De la Nu Halbrech Berthe née
Wild le 15-2-1893 à Marseille

Condamnée par Autorité Allemande

Décédé cause inconnue
quartier allemand —

Inhumé au cimetière de l'établissement
le 7 Juin 1943 en presence de M. l'Aumonier
sans famille

Le surf chef Le greffier Comptable

Moving to action.

Sabotage was a favored action of the Résistants. In June 1940 Etienne Achavanne, acting independently, sabotaged the telephone lines of a camp near Rouen where Luftwaffe war machinery had been stored. Arrested, he was killed by firing squad in July 1940. Throughout the occupation, railroad tracks often served as a target; in 1944 the German trains did not even venture on the secondary lines. The Resistance networks and movements both sent a great deal of information to London. The British increased their bombing raids, in theory aiming at military targets but unfortunately occasionally causing heavy civilian casualties; in effect, the Allies placed only a limited trust in the Résistants. Nonetheless, the Forces Françaises de l'Intérieur (FFI) scrupulously carried out Plan Green (sabotage of railroad tracks), as well as Plan Purple (the cutting of telephone lines) and Plan Blue (destruction of high-tension power lines)

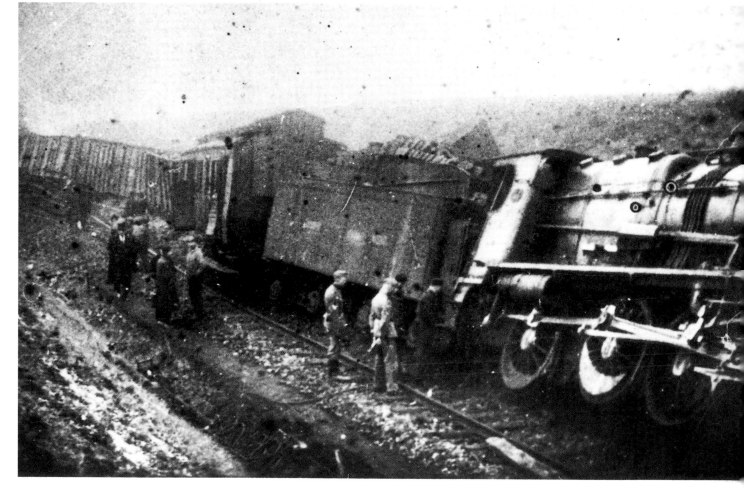

in the opening hours of Operation Overlord, thus slowing the arrival of German reinforcements.

opposite above: A conductorless train was started on a branch of the Besançon-Belfort line on 23 May 1944. It derailed in a village near Montbéliard.

opposite below: A train sabotaged near Lens (Pas-de-Calais) in March 1942.

above: This map of an airport near Angers was sent to the central office of information and action in London by the information service of the Francs-Tireurs et Partisans Français (FTP) at the end of 1942.

below: A poster put up in Sceaux in November 1940, signed by the mayor, informs the populace that if the acts of sabotage did not stop and those responsible arrested, the "entire population would suffer the consequences."

MAIRIE DE SCEAUX

AVIS TRÈS IMPORTANT

Le Maire informe la population que des **ACTES DE SABOTAGE** ont été à nouveau commis sur des installations téléphoniques de l'Armée d'occupation.

L'Autorité Allemande a bien voulu excuser ce nouvel incident, mais a précisé qu'en cas de renouvellement de ces faits regrettables des **sanctions extrêmement graves** seront **infligées à leurs auteurs**, et que faute de connaître ceux-ci la **population toute entière en subirait les conséquences.**

L'exemple dernier a été suffisant et la moindre sanction prévue dorénavant serait la **garde cotinuelle de toute l'installation téléphonique** en cause.

SCEAUX, le 24 Novembre 1940
Le Maire,
A. DEÍLLION

Imp. A. ROZE - 74, Grande-Rue - Bourg-la-Reine - Tél. 344

Feuille jointe aux photographies concernant l'explosion du quartier DE BONNE (2 décembre 1943)

schéma :

-1/9.2.44

a) zone complètement rasée par l'explosion
b) principaux batiments pour la troupe
c)
e) maison du peuple (cantonnement)
d) poste de transformation électrique

La photo (1) a été prise de l'immeuble A
Les photos (2,3,4,5) ont été prises de l'immeuble B
(6,7) " " " " C

Les photos 2 et 3 peuvent être accollées suivant les flèches pour donner une idée de l'ensemble de la caserne.

GRENOBLE.29.12.43.Valeur A - source : 248
Les allemands ont envisagé récemment de réduire les "maquis" du Jura. Ils ont étudié les moyens à mettre en oeuvre dans ce but et les ont évalués à 2 divisions. Devant ce résultat, ils ont renoncé pour l'instant à l'opération.

Autumn heat in Grenoble.
In November and December 1943, Grenoble experienced devastating and glorious moments. On 11 November, the Germans arrested hundreds of inhabitants demonstrating at the monument erected to the "Blue Devils," and they deported 450 of them. In response, the Corps Francs des Mouvements Unis de Résistance blew up the German ammunition dump. The Gestapo executed a new set of hostages. With the help of a Polish soldier in the Wehrmacht named Kospiski, the Résistance then attacked the Bonne barracks in Grenoble, killing about fifty Germans and destroying about a hundred tons of munitions. A detailed report of the operation, complete with photographs, went to London on 30 December 1943. On 4 March 1944, the BBC devoted its evening program *The French Speak to the French* to Grenoble.

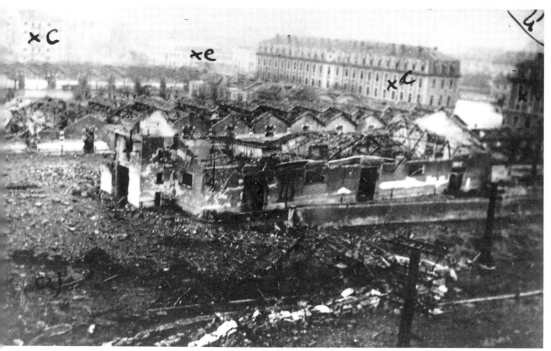

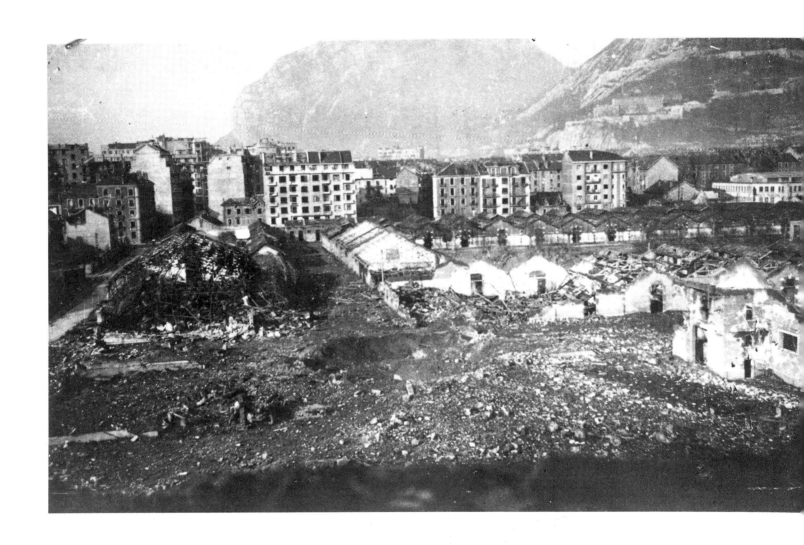

opposite: A map and photographs of the Bonne neighborhood attached to the report on the attack on the Bonne munitions barracks sent to London, December 1943.

The Bonne barracks after the explosion, December 1943.

To occupy the towns or not?

The town of Oyonnax was occupied for several hours, symbolically, on 11 November 1943 by the forces of the Ain Maquis, under the command of Henri Romans-Petit. With the French flag leading the procession and honor guard in white gloves, the Maquisards marched to the war memorial and placed on it a wreath in the form of the Croix de Lorraine, carrying this inscription: "The Conquerors of Tomorrow to Those of 14–18." A press photographer captured the moment. In December, the underground press devoted much space to this "historic day," and on 9 February 1944, the BBC devoted its evening program *The French Speak to the French* to the event—an example of a brief symbolic action.

Other actions, aimed at liberating towns, in retrospect seem premature: for example, Tulle. The town, occupied by Résistants, was retaken by members of the "Das Reich" Waffen-SS division. On 9 June 1944, they hanged 99 hostages from trees, from balconies, from streetlights, creating a particularly nightmarish scene. Another 149 were sent to the death camps. Nonetheless, it was part of the Resistance's mission to lead the French people to participate actively in their liberation.

Members of the Ain Maquis lead a procession through Oyonnax, 11 November 1943 (photo: A. Jacquelin).

opposite: This photograph, showing French hostages hanged in Tulle on 9 June 1944, was found on a German prisoner after the liberation of Tulle.

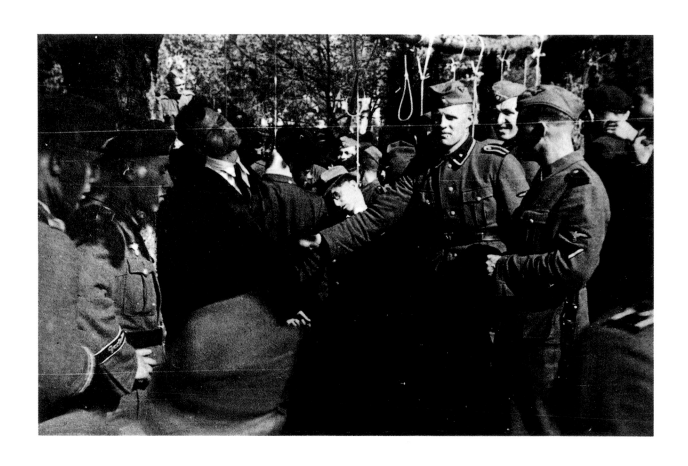

The long march of the Maquis.

The Maquis got its name from the scrubland in which those fleeing the forced conscription of the Relève decreed on 4 September 1942 took refuge. A new generation of Maquisards emerged a year later, after the Resistance movements transformed a certain number of these "dodgers" into fighters, thus considerably enlarging the activist base of the Resistance. The conditions of life for the Maquisards remained precarious; weapons were scarce, and in order to eat they had to win the trust of suspicious peasants. On top of that, security regulations kept them on the move; Maquisards who stayed too long in one place became easy targets for the Germans.

Maquisards take refuge in the Morin sheepfold in Taulignan (Drôme; below), eating their lunch nearby (above). They could not stay for long and were soon on the move (opposite) (photos: M. J. Mayer).

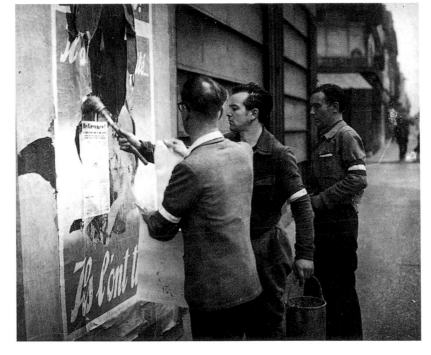

On 19 August 1944, the FFI pasted a tract head-
ed "Deliverance!" on a poster placed at the end
of June to denounce the assassination of
Philippe Henriot.

War of Images, War of Symbols

Between 1940 and 1944, the French were at war with one another. This war was waged with more than weapons: it was also a battle of words, of ideas, of feelings, and of images. Each of the camps faced off over a sizable stake: winning public opinion.

The occupying power cherished the same ambition. If the Germans sometimes tried to woo the French to their side, militarily and politically, more often they sought to discourage and neutralize any impulse toward rebellion by pointing to their "true" enemies "solely" responsible for all their woes: Great Britain, Jews, and Bolshevism.

In their propaganda, the Vichy authorities exploited the same targets, which they set within the context of all their various themes. In order to achieve their goal—to legitimize their government—they had to annihilate all influences over the French people that would deny it. In this respect, the Resistance was the principal enemy they had to discredit. First of all, they had to justify the armistice and the regime's friendly attitude toward the occupying power. The image of Pétain proved extremely effective for this purpose. "Are you more French than he?" a poster presenting the marshal's distinguished portrait asks of the passerby. Vichy's entire character and the justification for Pétainism reside in this question: by denying anyone else the right to give lessons on patriotism to this man who had defeated the Germans at Verdun, the authorities invoked trust in the word of the most French of the French when he affirmed that only one path was possible, that of collaboration with the Reich. It is this reference to memory and to victory in the previous war, even more explicit in the song "Maréchal, nous voilà!" that gave this message its weight, that implanted the identification between Pétain and France, that consecrated the legitimacy of he who twice "saved" his country, in 1916 and in 1940, that, finally, reduced the underground fighters and those of London to the status of rebels and usurpers. A comparable poster in

any other country under Nazi subjugation would be unthinkable. The question, "Are you more Norwegian than he?" under a portrait of Vidkun Abraham Quisling would make no sense. The name of this Nazi, without past and without glory, who ruled his land under the protection of the Nazis while the royal family lived in exile in London, quickly became synonymous with treason in all of occupied Europe.

If Vichy's goal was to make a convincing case for its legitimacy, that of the Resistance was to prove it actually existed. At the beginning of the occupation, patriots lacked the means to demonstrate their existence, except for graffiti they managed to place over German posters. From 1940, they led a veritable guerrilla war on the walls of Paris. The Prefecture of Police found it necessary to respond with a threatening notice: ". . . tearing and damaging posters of the occupying Authority will be considered an act of sabotage and punished by the most severe penalties." It clearly had little effect, as this form of combat only intensified. The best-known campaign was known as V, begun by the Belgians on the BBC; on 14 January 1941, they asked their fellow citizens to cover their country with a forest of Vs, a letter they chose because it was the first letter of both the French word *victoire* (victory) and the Flemish word *vrijheid* (freedom). In light of its success, the French section of the BBC began its own V campaign on 22 March. The letters proliferated in Paris, in Marseilles, and in fifteen or so other cities, especially in lower and high schools. After the movement overtook half of Europe, Joseph Goebbels, German minister of propaganda, decided to appropriate the sign for the Reich in July, using it to glorify German victories in Russia.

The example of the V campaign has another notable aspect; besides constituting an episode in the battle of the walls, it proved significant in the battle of the airwaves, demonstrating that the BBC had a large audience on the Continent. This was important for the Free French, as the radio remained the only link between the French in London and the French in France. It thus became the principal field of action of the Resistance outside France, as well as an essential means of information for the Resistance within.

The propaganda of all the camps was not limited to current events; it also made an appeal to collective memory and drew on the history of themes that justified the cause it aimed to serve. As noted, the glorious career of Marshal Pétain during World War I surfaced repeatedly in Vichy's propaganda. But it also went back further in time

to establish the regime's legitimacy, back to the ancient Gaul of Vercingetorix; the second anniversary of the Légion Française des Combattants at the end of August 1942 was celebrated on the site of Gergovie, where the militants of each French province and each territory of the empire brought a portion of their earth, in the presence of Pétain, a symbolic way of "reconstituting French unity." Vichy also borrowed the ancient battle-ax of the Franks as an emblem of the state. For heroes, it most often referred to the kings of France and their attendants. Thus Pétain, the man who wanted to reconstruct the country, was naturally presented as the successor of these great builders of France. In this area, the war of images cast a wide net, for the Resistance mined the French Revolution for the identifying myth to legitimate its combat against both the invaders and Vichy: the gathering of volunteers, the call to arms, the leap of the great nation against the enemy as well as the double defense of the fatherland and the republic. When the first is invaded the second is threatened, as in 1792–93—indeed, in 1940, assassinated and replaced by the French state.

Beyond this war of symbols that unfolded in the framework of the Franco-French confrontation, the two camps also invoked an involuntary community of feelings. The heroes of Vichy (Saint Louis, Joan of Arc, Seigneur de Bayard, and Henri IV) are the same as those that the Third Republic had honored in the schoolbooks of its free and compulsory secular school. The two regimes born of defeat shared certain attitudes. Very significant in this respect is the cult of Joan of Arc, the most claimed of French heroines.

Joan's iconography, established in the nineteenth century, of armor, sword, and standard evolved largely from the disastrous Franco-Prussian War of 1870–71. From that moment, Joan of Arc represented the incarnation of the wounded country and revenge. But there were different versions of Joan; two or three images, sometimes complementary, sometimes concurrent, prevailed: the saint and the patriot always, the daughter of the people sometimes. The leftist republican and radical preferred the second and third; the rightist favored the first while honoring the second. The number of representations of Joan of Arc grew between 1914 and 1918 to reach its high point in 1920, at the time of her canonization. However, during the 1920s, she symbolized the reconciliation and sacred union of the French, who, Catholic or republican, fought side by side. Since all

could find in her what suited them, she united rather than divided.

During the 1930s a differentiation appeared more clearly: slighted by the left, Joan was monopolized by the right. This differentiation turned into opposition and the object of adverse propaganda in 1940 through 1944. The Joan of reconciliation turned into the Joans of civil war. The Vichy regime glorified not Joan the warrior but Joan the saint, Joan the Catholic, symbol of a France regenerated through the National Revolution. When she took up arms, she defended the Church and the values it represented. Often she was depicted unarmed, her purpose not to fight the present occupier but to denounce the British, the occupier of the past. The Joan of Arc of the collaborationists and of German propaganda clearly took the resuscitated anti-British theme even further (for a long time, it had disappeared from her imagery). The bombing raids of the British made them hope to mobilize the emotion of public opinion against perfidious Albion, using Joan as the intermediary.

The Resistance also invoked Joan, but Joan the patriot, the warrior, the one who wanted to drive from France not the long-absent British but the Nazi occupier. Even the Communists made use of her. They revived the image that the radicals and anticlerics of the end of the nineteenth century had grown fond of, that of the daughter of the people, "the peasant girl from Domrémy" who was burned at the stake for having wanted to rescue her country, after being judged and delivered by Pierre Cauchon, "the bishop-collaborator" of the period. Ten years later, in May 1953 and 1954, the Communist organ *L'Humanité* would celebrate her in the same spirit, identifying her cult with the memory of Danielle Casanova, a Communist martyr who died after being deported in May 1943.

With propagandists of every stripe, "a certain idea" of French might emerges. All these references to history, however antagonistic in nature, take up the same compensating quest for a glorious past in the aftermath of defeat. For this reason, the colonial period was specifically invoked as much by Vichy as by London or Algiers. The historian Charles-Robert Ageron showed how the imperial myth also functioned after 1940 as a myth of compensation, which the French could cling to at the moment when their other bases of power were crumbling. The desire to restore France's position emerges from both French camps, the ones seeing this goal in the framework of "the new Europe," a Hitlerian Europe, the others hoping to attain it beside the

Allies, but both seeing in the empire the best means to arrive at their goal. Thus, it should not be surprising if Pierre Brazza and Hubert Lyautey, names related to the empire celebrated by Vichy propaganda, were also glorified in the speech given by General Charles de Gaulle in Brazzaville at the end of January 1944.

There was another way to play on the collective memory of the French: the use of commemorations. Unlike the simple historic evocation—that is, simple reminding—commemoration has as its function rousing public participation on a given anniversary for the celebration of a particular event, placing in perspective three inseparable elements: the past (the event commemorated), the present (that of the ceremony), and the future (the lesson of the past or the message it is desired to formulate for the future). Moreover, commemorations are already in ordinary times a demonstration, an action, the beginning of engagement. Carrying heavy weights in those unhappy times, they became important vehicles for propaganda.

May Day is not, properly speaking, a commemoration; who remembers or takes the trouble to bring up the founding event, the demonstration put down with blood in Chicago's Haymarket Square on 1 May 1886? Since the end of the nineteenth century, it was considered a demonstration of the international solidarity of workers, who in every Western country go on strike on that day. In occupied France, it was obviously celebrated in contradictory fashion by Vichy and the Resistance. Whereas the Communist Résistants continued to see May Day as a day of struggle, Marshal Pétain transformed it into a unifying celebration that spotlighted one of the fundamental values of the National Revolution: work. In the same spirit, his regime instituted Mother's Day. After Work, the Family was honored. But what of the Fatherland?

It is highly important to state that for this fatherland so glorified by Vichy, a single day in the year could not be found to celebrate it. July 14? Impossible, too republican; the Resistance, internal and external, had a stronghold on it. General de Gaulle took advantage of this anniversary to reconstitute a favorable image of France, so that the French would no longer have reason to blush, the image of an exciting, fighting France that was incarnated in the soldiers of the French Revolution and carried on by the soldiers of Philippe Leclerc and Pierre Koenig and in the soldiers of the underground. "'La Marseillaise,' it's fierceness," he declared on 13 July 1942. November

11? A celebration forbidden by the occupying power and thus taboo for Vichy, depriving the victor of Verdun of his day of glory. Pétain no longer had any soldiers to commemorate it with. He had left to him only his natural clientele, the veterans, with whom he shared many events that somehow never made it onto the commemorative calendar. Thus, it served only the actors, not the general public. The Resistance, however, turned the day of the 1918 armistice into a key date for commemoration-action. On 11 November 1943, the Maquis took over the town of Oyonnax for several hours to lay a wreath at the war memorial, with the following inscription: "The Conquerors of Tomorrow to Those of 14–18." More than simply carrying off a victory, however brief, over the Germans, they beat Pétain on his own turf, for they succeeded in bringing the two generations under fire into communion with a hope—thus, a project for the future, the true purpose of a commemoration.

"Are you more French than he?" is truly a question of extraordinary force, yet, a simple evocation of a memory, a simple "reminder," it refers only to the past glory of a man of the past, without ceremony or communion, without a public, without an explicit outlet to a global vision of the future. It certainly brings up the issue of a regenerated France, but Vichy, unlike the collaborationists, dared not own up to that international framework. It is surely this inability to commemorate that demonstrates the garbled nature of Vichy's message. In this sense, Vichy lost the war of images and commemorations, and thus the battle of public opinion, well before it lost the war.

Robert Frank

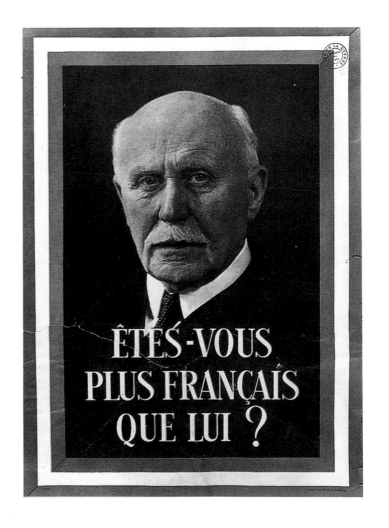

ÊTES-VOUS PLUS FRANÇAIS QUE LUI ?

Guerrilla warfare on the walls: the V campaign of 1941.

In 1940, patriots damaged German and Vichy posters. Starting in 1941, they went further, using them as the basis for counterpropaganda. Enemy posters began to sport the double-barred cross of Lorraine, Gaullist slogans, and the V for victory in order to neutralize the Vichy or Nazi messages. (On 5 April 1941, the Prefecture of Police recorded 6,400 such inscriptions.) The poster showing Pétain appealing for assistance for the Secours National and the highly anti-Semitic poster calling on the French people to save France from the "Jewish vulture" exhibit both symbols.

The V campaign of the Resistance, launched in Belgium in January 1941, overtook France in March. As it doubled in intensity for Bastille Day, the Germans decided to appropriate the V and use it against their adversaries. Replacing their word *Sieg* (victory) with the Latin term *Victoria*, they made posters celebrating their overwhelming victories against "Bolshevism" in the early days of their Russian campaign. To each a V in 1941: for one, a frail, hypothetical V full of hope; for the other, a triumphant, insolent, and highly menacing V.

218

above: An anti-Semitic poster published by the Institut d'Etudes des Questions Juives in the spring of 1941, placed in most of the French subway stations, was garnished with three crosses of Lorraine and a V.

below: A poster featuring Pétain situated under the aboveground subway in Paris, 1941.

opposite: The German response in a poster of 1941 heralds the "triumph of Germany which fights for a new Europe."

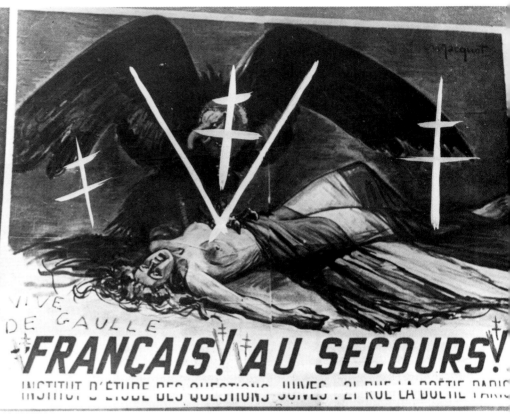

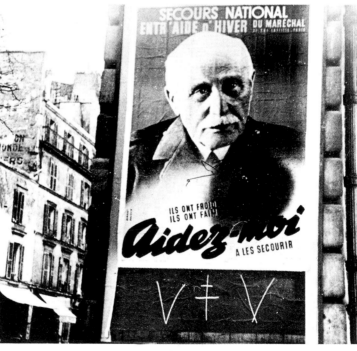

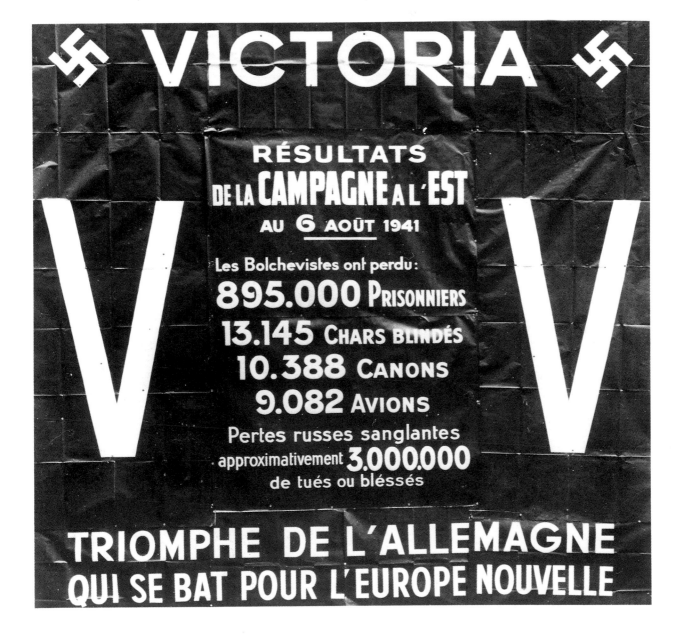

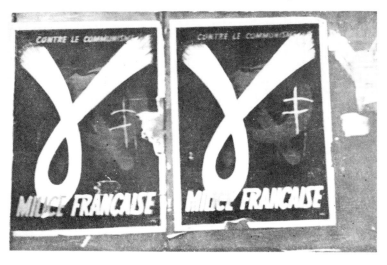

Guerrilla warfare on the walls: the graffiti of refusal.

Résistants and their sympathizers used walls to express their rejection of Vichy's policies, and *Cahiers Français* echoed the graffiti in its pages, drawing a cross of Lorraine on posters for the Milice next to the emblem chosen by the Milice, the Greek letter gamma, symbol of a "charging and headstrong ram." Laval became their favorite target when he regained control of the government in April 1942, especially after he made the infamous statement on 22 June, the anniversary of the invasion of the Soviet Union, "I hope victory goes to the Germans, because without them, Bolshevism would be everywhere." His "treason" was denounced on the walls: in artisanal fashion, with the "Laval to the firing post" emblem, and industrially, with stickers made in London and disseminated in France starting in the summer of 1942, which used the letters of his name to compose a swastika.

The play on letters was also employed against the Germans, in the consummate art of counterpropaganda: the appropriation of the poster to turn the meaning around.

Two pages of November 1943 and April 1944 from Cahiers Français, *a news periodical distributed in London by the Comité Français de Libération Nationale (Information Mission). The page opposite shows "a poster placed by the Germans in France" above and "the same poster 'corrected' by the French" below, which changed the message from "If you want France to go on, you will fight in the Waffen-SS against Bolshevism" to "If you want France to go on, you will fight against the Boche."*

UNE REPONSE BIEN FRANÇAISE

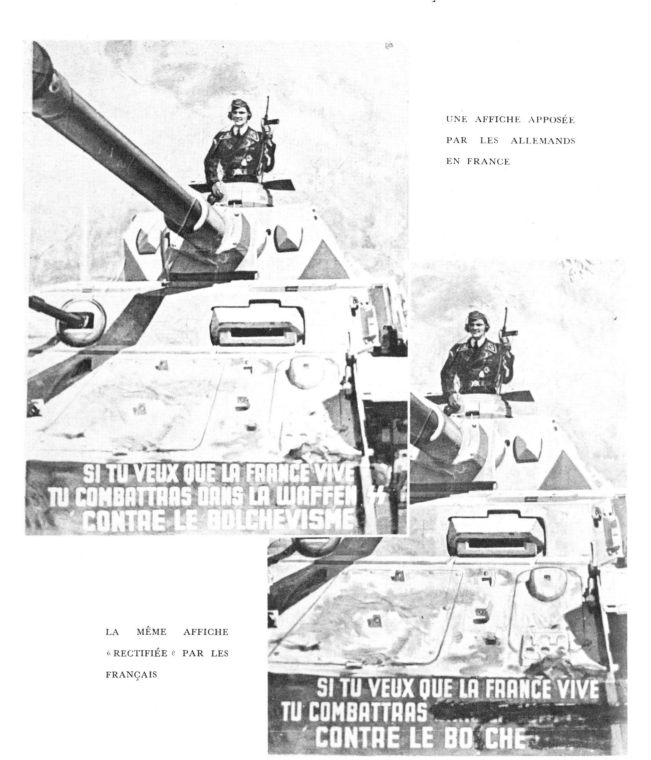

UNE AFFICHE APPOSÉE PAR LES ALLEMANDS EN FRANCE

LA MÊME AFFICHE « RECTIFIÉE » PAR LES FRANÇAIS

SI TU VEUX QUE LA FRANCE VIVE TU COMBATTRAS DANS LA WAFFEN SS CONTRE LE BOLCHEVISME

SI TU VEUX QUE LA FRANCE VIVE TU COMBATTRAS CONTRE LE BO CHE

Printed in Great Britain by Keliher, Hudson & Kearns, Ltd., London, S.E.1, for the Information Mission of the French Delegation, 4, Carlton Gardens, London, S.W.1

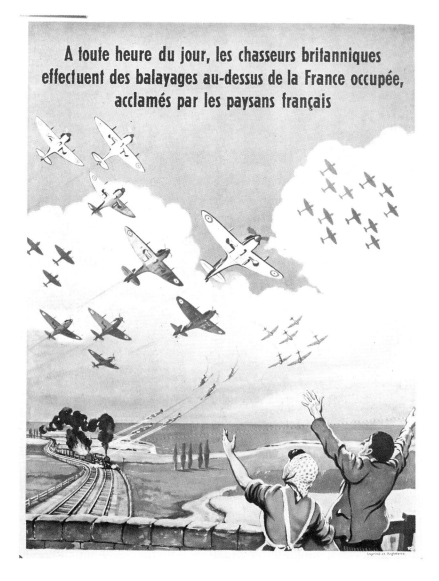

Guerrilla warfare on the walls: "liberators" or "destroyers"?

The Allied bombardments took many victims in France. The raids on the Renault factories (which were working for the German war machine) at Boulogne-Billancourt on 3 March 1942 destroyed 40 percent of the facility but also killed 367 and left 361 badly wounded. On 20 April 1944, the 1,500 bombs unleashed against the Gare de la Chapelle destroyed 304 buildings in the northern Paris area, damaged the Sacré-Coeur church, and killed 635.

Understandably, this sensitive subject became central to the propaganda of both Allies and, especially, their enemies. The former emphasized the strategic nature of their raids and their mastery of the French skies. The latter sought to transform the grief of the stricken into anger against the British.

opposite: A British poster, probably dating from the summer of 1942, asserts that "British fighters carry out sweeps above occupied France, cheered on by the French peasants."

An anti-Allied poster put up after the bombardment of northern Paris on 20 April 1944 shows a scene of devastation and the word "Dastards!" along with the exclamation "France will not forget!"

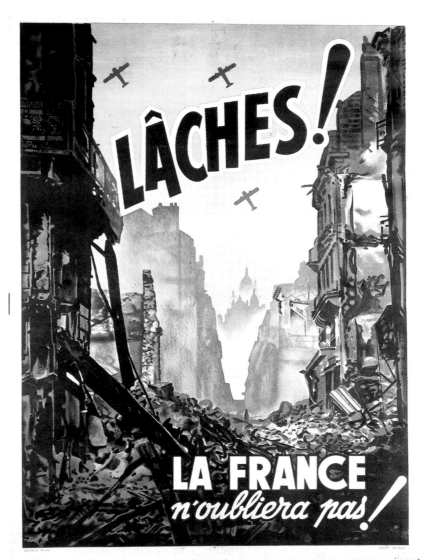

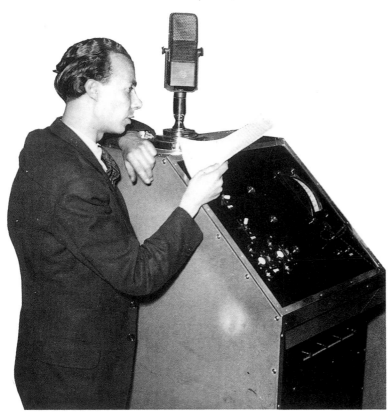

above left: Pierre Hiegel broadcasting from Radio-Paris, May 1941.

The cover (above right) and first pages (below) of an anti-BBC brochure published by German propaganda in Paris, 1942.

opposite above: A cartoon published in France, 28 October 1940.

opposite below: Jean Oberlé at the microphone of the BBC, 11 November 1942.

Pour permettre aux auditeurs des émissions françaises de RADIO-LONDRES de comprendre le véritable sens des informations lancées par la propagande britannique, cet opuscule vient à son heure.

Il est indispensable en effet que tout un chacun soit initié aux mille trucs qu'emploie traditionnellement la franche Albion, et que le plus candide des sans-filistes sache que le speaker anglais a pour mission de dire que le blanc est noir, que Staline est un ange et que ce qui est faux est vrai.

A

Quand le speaker dit:	Cela veut dire:
100.000 Anglais sont arrivés sur le front...	25.000 Canadiens, 25.000 Australiens, 25.000 Hindous, 24.999 Néo-Zélandais et un engagé volontaire gaulliste sont au feu. Le pur Anglais se conserve pour le négoce...
Nos chers Alliés...	Les poires qui se font tuer pour nos intérêts.

Quand le speaker dit:	Cela veut dire:
L'Avance allemande est arrêtée sur le front russe.	L'armée allemande est à plus de 800 Km de sa base de départ, sur un front de 2000 Km.... Sur un seul point d'une largeur de 100 mètres, les bolcheviks ont avancé de 2 mètres 75 par suite d'un glissement de terrain.
Nos Avions, descendant en piqué, ont bombardé des objectifs militaires.	Nos avions, volant à 7.000 mètres d'altitude, ont lâché leurs torpilles sur une pouponnière.

B

Nous avons établi une nouvelle Base aéro-navale à....	Nous avons encore chipé une colonie aux Français.
La bataille fait rage.	Le rembarquement de nos troupes est terminé.
Tous nos bateaux sont rentrés au port...	(C'est encore un bateau!)

The war of the airwaves.

This war, too, utilized images and texts. On one side, a cartoonist used his talent to reassure the French in London of Radio-London's large following in France. A number of signs gave an idea of that audience. In October 1940, around fifty letters from listeners managed to make their way across the Channel. At Tarbes, it was indicated, schoolchildren sang the musical theme of Jean Oberlé: "Radio-Paris lies, Radio-Paris lies, Radio-Paris is German," and in Chambéry—probably the source of inspiration for the cartoonist—it was said that the streets were deserted while the BBC program was broadcasting.

On the other side, German propaganda sought to discredit the information broadcast by British radio in a brochure in the form of a dictionary, with a cover that parodied that of the *Petit Larousse*—"Je sème à tout vent" (I scatter seed with every gust) changed to "I scatter lies with every gust." Such propaganda in effect acknowledged the influence of the BBC, despite the prohibition on listening to it and efforts at jamming reception. On 31 March 1943, German authorities went so far as to ban the sale of radio receivers, but it did not keep the French from listening to the BBC.

Radio-London won the battle of credibility, for even if it did not tell the complete truth, it did not hesitate to announce "bad news": the bombing of Britain in 1940, the arrival of the Wehrmacht near Moscow at the end of 1941, or the capture of Singapore by the Japanese at the beginning of 1942.

DANS UN VILLAGE DE FRANCE

L'heure de la B.B.C.

MARÉCHAL, NOUS VOILA!
MARCHE

Paroles de
André MONTAGARD

Musique de
André MONTAGARD
& Charles COURTIOUX

2

Tu as lutté sans cesse
Pour le salut commun;
On parle avec tendresse
Du héros de Verdun.
En nous donnant ta vie,
Ton génie et ta foi,
Tu sauves la patrie
Une seconde fois.
au Refrain

3

Quand ta voix nous répète
Afin de nous unir:
"Français, levons la tête,
Regardons l'avenir!"
Nous, brandissant la toile
Du drapeau immortel,
Dans l'or de tes étoiles
Nous voyons luire un ciel...
au Refrain

4

La guerre est inhumaine
Quel triste épouvantail!
N'écoutons plus la haine,
Exaltons le travail,
Et gardons confiance
Dans un nouveau destin,
Car Pétain, c'est la France!
La France, c'est Pétain!!!
au Refrain

VARIATIONS SUR UN THÈME ANCIEN

Sur un vieil air de Dorin
 Pourquoi pas
Je viens chanter ce refrain
 Pourquoi pas
Ces deux mots, en ce moment
Prenn'nt incontestablement
Une plac' de premier plan
 Pourquoi pas.
Avons-nous vraiment tout vu
 Pourquoi pas
Et verrons-nous encor' plus
 Pourquoi pas
A tout c' qui peut arriver
En s' basant sur le passé
On peut dire sans s'étonner
 Pourquoi pas ?

●

Dans Mein Kampf Hitler a dit
 Pourquoi pas
La Franc' ce pays maudit
 Pourquoi pas
Je n'aurai point de répit
Que j' n'ai enfin détruit
Ses valeurs et son esprit
 Pourquoi pas
Mais trouverai-je pour m'aider
 Pourquoi pas
Des hommes assez dégradés
 Pourquoi pas
Est-il des individus
Qui soient, à ce point vendus,
Et Pétain a répondu
 Pourquoi pas ?

* * *

Ce fut l'affreus' dérision
 Pourquoi pas
De la collaboration
 Pourquoi pas
Une band' de saligauds
Beuglait à tir larigaud
Devant cet ordre nouveau
 Pourquoi pas ?
Les Fridolins, pour le coup
 Pourquoi pas ?
Fir'nt leur besogne de voyous
 Pourquoi pas,
Et tandis qu'ils déportaient
Torturaient et fusillaient
A plat-ventre Vichy disait
 Pourquoi pas ?

●

Maint'nant que l' vent a tourné
 Pourquoi pas
Tous ceux qui se sont mouillés
Essaient de se retourner
Jouant des mains et des pieds
Pour tâcher d' se fair' sécher
 Pourquoi pas
Et je n' serais pas surpris
 Pourquoi pas
Que Laval, demain s'écrie
 Pourquoi pas
Votr' de Gaulle est bien gentil,
Mais j' peux vous l' dire aujourd'hui
J'étais gaulliste avant lui.
 Pourquoi pas ?

The songs of the fray.

The French head of state had numerous propaganda songs lauding him. The most famous was undoubtedly "Maréchal, nous voilà!" (Marshal, here we are!), which was popularized by André Dassary, thumped out at every official occasion, and learned by heart in every classroom in France. This song, intended to replace "La Marseillaise," assembled all the Vichy themes: the cult of the leader or the father, good and venerable; the celebration of the love that the French, baptized his "children," bore for him; a salutation of the hero who twice "saved" his country, at Verdun and in 1940; the glorification of the fatherland and the values of work; and, on the other hand, condemnation of war, declared "inhuman," to justify the armistice. Through this last touch the song reveals, more clearly than any scholar, where Vichyism, pacifist of necessity, parted company from fascism, essentially warlike. Moreover, the men of the Parti Populaire Français preferred "France, libère-toi" (France, free yourself) to "Maréchal, nous voilà!"; members of the Milice marched to the rhythm of SS songs and liked to cry out, "O comrades, against the Reds, against the enemy!"

Résistants and the Free French sometimes used songs to express their rejection of Vichyism. For example, a song composed in 1933 for the cabaret singer René Dorin was used as the basis of a parody depicting Pétain not as the savior of France but as the man of the handshake at Montoire, as the man who, to the question of collaboration, answers, as in the refrain, "Why not?"

opposite: The Vichy hymn, 1941. Part of the first verse goes, "A sacred flame shoots up from the native soil,/ And France, elated, salutes you, Marshal!/ All your children who love you/ And venerate your years,/ At your supreme call/ Responded, 'Present'/ Marshal, here we are!/ Before you, the savior of France."

One of the songs composed by Pierre Dac for a French group of Radio-London (drawing by Jean Oberlé for an edition published after the Liberation). A portion of the second verse has Hitler asking, "But will I find to help me/ Men debased enough/ Is there anybody/ Who would be a traitor for me?/ And Pétain answered him/ Why not?"

Le Maréchal s'assit sous un chêne et chacun pensa au Roi Saint Lou[...]
Chacun vit derrière le Maréchal l'ombre du Saint Roi de Franc[...]

O mon pays, je veux chanter l'Homme qui t'a conservé la vie, l'émule de Bayard le Chevalier et le disciple de Jeanne la Très Sainte, comme lui sans reproche et sans peur et comme elle portant l'armure de la Foi.

Vichy has its heroes.

The heroes of history that Vichy chose to glorify are highly telling. The republic is assuredly dead; it is the monarchy, with its kings and attendants, that wins the honors.

However, the glory of these personages must above all serve to aggrandize the image of the supreme hero of Vichy. Pétain possesses all the virtues—that is the message of these images: he is just, like Saint Louis, pious, like Joan of Arc, brave, like Seigneur de Bayard, one who can rally the troops, like good King Henri.

Charlemagne fits poorly with the Vichy imagery, although the marshal's photograph figured prominently at the ceremony marking the twelfth centennial of the emperor's birth. The admirers of National Socialism made better use of this hero, such as the writer Abel Bonnard, who, several days before he joined Laval's government as minister of education, gave a speech entitled "Charlemagne and Our Time" in which he likened "the new Europe" of Hitler to Carolingian Europe.

opposite left: A poster from Lyons, March 1944, shows the cast of historical figures appropriated by Vichy with the message, "They built your country."

opposite above right: A page from the book Oui, Monsieur le Maréchal *by "oncle Sébastien" (Léon Chancerel), published by B. Arthaud, Grenoble, La Gerbe de France, in which the ghost of Saint Louis is seen behind the marshal.*

opposite below right: The first page of the book Pétain *by Albert Paluel-Marmont, published by Librairie des Champs-Elysées, depicts Pétain flanked by Seigneur de Bayard and Joan of Arc.*

Pétain's photograph appears below the name of Charlemagne at a speech given by Abel Bonnard at the city hall of Saint-Denis on 2 April 1942 commemorating the twelfth centennial of the birth of the king of the Franks.

Pour que la France vive il faut comme Jeanne d'Arc bouter les Anglais hors d'EUROPE

13 Mai 1944 la France entière fête Jeanne d'Arc Héroïne Nationale

Joan of Arc, national heroine and martyr at the hands of the English.

Joan of Arc was undoubtedly the favorite heroine of not only the Vichy authorities but also the collaborators of Paris and the German propagandists, who made much use of her image. After all, by her life and her death, did she not, better than any other historic figure, denote the English as the enemy of France? Every May, her feast day occasioned religious and official ceremonies throughout the country, on both sides of the demarcation line.

The Jeunes du Maréchal, whose members saluted her statue in Paris, was a movement founded by a teacher at the Lycée Voltaire in November 1940. It initially recruited from Paris's preparatory classes and rapidly evolved toward an extreme right-wing collaborationism, to such a degree that Vichy ordered it dissolved in May 1943.

above: A propaganda leaflet, probably collaborationist, of May 1944 asserts, "So that France may go on, we must kick the English out of Europe, like Joan of Arc."

below: After the bombings of Rouen in April and May 1944, this anti-British poster appeared, claiming, "Killers always return to the scenes of their crime." The Parisian press wrote, "1431–1944, 512th anniversary of the execution of Joan of Arc at the place du Vieux-Marché."

opposite: The Jeunes du Maréchal salute the statue of Joan of Arc in the place des Pyramides in Paris, 1 May 1942.

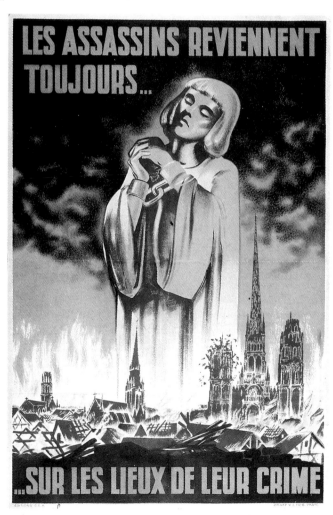

LES ASSASSINS REVIENNENT TOUJOURS...

...SUR LES LIEUX DE LEUR CRIME

LE 10 MAI, FÊTE DE JEANNE D'ARC

le Peuple de Paris ira rue de Rivoli

conspuer les capitulards et les traîtres

dont le défilé, sous l'œil des boches, est une insulte à la mémoire de l'héroïque paysanne de Domrémy.

Les cris de ralliement des patriotes seront :

A bas Hitler ! A bas Laval ! A bas Pétain et Darlan !
Hors de France les occupants !
Vive la France !

Au quinzième siècle, la France en guerre depuis cent ans, divisée et ravagée, était tombée sous la domination étrangère ; et alors, comme aujourd'hui, il y avait un parti de la trahison, un parti à la solde de l'envahisseur.

Mais la foi patriotique était ardente dans les masses populaires ; les paysans, les petites gens de France ne s'inclinaient pas devant la domination étrangère, et ce fut une humble paysanne de Domrémy, Jeanne d'Arc, qui prit la tête du parti de la résistance, combattit l'ambiance de résignation qui environnait le Dauphin et donna l'exemple du courage dans la lutte libératrice qui devait aboutir à chasser tous les soldats étrangers du sol de la Patrie.

Jeanne, faite prisonnière à Compiègne après avoir délivré Orléans et fait sacrer Charles VII à Reims, fut livrée aux envahisseurs.

Le Roi ne fit rien pour tenter de sauver la jeune héroïne et il devait appartenir au Baudrillart de l'époque, l'évêque Cauchon, de se couvrir de honte en condamnant Jeanne pour le compte des envahisseurs.

Cet évêque indigne fit contre Jeanne ce que font aujourd'hui des juges sans honneur contre des patriotes en les condamnant pour le compte de Hitler.

La jeune et héroïque paysanne fut brûlée par jugement de l'évêque-traître ; mais, aujourd'hui, elle est le symbole de la résistance à l'envahisseur, et les patriotes communistes et autres qui luttent pour la délivrance de la Patrie, qui tombent sous les coups des boches et de leurs valets, sont dans la tradition de Jeanne la Lorraine, tandis que les « collaborateurs », les hommes de Vichy, les Laval, les Pétain, Darlan et Cie sont dans la tradition de l'évêque Cauchon.

D'un côté, la Patrie ; de l'autre, la trahison ; et le Peuple est du côté de la Patrie. C'est pourquoi la fête de Jeanne d'Arc sera, en ce mois de mai 1942, célébrée par tous les Français dont le but suprême est le combat pour la délivrance de la Patrie.

Que le 10 mai prochain, tandis que les traîtres à la solde des boches iront insulter de leurs palinodies la mémoire de Jeanne, le Peuple de Paris se rassemble aux alentours de la statue de la paysanne de Domrémy et qu'il aille flétrir les misérables à la solde de l'étranger qui recouvrent d'un semblant de patriotisme leur odieuse trahison.

Que les traîtres soient accueillis aux cris de :

A BAS HITLER ! A BAS LAVAL ! A BAS PÉTAIN ET DARLAN !

HORS DE FRANCE LES OCCUPANTS !

VIVE LA FRANCE LIBRE ET INDÉPENDANTE !

Le Parti Communiste Français (S.F.I.C.)

JEANNE LA LORRAINE

—Et moi, vous allez aussi me déporter en Pologne ?

LA GRANDE - BRETAGNE
N'A PAS CESSÉ D'ÊTRE UNE ÎLE
DÉFENDUE PAR LES FLOTS, CE POUR
QUOI ELLE SE CROIT TENUE
DE MULTIPLIER LES CAUSES DE
DISCORDES ENTRE LES PEUPLES
DU CONTINENT POUR ASSURER
LA PAIX DE SES CONQUÊTES. CETTE
POLITIQUE A EU DE GRANDS JOURS
POUR ELLE CONTRE NOUS.
L'ANGLETERRE FUT HISTORIQUEMENT
NOTRE PLUS VIEILLE ENNEMIE.

CLEMENCEAU
GRANDEURS ET MISÈRES D'UNE VICTOIRE

Joan of Arc and Georges Clemenceau, on both sides.

Conveying a cult of the hero was not without its risks. If the Vichy regime chose to celebrate enthusiastically the feast day of Joan of Arc starting in 1941—the month of May of that year was declared the month of youth under her sign and that of the marshal—it did not anticipate the extent to which the message could be turned against it. For the heroine of Lorraine was equally honored by the Resistance, including the Communist Party. It saw in her the warrior, the patriot, the liberator, she who refused defeat, who fought the invader—the nationality mattered little, the enemy was the occupier of the moment—who slew traitors.

It was more difficult for the Vichy regime to put a claim on Clemenceau, despite his Anglophobia and his quarrels with England. This too republican hero embodied a Jacobin extremism against Germany in 1917. His motto "I make war" denoted an attitude completely counter to that of Pétain in 1940. Thus, in the Vichy censor's orders given to the newspapers of the southeast can be read (order number 434): "Limit to brief evocations articles on the subject of Clemenceau's centennial, which must be presented discreetly." The fighting French evidently did not have the same problem, as shown by the drawing below, which establishes a relationship between the Tiger and the General. It appeared in a newspaper for the French colony in the United States on the occasion of the twenty-fifth anniversary of 11 November.

opposite left: Joan, Daughter of the People, *a Communist tract dated 25 April 1942, called for a counterdemonstration in Paris during the celebration of Joan of Arc's feast day.*

opposite above right: The Joan of Vichy, lacking arms and armor, was used as the patron of the youth movements at the time of her celebration in 1941.

opposite below right: Joan of London, the warrior, asks a trio of collaborators, "And me, too, you're going to deport to Poland?" The drawing appeared in France, *13 November 1940.*

above: Clemenceau as anti-British was used for a Vichy poster.

below: Clemenceau as patriot thanks Charles de Gaulle in a drawing published in France-Amérique, *14 November 1943.*

ANNIVERSAIRE

Clemenceau : " Merci, de Gaulle ! "

Game of the French empire.
The empire was the object of pride for the majority of French people of the time. Vichy propaganda drew from this political prize a board game that combined the heroes of colonization and aviation, with the additional, and central, figure of Pétain. The player who lands on his square (number 42) can go directly to the square "arrivée" (arrival) and win the game.

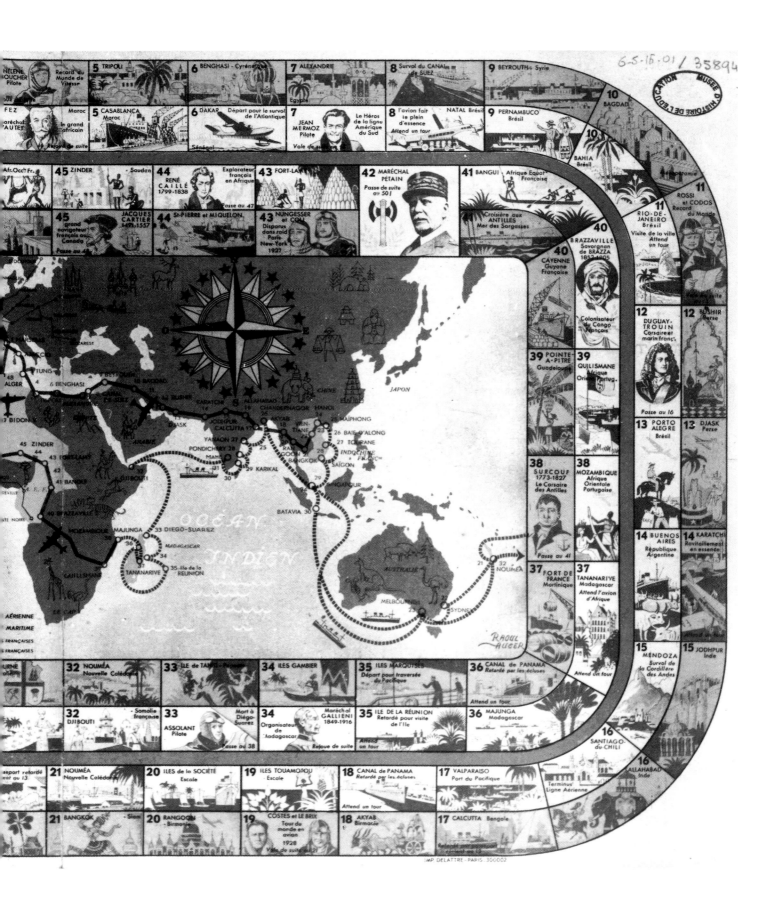

QUINZAINE IMPÉRIALE 1942

VISITEZ
LE TRAIN EXPOSITION
DES COLONIES

LE TRAIN STATIONNERA A **POITIERS**
du **24** au **27** Juin inclus

The empire under dispute.

For conquered France, all was lost except the empire. The last vestige of its power, it was at the heart of the contest between Vichy and the Free French. The ultimate bulwark of sovereignty for the former, for the latter it was the initial bastion where they could restore freedom and construct an embryonic state, capable of mobilizing an army. In sum, it was the object of great solicitude for both camps.

Vichy propaganda was particularly concerned with popularizing "the work" accomplished in the overseas territories and assuring the diffusion of the colonial idea. In 1942, many fairs and "imperial fortnights" were organized, in Algeria during the month of May and in the mother country for several months. A train exhibition made the tour of France between 1 May and 31 July, passing through university towns where it held the "fortnights," then a tour of the Paris region between October and December. It presented artworks, models, maps, photographs, and exotic products to satisfy the public's curiosity, as well as information on colonial careers to the young, whom it hoped to recruit.

QUINZAINE IMPERIALE
POSITION COLONIALE
18 · 31 MAI 1942

above left: Charles Noguès, governor-general of Morocco, visits a Franco-Berber school, March 1942.

above right: A poster advertising the train exhibition of the colonies advises that it will be stopping at Poitiers between 24 and 27 June 1942.

below: Governor-general Yves Chatel of Algeria emerges from the "imperial fortnight" of Algiers, 23 May 1942.

opposite: On the first Bastille Day (1943) of liberated North Africa, General de Gaulle watches the troops march by in Algiers. On his left is General Alphonse Juin, on his right, Admiral René Bouscat, and behind him, René Pleven.

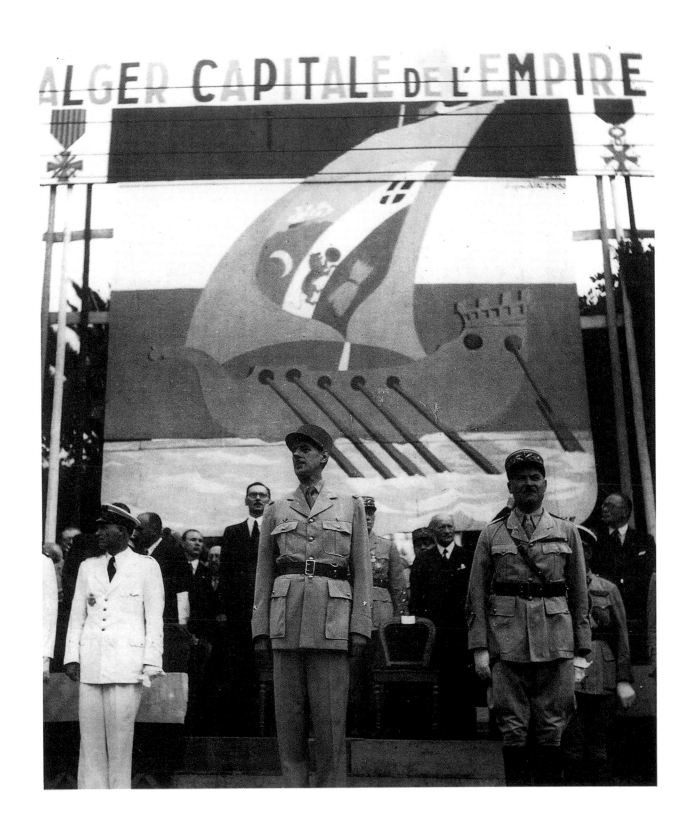

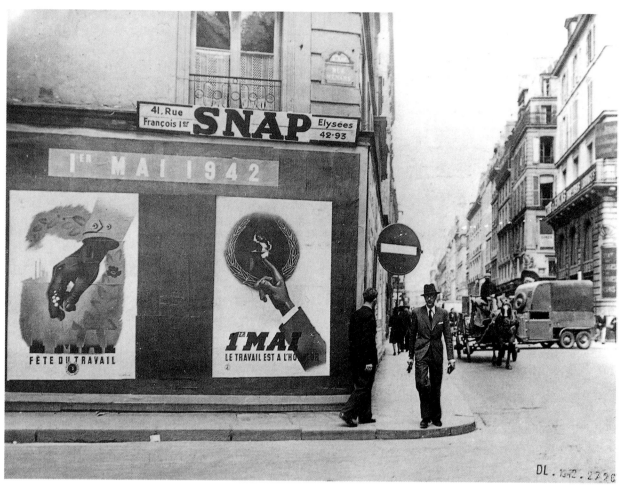

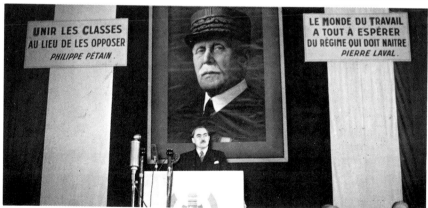

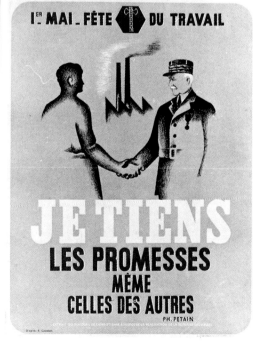

1ᵉʳ MAI
APPEL DU TRAVAIL AIDE AUX REFRACTAIRES ET F.T.P.F

The dispute over May Day: celebrate or strike?

In 1941, Pétain made 1 May a celebration of work. Speaking in Commentry on 1 May 1941, he declared, "Up to now the first of May has been a symbol of division and ill will; from now on it will be a symbol of union and friendship because it will be the celebration of work and workers." Several weeks earlier, he had instituted pensions for the elderly. The pension had been among the goals of the Popular Front's program in 1936, but Léon Blum's government had had to relinquish it in February 1937 when he decided to take a "pause" in carrying out reforms. This explains the famous phrase of the marshal's in his address of 15 March 1941 announcing the measure: "I keep my promises, even those of others, when the promises are based on justice." For Vichy, May Day was thus the ideal occasion to glorify the "social work" of the regime and to affirm its doctrine of the collaboration of classes.

The Communists, on the other hand, considered that May Day should remain a day for workers to make demands and for action in service of the Resistance.

opposite above: Posters in Paris (2nd arrondissement) announce the regime's celebration of 1 May in April 1942.

opposite below left: Marcel Déat, minister of labor and national solidarity, during a demonstration at the Palais de Chaillot in Paris during the day celebrating work, 1944.

opposite below right: On a poster proclaiming the "Celebration of Work," Pétain proclaims, "I keep my promises, even those of others."

Two tracts call for strikes on 1 May 1943 and 1944.

1ᵉʳ MAI 1944
JOURNEE D'UNION ET DE LUTTE
JEUNES
CESSEZ LE TRAVAIL DE 11ᴴ A 12ᴴ POUR EXIGER:
500 GR DE PAIN PAR JOUR
50% D'AUGMENTATION DES SALAIRES
LA CESSATION DES DEPORTATIONS
LE DROIT AU METIER
LE RETOUR AUX 40 HEURES
LE RETABLISSEMENT DES LIBERTES SYNDICALES ET POLITIQUES
FEDERATION DES JEUNESSES COMMUNISTES DE FRANCE

November 11 belongs to the Resistance.

Unlike May Day, 11 November caused no rivalry. The German authorities banned all demonstrations on the day that celebrates the signing of the armistice of 1918, and Vichy abstained from all commemoration. The patriots were thus the only ones to celebrate the victory of World War I, and that celebration amounted to an act of resistance. The procession of students marching in Paris to the Arc de Triomphe on 11 November 1940 constituted one of the earliest group demonstrations, harshly repressed by the German troops.

Three years later, the Resistance had grown up. The Maquisards of the Ain made themselves known in an audacious act—occupying the town of Oyonnax in broad daylight on 11 November 1943 to celebrate the anniversary of France's victory. They marched through the streets with a wreath in the shape of the cross of Lorraine and, in front of an enthusiastic crowd, carried out the standard ritual of the commemorative ceremony: the laying of the wreath, the moment of silence, and the singing of "La Marseillaise," which was taken up by the entire audience. Then the Maquisards got back in their trucks and the town was returned to the official authorities.

The same day, General de Gaulle lit the flame of memory at the war memorial in Algiers. Thus, 11 November became the symbol and rallying point for all those who refused defeat and Vichy.

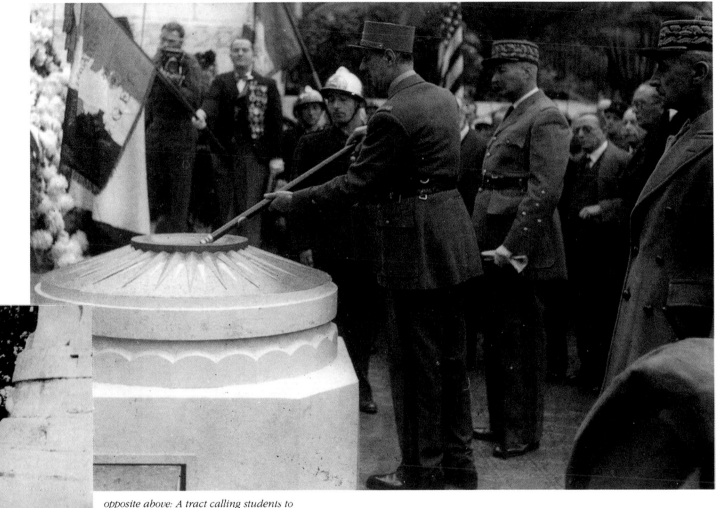

opposite above: A tract calling students to the Arc de Triomphe on 11 November 1940.

opposite below: Maquisards march through the streets of Oyonnax, in Ain Department, on 11 November 1943 (left), and observe a minute of silence (right) in front of the war memorial. In the foreground, left to right: Lieutenant Bonnet, Lieutenant Molher, Captain Romans-Petit, the head of the Maquis of Ain Department, and Lieutenant Jaboulay. The photographs were taken by the underground journalist André Jacquelin.

In Algiers, a trio of French generals—Charles de Gaulle, Henri Giraud, and Georges Catroux—attend a ceremony honoring the armistice on 11 November 1943.

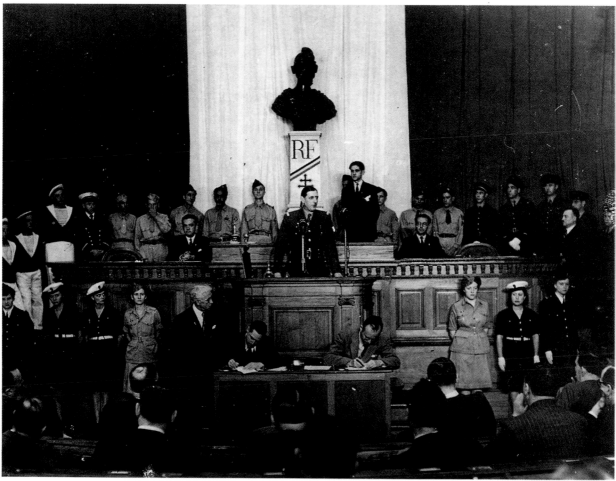

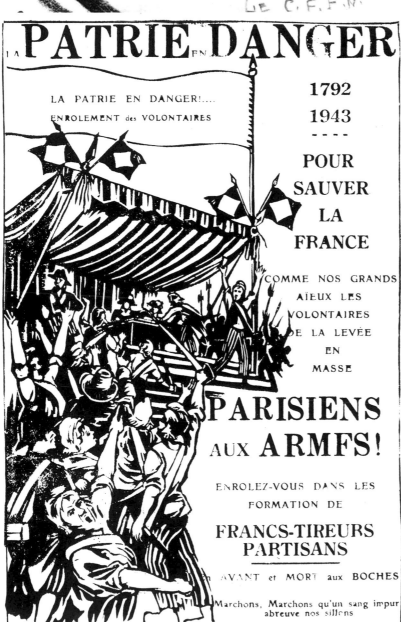

Revolution and resistance— same fight.

Whereas Vichy chose its heroes from French history before 1789, the Resistance and the Free French took many of their symbols from the French Revolution.

Valmy evoked simultaneously the victory over the Prussians on 20 September 1792, the heading off of the invasion, the leap to arms of the nation, and the birth of the republic, proclaimed the next day by the Convention. This event became a favored reference of the underground fighters. It gave its name to the movement founded by Raymond Burgard, a teacher at the Lycée Buffon in Paris, on the anniversary of the battle 148 years later, in 1940.

Republican imagery also enjoyed preferred status in Resistance imagery. For the fourth anniversary of his June 18 appeal to the French to resist the Germans, General de Gaulle addressed the consultative assembly in Algiers under the protection of Marianne, symbol of the French republic.

The fight against Nazi Germany and Vichy was a contest for the fatherland, but it was also a battle for the republic and for freedom.

opposite above: Marianne, symbol of the French republic, stabbed in the back was one of the last republican images before the installation of the Vichy government. It appeared in the weekly newspaper Marianne, *17 July 1940.*

opposite below: General de Gaulle addresses the consultative assembly in Algiers under a bust of Marianne, 18 June 1944.

above: Valmy was a Resistance movement; this tract placed on the tombs of students shot by firing squad in Dijon says, "Honor the heroes who died for France."

below left: This poster placed on the walls of Paris during the night of 19 to 20 September 1943, entitled "Fatherland in Danger" and urging enlistment in the Francs-Tireurs et Partisans Français, noted the 151th anniversary of Valmy's victory.

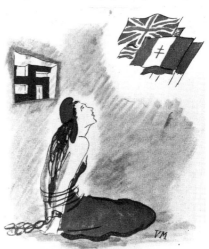

below right: In this watercolor by Von Moppes, London, Marianne in her cell awaits liberation by the Allies and the Resistance.

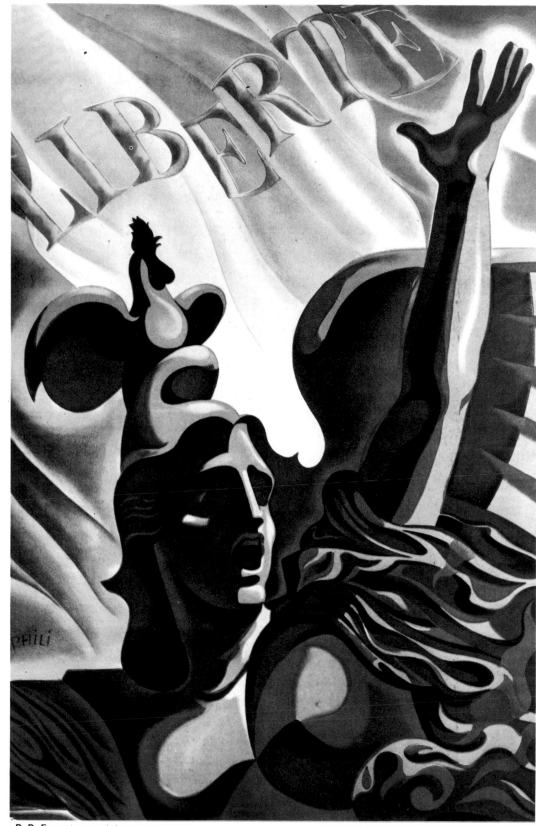

.P.R.F. SECRETARIAT GÉNÉRAL A L'INFORMATION AFFICHE EXÉCUTÉE SOUS L'OCCUPATION ALLEMANDE — AOUT 1944

*A poster by Phili of August 1944 features Marianne
urging patriots into battle for freedom.*

APPENDICES

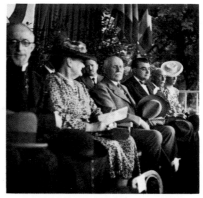

From Vichy to London: The double use of a press photograph

PARIS. M. DÉAT, MINISTRE DU TRAVAIL, PREND POSSESSION
DE SES POUVOIRS.

AU MINISTÈRE DU TRAVAIL, M. DÉAT, MINISTRE DU TRAVAIL
ET DE LA SOLIDARITÉ NATIONALE, EST REÇU PAR M. BICHE-
LONNE, AU SECOND PLAN, MM. BRUNETON ET CHASSEIGNES.

V. 95.521

Caption of the Service Central Photographique (SCP), Photo Trampus

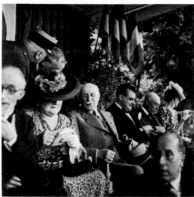

Caption of the Office Français d'Information Cinématographique (OFIC)

OFIC 7491- FRANCE, le regime de Vichy.

Paris, Mr. Déat, Ministre du travail, prend possession de ses
pouvoirs.

Au Ministère du travail, M. Déat, Ministre au travail et de
la Solidarité Nationale , est reçu par M. Bichelonne, au second
plan, MM. Bruneton et Chasseignes.

Henriot and his "image"

Caption: *Mr. Ph. Henriot, minister of information and propaganda, recently photographed in Vichy. Photo Trampus.*
It was passed by the censor, as it carries a certificate *(visa)* number, V. 91511, but the notation "banned" was added.

Caption: *Mr. Philippe Henriot, minister of information and propaganda. Passed by the censor Visa 93799. Photo Actualit. (23 February 1944).*

Pétain censored

Caption: *The marshal of France attends the Vichy Grand Prix. In the head of state's grandstand, the marshal has beside him Mr. Bonnafous, minister of agriculture, and Baron Nexon. Corporative reporting. Trampus, photography.*

On the whole, the press treatment of Pétain proved unflattering; he rarely appeared in photographs. The above images all carry the stamped notation, "The reproduction of this photograph is absolutely forbidden."

Appendix 1

The Collection of War Photographs of the Documentation Française

In October 1945 the Direction de la Documentation et de la Diffusion was established in the Etoile neighborhood, not far from the Ministry of Information, its parent organization.[1] Its archives accumulated boxes of photographs from the Comité National Français in London, the Office Français d'Information Cinématographique (OFIC) in London, then in Algiers, and the Service Central Photographique (SCP) of Vichy.

Many of these photographs had retained their identifying number and original caption, glued on the back, but others, many of which were doubles, could be identified only by patiently cross-checking them and through the help of iconographer Jacques Ostier. This collection is considerable; tens of thousands of its photographs will be given by the Documentation Française to the Bibliothèque Nationale, the Service Cinématographique des Armées (the SCA, then the ECPA), and the Comité d'Histoire de la Seconde Guerre Mondiale.[2]

The war collection presently preserved by the Documention Française constitutes a group of particularly interesting photographs because their sources are well known. The archival documents that accompany them make it possible to reconstitute the record of the services that produced and distributed them: logbooks of the Vichy photographic censor that begin in 25 July 1940, reports, correspondence folders, of which a part goes back to the period August 1939 to June 1940, and others. For the services of London and Algiers, the lists are more succinct, the information sparse; thus, the recollections of witnesses remain invaluable.

Photography in the Service of Information

The photographic services of the information bureaus reflect the orientations of the latter.

Those of the Vichy government and the Service Central Photographique drove the state's political propaganda, conveying the ideology of the National Revolution through images glorifying Marshal Pétain.

The Allies dispensed information freely, tempered by the exigencies of war. War correspondents, photographers attached to various army corps, and the "photo pool" produced an impressive quantity of photographs.

The Free French participated in the production of Allied information by means of the Office Français d'Information Cinématographique. Created in April 1942, its bylaws (tardily adopted in 1944) established a public organization run by the state but commercial in nature, "subject to the trusteeship powers exercised by the commissioners of information and finance."

A Coherent Propaganda: The Service Central Photographique de Vichy (SCP)

Through an act of 21 July 1941, the SCP was handed the mission of "guiding, coordinating, controlling the production and the diffusion of photography for the press and the publishing industry." This definition approaches the "controlling principles" published in 1942 by the minister of information, Paul Marion,[3] who insisted on the necessity of guiding and censoring all the information media, including radio and film as well as the press.

An important report of 21 November 1942 submitted by Georges Reynal, head of the SCP, to René Bonnefoy, director of the office of the minister of information, describes the activities and function of the service.[4] At first, directives and instructions were elaborated through daily meetings with the representatives of photographic agencies. These were replaced by more peremptory written guidelines. About fifteen agencies had their main office or a branch in Vichy, so that several accredited reporters worked "in the direction imposed by the orders of the marshal and the head of government." These agencies were given material benefits in the form of purchases of photographs, but the contracts they had with the newspapers did not suffice to keep them going.

Faced with "the unfortunate insolvency" of these agencies, for which they gave proof, according to the report, the SCP developed a network of clients and poster centers for them, in the empire as well as in France: Chantiers de la Jeunesse, Centres de Révolution Nationale, Unions Départementales Légionnaires, deputies of the Ministry of Propaganda, Maisons de Prisonniers, and individuals. In addition, four hundred cards made up of twelve photographs "illustrating the trinity of the National Revolution, Work-Family-Fatherland, left each week to carry the image of a reborn France around the world."

The report commented particularly on the distribution agreement passed in September 1941 between the SCP in Vichy and the Propaganda Staffel in Paris, which permit-

ted the photographs of agencies to circulate from one zone to the other under the surveillance of the two organizations. Also, a rotation of agencies—known as the "Rota"—was instituted to limit when necessary the number of photographers permitted at the same event. The images were then dispatched by the agencies or sent directly to the newspapers.

The figures in the report give an idea of the scope of the SCP's activities: 88,000 photographs were distributed in the three months of July to September 1942—45,000 documents to be placed on the 740 existing panels in France and the empire, 32,000 to the press services and French newspapers, and 11,000 abroad.

Once accepted by the censor, each of these photographs was noted down in a logbook with a certificate number, the name of the agency or the reporter, and a precise caption. A print was preserved in the archives. The censors, in their monthly reports, emphasized the regrettable tendency of the agencies to cultivate the anecdotal and the frivolous in order to please their clients instead of illustrating important issues—which justified the existence of the Service Central Photographique. Regular counts allowed them to view the subjects covered and the shares of French versus foreign photographs. "By French photographs is meant the documents representing French subjects photographed in France and the empire. . . . By foreign photographs is meant all the others. . . ." (memo of September 1941). One of the purposes behind the count was to limit the number of photographs from American agencies; some of the documents in the archives seem to suggest a desire to bring down the increasing numbers of German images.

The image of the marshal was the special province of Dr. Bernard Ménétrel. Pétain's personal doctor and secretary, who always remained near the head of state, thus watched over his popularity as well as his health.

Allied Photographs, Photographs of the Free French

From the succinct lists that serve as catalogues, the distribution of the Office Français d'Information Cinématographique in London and Algiers can be estimated at about fifteen thousand photographs, a small number in relation to the impressive mass of English and American images. They are uneven in quality, as some excellent reporters worked with the French forces along with almost novice photographers; those living outside the norms had most access to other such types.

Some brief reports evoke the celebrations in London and then in Algiers of 14 July, 11 November, and 1 May and the activity of General de Gaulle. But the majority of material covers the operations of fighting France, at Bir Hacheim, Italy, and other sites.

The underground journals that since 1942 received numerous written documents assembled by the Service de Diffusion Clandestine du Commissariat à l'Intérieur were also provided with photographs, regularly beginning in August 1943. Photographs went in the reverse direction as well, arriving in London from France, especially in 1943 and 1944. The OFIC took those it deemed necessary to make known: portraits of Vichy's politicians, images of the occupation, and those sent by the Resistance, to the extent that they did not endanger the underground fighters, that could convince the Allies of the reality of the counteractivity occurring in France, such as the procession of the Maquis in Oyonnax, which "impressed the Allies most with the value of the Maquis."[5]

After the Liberation, certain photographers or agencies that worked most regularly for the Germans were "forbidden." The list issued by the Ministry of Information in 1945 specified the names Safara, Fulgur, DNP, ABC, and Trampus, among others. Some former agencies regained their status, after eliminating their Vichy branch. Photograph archives, official and private, multiplied; there would no longer be a single official photographic service.

Jacqueline Eichart

1. The Direction de la Documentation et de la Diffusion was attached to the Secrétariat Général du Gouvernement as of 22 November 1947.

2. Created in 1979, the Institut d'Histoire du Temps Présent was amalgamated with the Comité d'Histoire de la Seconde Guerre Mondiale two years later. Its collection of photographs was deposited with the Secrétariat d'Etat aux Anciens Combattants.

3. These "controlling principles" appeared in *Documents Français,* no. 1 (January 1942) and are reproduced in Hélène Eck, ed., *La guerre des ondes* (Paris: Armand Colin; Lausanne: Payot, 1985).

4. The quotations in the following paragraphs are from this crucial report.

5. Alban Vistel, *La nuit sans ombre* (Paris: Fayard, 1970), 35, quoted in Claude Bourdet, *L'aventure incertaine* (Paris: Stock, 1975), 265, 269.

Appendix 2

The Relève through the Filter of Propaganda, from the Photographic Collection of Vichy

To end this book, we offer a group of photographs of an event of major political significance: the first Relève, or relief shift. It presents a fine summary of the machinery and the propaganda efforts set in place to persuade—the well-known power of the image to stage political action, the choice of vantage points, and the manipulation of framing. This provides only one example. Taken in its entirety, the Vichy photograph collection offers an excellent resource for those interested in studying the role of the image in the conditioning of public opinion in the years 1939 through 1945, its successes and failures.

On 11 August 1942 the first train returning prisoners of war *(permissionnaires)*, freed by means of the Relève, arrived in Compiègne. Careful preparation had gone into the event. The head of the government, Pierre Laval, had negotiated a magnificent "coincidence" with Otto Abetz: at the Compiègne station, the train bringing the freed prisoners would meet the train of "volunteer" workers leaving for Germany.

Before the arrival of the two trains, French and German personalities, Laval at their head, took their places on the platform (fig. 1). The trains arrived and the crowd pressed forward (fig. 2). Laval addressed the repatriates; he was the star of this immense stage production (figs. 3, 4). Ordinarily he appears infrequently in the Vichy photographs.

On the same day, the press received the following instructions:[1]

> Order no. 598: The newspapers are required to publish on a minimum of six columns, at the top of the column and on the first page, the broadcast speech of President Laval in Compiègne, as well as information related to the return of the first train of *permissionnaires*. The best presentation (title and subtitle), detailed, is demanded. The newspapers will make up their own titles, emphasizing the moving character of this day.
>
> The following phrases from the speech of the head of the government:

1. "All France, through me, welcomes you with a solemn joy and greets you warmly";
2. "The arrival of the first train makes it clear that the workers of France have responded to my appeal";
3. "You will not be skeptical, you who have known the moral sufferings of exile. You will understand better than others the logic of a policy that is exclusively inspired by concern for French interests";
4. "The road we have to follow is long; we will meet obstacles. In order to clear them, all we need do is remain always inspired by the example given us by that great soldier who presides over the country's destiny";

must of necessity figure in the general title.

It will not do to give information relative to numbers.

For their part, the news photographers covered themselves from all angles at this event: 309 photographs were registered with the censor's office during the month of August alone. They translated into their own language the symbolic meaning and the political import of what the government wanted to convey.

The multiplicity of shots included a general view of the platform with its microphones and loudspeakers and, behind the actors of the exchange, the crowd, well framed. There are medium shots of Laval. Then close-ups of the beneficiaries of the Relève agreement (figs. 5–8); enthusiasm and laughter; a pose with cigarettes, a luxury commodity (one of the cigarettes seems to have been added to the photograph); trains decorated with foliage and bearing slogans.

Again a general view and medium shots, in the courtyard of the Jeanne d'Arc neighborhood in Compiègne, of the prisoners "who write postcards to announce their return to their family" (figs. 9, 10) and "abandon their military uniforms before recovering their civilian clothes" (fig. 11, "banned").[2]

Two photographs (figs. 1, 3) were "absolutely

banned" for publication by the censor, the only implicit reason in the explicit mention being the presence of German authorities beside Laval. On this point, as on the speech given there by Ambassador Karl Ritter, who represented the "work front" in France, the press had to remain silent, whereas Laval's speech had to be reproduced in its entirety.

At the end of the day, the prisoners of war thanked Laval and asked to be returned home as quickly as possible.

One of the photographers (among others) had the idea to encapsulate the liberation of the prisoners of war by following one of them, Maurice Courtin, a farmer from Saint-Hilaire-Saint-Mesmin, near Orléans. "In the Jeanne d'Arc neighborhood in Compiègne, he received his final instructions" (fig. 12), "left the barracks" (fig. 13), "took leave of his comrades in captivity" (fig. 14), and "regained his farm" (figs. 15, 16).[3]

Many of these men were not released after the Compiègne event; they were retained so that they could tell the story of their liberation. At the end of August, a dispatch announced "a trainload of prisoners of war is about to arrive in Toulouse";[4] others were photographed in Mâcon. Thus, they were used to show men returning with a smile and in good health and others confident from the start (fig. 17). In this way, visual stereotypes were arrived at (even though the photographs emerged from numerous agencies) that, repeated, would make the case for the solid basis of the Relève agreement.

Every day, the newspapers had to find something to say about the Relève on the first page, and "the illustrated weeklies [had to] devote a full page of photographic reportage to it" (order number 613).[5]

Inflated numbers, reassuring dispatches, photographs of hope, three for one, 150,000 for 50,000: the historian has established that this piece of work was, in fact, an immense dupe.

Denis Maréchal

250

1. The orders and commentaries are quoted from P. Limagne, *Ephémérides de quatre années tragiques,* new ed. (La Villedieu-Ardèche: Editions de Candide, 1987). Pierre Limagne, a journalist for *La Croix,* in 1945–46 published the notes he made from day to day, bearing witness to the difficulty of the profession at a time when the press had to submit to the imperious instructions it received from Vichy. The originals of these instructions were burned by the censors as the Liberation forces approached.

2. From captions written on the backs of the photographs.
3. From captions written on the backs of the photographs.
4. From captions written on the backs of the photographs.
5. Limagne, *Ephémérides.*

3

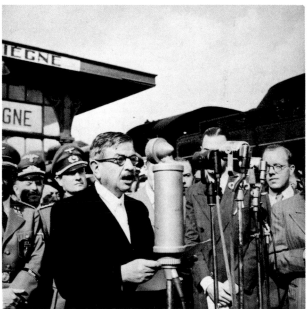

4

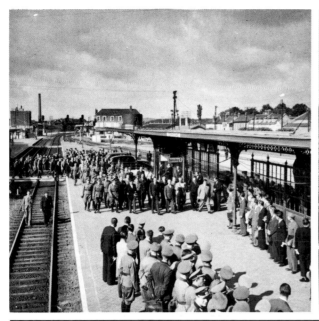
1

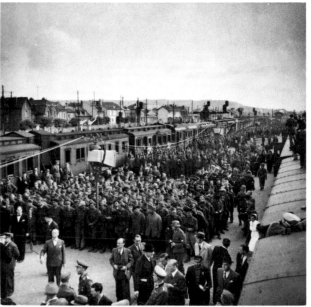
2

5

6

7

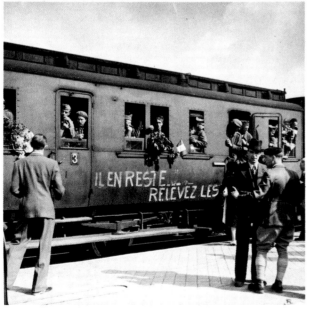
IL EN RESTE...
RELEVEZ LES

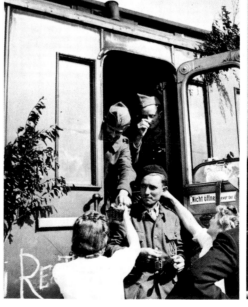
Nicht öffne
Re

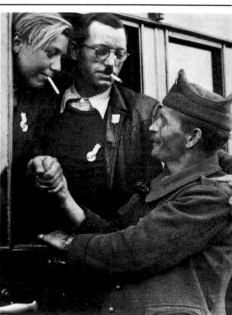

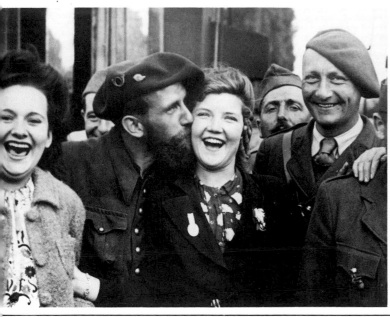

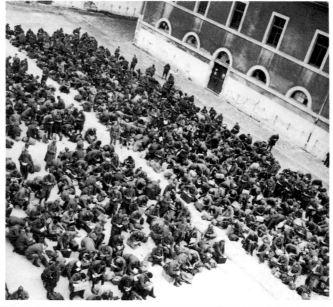

8

9

10

13

14

15

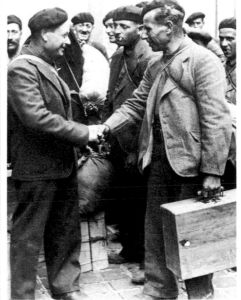

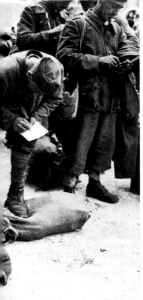
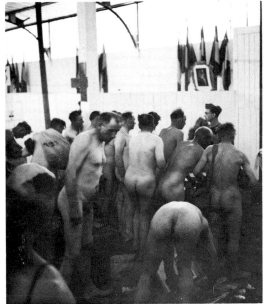
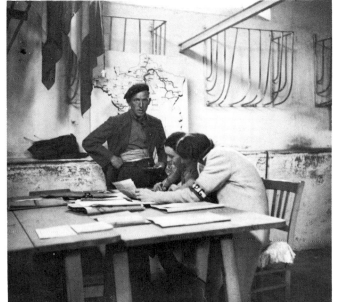

11

12

16

17

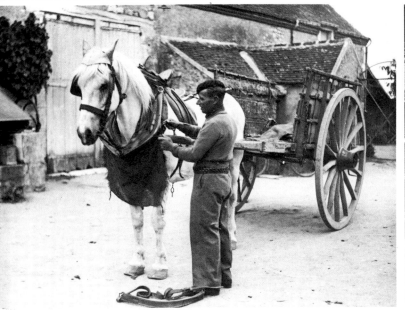
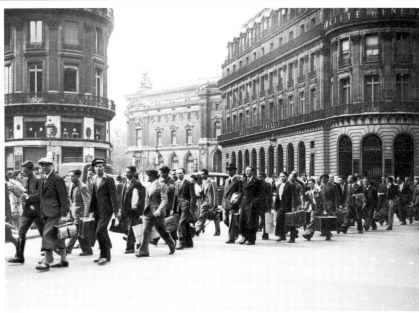

Chronology

1940

	Vichy France		Opposition France
Restrictions	**Culture**	**Politics**	
		25 June: The armistice, signed at Rethondes on 22 June, becomes effective.	20 June: Etienne Achavanne sabotages the telephone lines to the Wehrmacht near Rouen; he is executed by firing squad.
	July: Bernard Grasset sends to Vichy the text *Nécessité d'un armistice de l'esprit* on the reorganization of the publishing business.	10 July: The National Assembly votes full constituent powers to Marshal Pétain. 12 July: Laval becomes second to Pétain in the Vichy government.	
3 August: Sugar, bread, and pasta become subject to rationing.	18 August: Propaganda Abteilung, German propaganda, begins to oversee all cultural activity in the occupied zone. September: First Otto list (books banned by the Germans). 6 September: The exhibition *Art français contemporain* opens at the Musée de l'Orangerie. 25 September: Creation of the corporative association of the daily press in Paris.	7 August: Alsace and Moselle are placed under the trusteeship of two German area commanders. 13 August: A decree dissolves secret societies. 29 August: Creation of the Légion Française des Combattants. 3 October: A statute forbids Jews from following certain professions. 4 October: From here on, prefects may intern foreign Jews. 24 October: Pétain and Hitler meet at Montoire. 30 October: In a radio address, Pétain states, "Today I set out on the path of collaboration."	Beginning of August: The first agents of the Free French arrive to set up information networks. August: Jean Texcier publishes *Conseils à l'occupé* in the occupied zone.
20 October: Ration books are distributed.			
	22 November: The association Jeune France is established. 2 December: A decree establishes the Comité d'Organisation des Industries Cinématographiques. 15 December: The Germans offer to return the ashes of Napoléon II (known as l'Aiglon) to Paris. 19 December: Grand Festival of Jazz, Salle Gaveau. 31 December: Creation of the Order of Architects. Louis-Ferdinand Céline publishes the novel *Les beaux draps*.	November: Expulsion of 70,000 citizens of Lorraine to the southern zone. 9 November: A decree dissolves professional organizations. 2 December: A law is made concerning the corporative organization of agriculture. 13 December: Laval is dismissed.	November: Militant democrat-Christians form the movement Liberté. 11 November: High school and university students demonstrate in Paris. December: First issue of *Résistance* appears.

Vichy France

Opposition France

Restrictions

5 January: Shoes become subject to rationing.
23 January: A decree forbids throwing out, destroying, or burning "old metals, old papers, feathers, rubber, bones, skins, leathers."

8–16 June: The Grenoble fair is devoted to substitute products.

1 July: Clothes become subject to rationing.

18 September: A law institutes the compulsory harvesting of Spanish broom.

Culture

February: The film *Le Juif Süss* is shown in Parisian movie theaters.

10 May: The exhibition *Twenty Young Painters in the French Tradition* opens at the Galerie Braun in Paris.
11 May: Inauguration of the Institut d'Etudes aux Questions Juives.
22 May: Herbert von Karajan directs an opera by Richard Wagner at the Palais de Chaillot.

September: A festival of "swing" is held at the Salle Pleyel.

October: The first Salon for those under thirty is held at the Galerie Royale, Paris.

December: The Prix Goncourt is awarded to Henri Pourrat for *Vent de mars*.

Politics

February: Paul Marion becomes head of the information services.
1 February: Founding of the Rassemblement National Populaire (RNP).
9–10 February: François Darlan becomes deputy prime minister and second in the government.

14 May: Foreign Jews are arrested in Paris.
27–28 May: Darlan signs the "protocols of Paris" with the occupier.

2 June: The second statute on Jews and a law requiring them to register.
22 June: The German army attacks the Soviet Union.

18 July: The first meeting of the Légion des Volontaires Français contre le Bolchevisme (LVF).

12 August: In a speech, Pétain denounces the "evil wind" he senses rising in the French spirit.
14 August: Creation (antedated) of special sections in the courts.
20 August: Jews of the 11th arrondissement in Paris are rounded up and sent to Drancy.
22 August: Promulgation of the hostage ordinance.

5 September: The exhibition *France and the Jew* opens in Paris.

4 October: Promulgation of the labor charter.

1 December: Pétain and Hermann Goering meet in Saint-Florentin.
8 December: The United States enters the war.
12 December: In Paris, 750 Jews of French nationality are arrested.
 The official constitution of the Service d'Ordre Légionnaire is established.

28 January: The leaders of the group Musée de l'Homme are arrested.

March: The first Comité d'Action Socialiste (CAS) is established in the southern zone.
 The Main-d'Oeuvre Immigré (MOI) is augmented by the underground Parti Communiste Français.
 Rémy founds the Confrérie Notre-Dame, a Gaullist information network.

15 May: Creation of the Front National.

14 July: *Défense de la France* comes out.

21 August: Colonel Fabien kills the German naval subaltern Alphonse Moser in the Barbès-Rochechouart subway station in Paris.

22–23 October: Execution of hostages in Châteaubriant.

November: The movement Combat is founded in Grenoble.
 First issue of *Cahiers du Témoignage Chrétien* comes out.

255

Vichy France

Opposition France

Restrictions	Culture	Politics	
15 March: A law regulating the black market is passed. 25 March: A decree calls for recovering all hair from hairdressers.		February: Several Third Republic leaders are tried at Riom (proceedings suspended 15 April). 1 March: The exhibition *Bolshevism against Europe* opens in the Salle Wagram, Paris. 3–4 March: Creation of the Comité Ouvrier de Secours Immédiat (COSI). 27 March: The first trainload of deportees departs for Auschwitz.	2 January: Jean Moulin, Charles de Gaulle's representative, returns to France by parachute. February: Les Editions de Minuit publishes Vercors's *Le silence de la mer* sub rosa. 28 March: The Francs-Tireurs et Partisans Français (FTP) is formed.
	4 April: The Franco-German exhibition *The New Life* opens at the Grand Palais. 15 May: Opening of the exhibition of sculptor Arno Breker at the Museé de l'Orangerie.	18 April: Laval returns to power as "head of government." 6 May: Louis Darquier de Pellepoix replaces Xavier Vallat as commissioner-general for Jewish affairs. 29 May: Jews are required to wear a yellow star in the occupied zone.	16 April: High school students demonstrate in Paris. 1 May: Patriotic demonstrations in numerous cities of the southern zone.
	June: A large artisanal exposition is held at the Orangerie at the Château de Versailles.	22 June: Laval broadcasts the first appeal for the Relève and states he hopes that Germany will win the war. 16–17 July: The roundup known as the Vél'd'Hiv (for Vélodrome d'Hiver) takes place in Paris.	11 June: The FFL manages to escape at Bir Hacheim. August: In London, the BCRA takes charge of political action in France.
	6 August: Inauguration of the Musée d'Art Moderne (Palais de Tokyo). October: Lucien Rebatet's novel *Les décombres* is published. Marcel Carné's film *Les visiteurs du soir* comes out.	August: Thousands of foreign Jews in the southern zone are delivered to the Nazis. 4 September: A law authorizes the Vichy government to requisition men for labor. 11 November: The Germans occupy the southern zone. 27 November: The armistice army is disbanded. The fleet at Toulon is scuttled.	September: Noyautage des Administrations Publiques (NAP) is formed. 16 October: A committee to coordinate the movements of the southern zone is formed. December: Officers of the former armistice army found the Organisation Métropolitaine de l'Armée (OMA).

Restrictions	Culture	Politics	
Exhibition of substitute products is held at the Grand Palais, Paris.	15 January: The first issue of *Le Téméraire*, a newspaper for children financed by the Germans, appears. 31 March: The sale of radio receivers is banned.	30 January: The Milice Française is instituted in the southern zone. 15 February: The age groups 40, 41, and 42 are called up for the Service du Travail Obligatoire (STO). 2 March: Travel restrictions across the demarcation line are relaxed. 5 April: The French government delivers Léon Blum, Edouard Daladier, Georges Mandel, Paul Reynaud, and Maurice Gamelin to the Germans.	January: The Maquis infiltrates the occupied zone. 22 January: The first meeting between de Gaulle and General Henri Giraud. 26 January: The three main movements of the southern zone are amalgamated to form the Mouvements Unis de la Résistance (MUR). 17 April: The reunification of the underground Confédération Générale du Travail (CGT). 24 April: Death of the first member of the Milice killed by the Resistance. 27 May: The Conseil National de la Résistance (CNR) is founded.

Restrictions | Culture | Politics

Culture

23 May: Rose Valland, connected with the Musée du Jeu de Paume, is present at the burning of artworks organized by the German authorities.

1 December: Paul Claudel's play *Soulier de satin* is performed at the Comédie Française.
Jean Grémillon's film *Lumière d'été* comes out.

Politics

2 June: The Franc Garde of the Milice Française is formed.
22 July: A decree authorizes the French to enter an alliance with Germany.
17 September: "A national plan for French recovery" is put forward by the collaborationist extremists (including Marcel Déat, Darnand, and Jean Luchaire).
13 November: Pétain is banned from the airwaves by order of the Reich. The head of state ceases to carry out his functions.
18 December: Pétain accepts all the conditions demanded by the Reich.

Opposition France

30 May: De Gaulle arrives in Algiers.
3 June: Creation of the Comité Français de Libération Nationale (CFLN).
21 June: Jean Moulin is arrested in Caluire.
8 July: Probable date of Jean Moulin's death.
September: Georges Bidault is elected president of the CNR.
9 September: Revolt of the Corsican Resistance.
5 October: Corsica's liberation is ended.
3 November: The consultative assembly holds its first meeting in Algiers.
11 November: Widespread celebration of Armistice Day in France (for example, Grenoble, Oyonnax).
29 December: The Forces Françaises de l'Intérieur (FFI) is formed.

Culture

February: Salon of the French provinces at the Musée Galliéra.

April: The circular for a "Service artistique du Maréchal," directed by Robert Lallemant, supports the project for an "art of the marshal."

May: The German trust Hibbelen oversees 50 percent of the Parisian press.
Jean Grémillon's film *Le ciel est à vous* comes out.
Marcel Carné's film *Les enfants du paradis* is made.

Politics

1 January: Darnand and Philippe Henriot join the government.
20 January: The establishment of courts-martial.
27 January: The authority of the Milice is extended to the occupied zone.

16 March: Marcel Déat joins the government.

20 August: The Reich forces Pétain to leave Vichy and go to Belfort.

September: Pétain, Laval, and the extremists of the collaboration arrive at Sigmaringen (Baden-Württemberg).

Opposition France

5 January: Some of the movements of the occupied zone are amalgamated, and the MUR becomes Mouvement de Libération Nationale.
21 February: The execution of 22 partisans of the MOI, condemned without due process by the "Affiche Rouge."
March: The Maquis of Glières is destroyed.
15 March: The "Program of the CNR" is published.
9 April: "Red Easter" in the Jura.
2 June: The CFLN is transformed into the Gouvernement Provisoire de la République Française (GPRF).
7 June: Proclamation of the "Republic of Mauriac."
28 June: Philippe Henriot is killed by the Resistance.
23 July: The Maquis of Vercors is decimated.
August: The cities of the west, southwest, and Provence are gradually liberated, often at heavy cost.
19 August: Beginning of the Paris insurrection.
23 August: Eisenhower gives the order for General Philippe Leclerc's armored division to advance on Paris.
25 August: General Dietrich von Choltitz surrenders in Paris.

257

Bibliography

Adler, Jacques. *Face à la persécution: Les organizations jiuves à Paris de 1940 à 1944.* Paris: Calman-Lévy, 1985. In English as *The Jews of Paris and the Final Solution: Communal Response and Internal Conflicts, 1940–1944.* New York: Oxford University Press, 1987.

Amouroux, Henri. *La grande histoire des français sous l'occupation.* 10 vols. Paris: Laffont, 1976–93.

———. *La vie des français sous l'occupation.* New ed. Paris: Fayard, 1990.

———. *Pour en finir avec Vichy.* Paris: Laffont, 1997.

Atack, Margaret. *Literature and the French Resistance: Cultural Politics and Narrative Forms, 1940–1950.* Manchester, Eng.: Manchester University Press, 1989.

Azéma, Jean-Pierre. *La collaboration, 1940–1944.* Paris: Presses Universitaires de France, 1975.

———. *De Munich à la libération, 1938–1944.* Paris: Editions du Seuil, 1979. In English as *From Munich to the Liberation, 1938–1944.* Trans. Janet Lloyd. Cambridge: Cambridge University Press, 1984.

———. *Les archives de guerre, 1940–1944.* Paris: Documentation Française, 1996.

———, and François Bédarida, eds. *La France des années noires.* 2 vols. Paris: Editions du Seuil, 1993.

———, François Bédarida, and Robert Frank. *Jean Moulin et la Résistance en 1943.* Paris: Institut d'Histoire du Temps Présent, 1994.

———, and Olivier Wievorka. *Vichy, 1940–1944.* Paris: Perrin, 1997.

Beauvoir, Simone de. *La force de l'âge.* Paris: Gallimard, 1960. In English as *The Prime of Life.* Trans. Peter Green. New York: Harper and Row, 1976.

Bertin-Maghit, Jean-Pierre. *Le cinéma français sous l'occupation.* Paris: Presses Universitaires de Paris, 1994.

Bertrand-Dorléac, Laurence. *Histoire de l'art, Paris, 1940–1944: Ordre national, traditions et modernités.* Paris: Publications de la Sorbonne, 1986.

Bourdet, Claude. *L'aventure incertaine: De la Résistance à la restauration.* Paris: Stock, 1975.

Burrin, Philippe. *La France à l'heure allemande: 1940–1944.* Paris: Editions du Seuil, 1993. In English as *France under the Germans: Collaboration and Compromise.* Trans. Janet Lloyd. New York: New Press, 1996.

Cassou, Jean. *La mémoire courte.* Paris: Editions de Minuit, 1953.

Cointet, Michèle. *Vichy capitale: 1940–1944.* Paris: Perrin, 1993.

Conan, Eric, and Henry Rousso. *Vichy: An Ever-Present Past.* Trans. and annot. Nathan Bracher. Hanover, N.H.: Dartmouth College; University Press of New England, 1998.

Cone, Michèle C. *Artists under Vichy: A Case of Prejudice and Persecution.* Princeton, N.J.: Princeton University Press, 1992.

Cordier, Daniel. *Jean Moulin: L'inconnu du Panthéon.* 3 vols. Paris: Editions Jean-Claude Lattès, 1989–93.

Crémieux-Brilhac, J.-L., ed. *Londres, 1940–1944: Les voix de la liberté.* 5 vols. Paris: Documentation Française, 1975–76.

Debordes, Jean. *A Vichy: La vie de tous les jours sous Pétain.* [Thionne]: Editions du Signe, 1994.

Delperrié de Bayac, Jacques. *Histoire de la Milice.* Paris: Fayard, 1969.

Duquesne, Jacques. *Les Catholiques français sous l'occupation.* Rev. and enl. ed. Paris: Editions du Seuil, 1996.

Durand, Yves. *Vichy, 1940–1944.* Paris: Bordas, 1972.

———. *Libération des Pays de Loire.* Paris: Hachette, 1974.

———. *La vie quotidienne des prisonniers de guerre.* Paris: Hachette, 1987.

Eck, Hélène, ed. *La guerre des ondes: Histoire des radios de langue française pendant la Deuxième Guerre mondiale.* Paris: Armand Colin; Lausanne: Payot, 1985.

Ehrlich, Evelyn. *Cinema of Paradox.* New York: Columbia University Press, 1985.

Ferro, Marc. *Pétain.* Paris: Fayard, 1987.

Gaulle, Charles de. *Mémoires de guerre.* 3 vols. Paris: Librairie Plon, 1954–59. In English as *The Complete War Memoirs of Charles de Gaulle, 1940–1946.* Trans. Jonathan Griffin (vol. 1) and Richard Howard (vols. 2, 3). New York: Da Capo Press, 1984.

Gervereau, Laurent, and Denis Peschanski. *La propagande sous Vichy, 1940–1944.* Nanterre: Bibliothèque de Documentation Internationale Contemporaine, 1990.

Gide, André. *Journal.* Vols. 5, 6. Paris: Gallimard, 1946, 1950. In English as *The Journals of André Gide.* Trans. Justin O'Brien. Vol. 4. London: Secker and Warburg, 1951.

Gordon, Bertram M. *Collaborationism in France during the Second World War.* Ithaca, N.Y.: Cornell University Press, 1980.

Guéhenno, Jean. *Journal des années noires (1940–1944).* Paris: Gallimard, 1947.

Guitry, Sacha. *Quatre ans d'occupations.* Paris: L'Elan, 1952.

Halls, W. D. *The Youth of Vichy France.* Oxford: Clarendon Press, 1981.

———. *Politics, Society and Christianity in Vichy France.* Oxford: Berg, 1995.

Hirschfeld, Gerhard, and Patrick Marsh, eds. *Collaboration in France: Politics and Culture during the Nazi Occupation, 1940–1944.* Oxford: Berg, 1989.

Homze, Edward L. *Foreign Labor in Nazi Germany.* Princeton, N.J.: Princeton University Press, 1967.

Kedward, H. R. *Resistance in Vichy France: A Study of Ideas and Motivations in the Southern Zone, 1940–1942.* Oxford: Oxford University Press, 1983.

———. *Occupied France: Collaboration and Resistance 1940–1944.* Oxford: B. Blackwell, 1985.

———. *In Search of the Maquis: Rural Resistance in Southern France, 1942–1944.* Oxford: Clarendon Press, 1993.

———, and R. Austin, eds. *Vichy France and the Resistance: Culture and Ideology.* London: Croom Helm, 1985.

Latreille, André. *De Gaulle, la libération et l'Eglise catholique.* Paris: Editions du Cerf, 1978.

Limagne, Pierre. *Ephémérides de quatre années tragiques, 1940–1944.* New ed. La Villedieu-Ardèche: Editions de Candide, 1987.

Loiseaux, Gérard, and Bernhard Payr. *La littérature de la défaite et de la collaboration.* Paris: Publications de la Sorbonne, 1984.

Lottman, Herbert R. *Pétain: Hero or Traitor, the Untold Story.* New York: William Morrow, 1985.

———. *The People's Anger: Justice and Revenge in Post-Liberation France.* London: Hutchinson, 1986.

Marrus, Michael R., and Robert O. Paxton. *Vichy France and the Jews.* New York: Basic Books, 1981. Reprint, Stanford: Stanford University Press, 1995.

Martin du Gard, Maurice. *La chronique de Vichy, 1940–1944.* Paris: Flammarion, 1975.

Michel, Henri. *Paris allemand.* Paris: Albin Michel, 1981.

———. *Paris résistant.* Paris: Albin Michel, 1982.

Milward, Alan S. *The New Order and the French Economy.* Oxford: Clarendon Press, 1970.

Morgan, Ted. *An Uncertain Hour: The French, the Germans, the Jews, the Barbie Trial and the City of Lyon, 1940–1945.* London: Bodley Head, 1990.

Noguères, Henri, with Marcel Degliame-Fouché and Jean-Louis Vigier. *Histoire de la Résistance en France de 1940 à 1945.* 5 vols. Paris: Laffont, 1967–81.

Novick, Peter. *The Resistance versus Vichy: The Purge of Collaborators in Liberated France.* New York: Columbia University Press, 1968.

Ory, Pascal. *La France allemande, 1933–1945: Paroles du collaborationnisme français.* Paris: Gallimard/Julliard, 1977.

———. *Les collaborateurs, 1940–1945.* Rev. ed. Paris: Editions du Seuil, 1980.

Ousby, Ian. *Occupation: The Ordeal of France 1940–1944.* London: John Murray, 1997.

Paxton, Robert O. *Vichy France: Old Guard and New Order, 1940–44.* New York: Alfred A. Knopf, 1972. Reprint, New York: Columbia University Press, 1982.

Perrault, Gilles. *Paris sous l'occupation.* Paris: Belfond, 1987.

Peschanski, Denis. *Vichy, 1940–1944, les archives de guerre d'Angelo Tasca.* Paris: CNRS, 1986.

Pryce-Jones, David. *Paris in the Third Reich.* London: Collins, 1981.

Rajsfus, Maurice. *Des juifs dans la collaboration: L'UGIF (1941–1944).* 2 vols. Paris: Etudes et Documentations Nationales, 1980–89.

Rossignol, Dominique. *Vichy et les Franc-Maçons: La liquidation des sociétés secrètes 1940–44.* Paris: Editions Jean-Claude Lattès, 1981.

Rousso, Henry. *Le syndrome de Vichy: De 1944 à nos jours.* 2d ed. Paris: Editions du Seuil, 1990. In English as *The Vichy Syndrome: History and Memory in France since 1944.* Trans. Arthur Goldhammer. Cambridge, Mass.: Harvard University Press, 1991.

Sartre, Jean-Paul. *Situations, III.* Paris: Gallimard, 1949. In English as *Situations: Selections.* Trans. Annette Michelsen. New York: Criterion, 1955.

Seghers, Pierre. *La Résistance et ses poètes: France 1940–1945.* Paris: Seghers, 1974.

Shennan, Andrew. *Rethinking France: Plans for Renewal 1940–1946.* Oxford: Clarendon Press, 1989.

Siclier, Jacques. *La France de Pétain et son cinéma.* Paris: Henri Veyrier, 1981.

Veillon, Dominique. *Le Franc-Tireur: Un journal clandestin, un mouvement de Résistance, 1940–1944.* Paris: Flammarion, 1977.

———. *La mode sous l'occupation: Débrouillardise et coquetterie dans la France en guerre.* Paris: Payot, 1990.

———, ed. *La collaboration: Textes et débats.* Paris: Livre de Poche, 1984.

Vercors [Jean Bruller]. *La bataille du silence.* Paris: Presses de la Cité, 1967. In English as *The Battle of Silence.* Trans. Rita Barisse. London: Collins, 1968.

———. *The Silence of the Sea=La silence de la mer: A Novel of French Resistance during World War II.* Edited by James W. Brown and Lawrence D. Stokes. New York: Berg, 1991.

Vistel, Alban. *La nuit sans ombre: Histoire des mouvements unis de résistance, leur rôle dans la libération du sud-est.* Paris: Fayard, 1970.

Warner, Geoffrey. *Pierre Laval and the Eclipse of France.* London: Eyre and Spottiswoode, 1968.

Warner, Marina. *Joan of Arc: The Image of Female Heroism.* New York: Alfred A. Knopf, 1981.

Weber, Eugen. *The Hollow Years: France in the 1930s.* London: Sinclair-Stevenson, 1995.

Index